The Invention of the Visible

Reinventing Critical Theory

Series editors:

**Gabriel Rockhill, Associate Professor of Philosophy,
Villanova University**

**Yannik Thiem, Associate Professor of Philosophy,
Villanova University**

The *Reinventing Critical Theory* series publishes cutting-edge work that seeks to reinvent critical social theory for the twenty-first century. It serves as a platform for new research in critical philosophy that examines the political, social, historical, anthropological, psychological, technological, religious, aesthetic and/or economic dynamics shaping the contemporary situation. Books in the series provide alternative accounts and points of view regarding the development of critical social theory, put critical theory in dialogue with other intellectual traditions around the world and/or advance new, radical forms of pluralist critical theory that contest the current hegemonic order.

Commercium: Critical Theory from a Cosmopolitan Point of View
by Brian Milstein

Resistance and Decolonization
by Amílcar Cabral, translated by Dan Wood

Critical Theories of Crisis in Europe: From Weimar to the Euro
edited by Poul F. Kjaer and Niklas Olsen

Politics of Divination: Neoliberal Endgame and the Religion of Contingency
by Joshua Ramey

Comparative Metaphysics: Ontology after Anthropology
edited by Pierre Charbonnier, Gildas Salmon and Peter Skafish

A Critique of Sovereignty
by Daniel Loick, translated by Markus Hardtmann (forthcoming)

The Invention of the Visible: The Image in Light of the Arts
by Patrick Vauday, translated by Jared Bly

Metaphors of Invention and Dissension: Aesthetics and Politics in the Postcolonial Algerian Novel
by Rajeshwari S. Vallury

The Invention of the Visible

The Image in Light of the Arts

Patrick Vauday
Translated by Jared Bly

ROWMAN & LITTLEFIELD
————————— INTERNATIONAL
London • New York

Published by Rowman & Littlefield International Ltd
Unit A, Whitacre Mews, 26–34 Stannary Street, London SE11 4AB
www.rowmaninternational.com

Rowman & Littlefield International Ltd.is an affiliate of Rowman & Littlefield

4501 Forbes Boulevard, Suite 200, Lanham, Maryland 20706, USA
With additional offices in Boulder, New York, Toronto (Canada), and Plymouth (UK)
www.rowman.com

British Library Cataloguing in Publication Data
A catalogue record for this book is available from the British Library

ISBN: HB 978-1-7866-0049-3

Library of Congress Cataloging-in-Publication Data
Names: Vauday, Patrick, 1949– author.
Title: The invention of the visible : the image in light of the arts / Patrick Vauday ;
 translated by Jared Bly.
Other titles: Invention du visible. English
Description: Lanham : Rowman & Littlefield International, 2017. | Series:
 Reinventing critical theory | Includes bibliographical references.
Identifiers: LCCN 2017018140 (print) | LCCN 2017028817 (ebook) | ISBN
 9781786600516 (Electronic) | ISBN 9781786600493 (cloth : alk. paper)
Subjects: LCSH: Painting—Philosophy. | Aesthetics. | Image (Philosophy) |
 Painting, French—20th century. | Painting, French—19th century.
Classification: LCC ND1140 (ebook) | LCC ND1140 .V37813 2017 (print) |
 DDC 701—dc23
LC record available at https://lccn.loc.gov/2017018140

♾™ The paper used in this publication meets the minimum requirements of
American National Standard for Information Sciences – Permanence of Paper
for Printed Library Materials, ANSI/NISO Z39.48–1992.

Printed in the United States of America

Contents

Contents

Preface to the English Edition

Apart from Plato who serves as a point of entry, the philosophers brought together in this book to elaborate a thinking of the visible are, for better or worse and despite our reticence in this regard, the so-called representatives of contemporary French thought situated after World War II. This hexagonal privilege is, however, more by practice than by right. Indeed, rather than talk of 'French thought', we prefer speaking of a geographic and historical site of philosophy practised in France since this period, that is to say, of particular, situated circumstances whose exercise we can condition to the point of producing an original profile. This 'situation', to reprise a concept of one of the philosophers in question (Sartre), does not at all exclude the consideration of philosophical circulations, both intra-European and extra-European, on which philosophy has sustained itself in France. On the contrary, it presupposes these circulations in principle, even though the emphasis in this book is not on this point. Yet, concerning this situation and this French locus of post-war philosophy, a fact does not fail to draw attention: a marked interest is shown, for lack of a better word and to designate it generically, in what we call *aesthetics*. To this point, it would not be an exaggeration to speak in this respect of an aesthetic 'orientation' [*une tournure*] or indeed of an aesthetic 'turn' [*un tournant*], provided this word does not induce the idea of an exclusive interest in *the* aesthetic. This would probably be the case only whenever this term is understood in its Kantian acceptation and alongside that with which it engages from the point of view of the construction of phenomena and the 'invention' of the stage of the visible. To back this up, here are some notable dates and works: Sartre's *The Imaginary* (1940), which announces at its conclusion an aesthetic theory that will certainly not be realized but whose premises are all there; Mikel Dufrenne's *The Phenomenology of Aesthetic Experience* (1953); Merleau-Ponty's *L'œil et l'Esprit* (1960); Foucault's *The*

Order of Things (1966); Jean-François Lyotard's *Discours, Figure* (1971); Henri Maldiney's *Regard, Parole, Espace* (1973); Jacques Derrida's *The Truth in Painting* (1978); Gilles Deleuze's *Francis Bacon: The Logic of Sensation* (1981); and Jacques Rancière's *The Distribution of the Sensible* (2000). There could be grounds for mentioning the aesthetic oeuvre, properly speaking, of Etienne Souriau, recently brought to light by Bruno Latour and Isabelle Stengers and, in the field of psychoanalysis, Seminar XI of Jacques Lacan, *The Four Fundamental Concepts of Psychoanalysis*.

Hardly exhaustive, this list of authors and works is here only to trace the main thrust of philosophy in France, whose high points are dotted across a half century, without even considering how certain authors, included in virtue of relatively belated books which are more significant or more well known than their other works, were working in this field much earlier. This is notably the case for Gilles Deleuze who published *Proust and Signs* as early as 1964. It is perhaps surprising, speaking of the post-war period, to note the inclusion of Sartre's *The Imaginary*, published as early as 1940. Beyond indicating a pre-war filiation with Husserlian phenomenology, this book concerns an insistence on Sartre's invention that connects the imaginary's production with the 'nihiliating' [*néantisante*] activity of desire. In other words, this suggests the inscription of the aesthetic into an immediately metaphysical dimension. This is one of the reasons for his presence in this book, intending to do him justice before gaining traction through critiquing him in order to head off in the more pragmatic direction, alongside Deleuze and Jacques Rancière, towards an aesthetics and a politics. All the same, we might be surprised here by the presence of Foucault's *The Order of Things*. Although this work does not deal with aesthetics in the most received meaning of the term, it derives from it if we understand 'words and things' in their Kantian sense, that of a transcendental shaping that Foucault additionally subjects to an epistemologically and historically situated discursive inscription. Let us add, for good measure, that the sumptuous opening of the work, pulling back the curtain on Velasquez's *Las Meninas*, constitutes a bit of history regarding the articulation of the visible with discourse which no aesthetic can henceforth ignore, not to mention that it is practically the source of a genre, setting a precedent for more than a few French authors. Finally, in light of a definitive interest on the part of Foucault for aesthetics and painting, let us mention his project for a work consecrated to Manet, one which will never see the light of day, but which fed into the recently published conference that he delivered in Tunis.[1]

However, let us agree that a list of names and titles, as remarkable as they are, does not explain their susceptibility to being gathered into a unified totality. Beyond the generic term *aesthetics*, what connections actually are there between the phenomenological approach and Foucauldian epistemo-structural analysis, or the genealogical critique of Deleuzian forces,

or, even, the psychoanalysis of drives? In no way exhaustive, our list is also heterogeneous, which is doubtlessly worse. So will we attempt to put a square peg in a round hole [*tenter le marriage de la carpe et du lapin*]? Not at all, but we can at least trace a few lines of division, that is to say, also lines of divergence, from out of common objects. One of these common objects seems to be at the heart of aesthetics: the body. Even for Sartre, in distinction from Merleau-Ponty's phenomenology, the body is elided, but, overall, remains present in the negation-nihilation operation whose object he fashions on behalf of the subject. However, this body, the central object of the aesthetic approach, is specifically an object of dispute. This is a discord between phenomenology on one hand, notably Merleau-Ponty and Maldiney who make it the site of an openness to and the insertion into the world, and, on the other, Foucault's biopolitics, which exposes the apparatuses of domination investing in the body's deepest capacities, or even Deleuze and Guattari's vitalist theory of the body without organs. Jacques Rancière also partakes in this anti-phenomenological common front with his theory of regimes of visibility that foregrounds speaking bodies and divides them according to the social distribution of status. Even if we find in Deleuze's *Francis Bacon: The Logic of Sensation* an explicit reference to phenomenology, namely to Henri Maldiney, it is no less explicitly understood in the opposite sense when Deleuze writes, 'Presence, presence . . . this is the first word that comes to mind in front of one of Bacon's paintings'.[2] If the reference to the phenomenology of presence here is indeed without question, the repetition in the form of an *insistence*, a word that comes from a bit far afield in his writing, indicates that it is a question of something other than the lived body. In this precise case, it is a question of a power [*une puissance*] or a force that traverses and seizes hold of the body in order to contort it outside of itself. Deleuze consequently inscribes this power into the register of hysteria and excess rather than in the unity that allows the subject to find itself in harmony with itself and with the world. As for Jean-François Lyotard, who ceaselessly drifts from phenomenology and, at the same time, never totally separates himself from it, he imbues the body with a significant twist in *Discourse, Figure* by submitting it to the disorganizing labour of the drives. If consequently the body is the intentional object of contemporary French aesthetics, then it is only ever as such at the crossroads of divergent points of entry.

Another dividing line in the aesthetic 'orientation' of philosophy in France in the second half of this century is to be sought in a theory and practice of the sign, which is, moreover, not without a connection to the question of the body. Indeed, the ultimate stakes of the different approaches to the body that were just very succinctly evoked could have very well been the critique, not of the concept as such but of a form of transcendent conceptualization that ignores living singularities. This is where one finds the anti-Hegelian

inspiration for a large number of post-war French philosophers who reacted against the strong Hegelian current that prevailed before the war and the period immediately after. It was not a question, in doing so, of playing the lived body against the abstraction of the concept, 'the matters of life' against a systematic mindset, but rather it concerns giving life to a concept by connecting it to experiences that are likely to enrich it and to define its plane of consistency. The concept, therefore, is a response to a need for the resolution of a problem. Since judgement from out of a concept, a principle or a value was disqualified, what other route was able to offer itself to the practice of philosophy? The answer was found with the sign.

Georges Canguilhem's work was without a doubt decisive in this regard if we think of the programmatic formula under which he placed as much his professorial and pedagogical duty as his practice of philosophy and historical epistemology, a practice essentially turned toward the medical disciplines and vitalist thought: 'Philosophy is a reflection for which all unknown material is good, and we would gladly say, for which all good material must be unknown'.[3] The error to avoid in interpreting this formula would be to see in it nothing other than the recycling of the old theory according to which philosophy alone would extract the idea or concept from other disciplines which would do what they do without really being aware of what they do, that is to say, a definition of philosophy as a 'reflection on', consequently overshadowing other practices, even though, quite to the contrary, such a formula invites philosophy to exit from its dogmatic self-importance in order to converse with [*prendre langue*] other 'disciplines' [*matières*] (recall in France at school we teach disciplines [*matières*]: literature, history, law, economics, mathematics, etc.) or even better to learn the language [*apprendre la langue*] of other disciplines. The disciplines, in effect, are not solely defined by the specificity of their object of study but are defined just as much, if not more, by their manner of elaborating them, of forming them, and we almost might say, of making them speak and think, in short of making them discursive. Disciplines are not given but *produced* by a discourse that makes them signify through organizing the rules of the constitution and the transformation of their object. Working within a discipline [*travailler une matière*], whether literary, economic or physical, is nothing other, yet nothing less, than to proceed by deciphering the signs which render it singular and command the operations that make an engagement in and with it possible. Gone were the days when philosophy allowed itself to take up, as an example, this or that discipline [*telle ou telle matière*], without truly knowing it, with the sole aim of making it conform to its idea. It was henceforth necessary to envisage these disciplines like foreign languages that open on to new territories of thought and also new ways of thinking. Canguilhem himself led by example in engaging in a medical education consecrated by a thesis in medicine, a

discipline that he had otherwise the chance to practise as part of his activity during the French resistance against the Nazi occupation. This figure of the doctor-philosopher, whose characteristics Nietzsche had already sketched out, is not a simple stylistic device. It corresponds to a new practice of philosophy that is presented as an aesthetic clinic that listens to the sensible signs emitted by different disciplines [*matières*] and is on the lookout, like a doctor, for discordances betraying malfunctions or renewals in modes of acting, feeling and thinking. From this point of view, the work of Canguilhem assuredly derives from what Jacques Rancière calls, referenced more than once in this book, the *aesthetic regime* of the modern epoch,[4] understood here as a regime of sense in which it is not a speaking, intentional subject who acts or suffers but a mute body belonging to beings just as much as to things and bearing the traces of the history and geography that made it what it is by capturing it at the heart of a network of relations. What counts for signs counts equally for images, the object of this present book which supports the idea that images are not representations or expressions of a subject [*un sujet*] but the shaping of the becoming of disciplines [*les matières*] within their spatio-temporal coordinates. Images are neither reproductions nor presentations; they are productions and effectuations of relations between different disciplines [*matières différentes*], for example, in literature, and between the visible and the audible or within the same subject, for example, in painting. Conceived as such, images no longer derive from an ontology or a relation, degraded as it is, to being, but from a pragmatics that generates being.

Regarding what appears in post–World War II France as philosophy's aesthetic orientation, in the previously defined sense, an aspect of this book could misdirect the reader. Indeed, with the notable exception of cinema, and most likely photography in part as well, the pictorial works in question supporting the thesis of a pragmatic of images are almost always diachronically displaced in relation to the philosophical works called upon to account for them. Thus it is a question, among others, of a drawing of Rembrandt, a picture of Manet and Gauguin, without reference, more or less, to the works contemporaneous to the philosophical moment that was just evoked. To this we have an initial response: whether it is a question of Deleuze or of Jacques Rancière, or even of Lyotard in *Discourse, Figure*, the works at issue are only rarely of their time. Without a doubt, Deleuze consecrated an entire book to Francis Bacon, but he does not decipher Bacon's work without resituating it in the long history of occidental painting passing notably through Greco and Cezanne, with an eye for, it is true, emphasizing its originality within the post-war debate that raged between figuration and abstraction. As for Jacques Rancière, his interest is less directly in the works themselves than in the critical discourse that renders them visible and stages them,[5] without even mentioning his tendency to search for one of the origins of contemporary art in

the first fruits of the aesthetic age at the beginning of and throughout the nineteenth century. It is, moreover, in Jacques Rancière's theory of the 'aesthetic regime' of the arts that a second explanation can be given for the observed temporal gap. It is indeed significant that one of the characteristics of the aesthetic regime is not so much the production of new works as the invention of a new visibility of works, notably from the past, and not without consequences in return for the production of new works. This is notably the case in the analysis that he performs on the shift in the gaze exhibited by the work of Chardin, comparing Diderot's critique in the *Salons*[6] during the eighteenth century with the new vision of the Goncourt brothers, close to a century later, in which he detects the premises of impressionist painting. Beyond these two reasons that apply to these two cited authors, it is doubtlessly the case that the thesis of a pragmatic of images certainly gains legitimation in being exercised on the terrain of the contemporary arts to the extent that the artists themselves explicitly put this thesis to the test of their practice, as Eric Alliez has notably shown in *Défaire l'image*[7] apropos of Matisse, Duchamp and Ernesto Neto and as we demonstrated in a previous work titled *Faut voir! Contre-Images*[8] dedicated to the analysis of singular works by contemporary artists.

A second reason for this book, beyond highlighting an aesthetic moment in post-war French philosophical production, is more intensely connected with contemporary theories of art and to the way in which, in the wake of conceptual art, such theories were able to be situated and set in opposition to the question of the artistic status of images. It seemed to us that the terms of the debate, often reduced to the 'for or against' alternative, were too simplistic and that a place should be made for the critical, indeed agonistic, dimension of images in the practice of the arts. To be made to see otherwise, to be made to see in a better way or to be made to see what is invisible, whatever happens to be the nature of this invisibility, whether religious, social or anthropological, seems to us in effect to be one of art's essential motifs. As Aristotle writes: 'Art loves risk', so it would be suiting to add for good measure that it loves the risk of differences, gaps and irregularities. In a previous work, *La décolonisation du tableau: Delacroix, Gauguin, Monet*, we attempted to show that these three artists, contemporaries to the establishment of the French colonial empire, had found, each on their own and not without contradiction, in exogenous and heterogeneous arts, from Morocco and Algeria for Delacroix, from Polynesia for Gauguin and from Japan for Monet,[9] the opportunity for an aesthetic experience of a nature conducive to displacing and renewing their art. These displacements, particularly perceptible in the new manner of discerning space that breaks with the perspectival tradition inherited from the European Renaissance, also resulted in a new use of colour and arabesque line, becoming undulating and open to metamorphoses. In the popular sphere of exoticism that marked the century of colonial conquest in Western Europe,

from Spanish exoticism to Japonism passing through orientalism, artists were not satisfied with following a trend. These artists belonged to what Victor Segalen calls *exots*,[10] designating those who seek to unite foreign cultures together with their own in order to receive from them new modes of seeing, feeling and thinking. This is perhaps less due to a logic of conversation or, to the contrary, of appropriation following the model of orientalism emphasized by Edward Said,[11] than to a logic of diversion and invention that opened up new territories to sensibility. It is also remarkable that these artistes, among many others, including Matisse and Picasso, do not repudiate images but give them a function distinct from illustration or representation through pictorial surface techniques, ones that are sensitive to textures as well as to the tensions of lines and colours so that painting gives life to images, giving birth to them and becoming invigorated by them instead of serving and reproducing them. Rather than images being representative, serving the power of representation and, consequently, as Edward Said shows, the power of domination, images became decorative, being the free expression of a surface and the tensions that play there. If one had to characterize exoticism, it would be by its picturesque treatment of places, figures and ways of life without modification of the relation to the space proper to the representative tradition that defines it as the distortion of a norm and hence an intentionally exaggerated style rather than the investigation of another 'manner of being in space, of being toward space'.[12] If Delacroix and Gauguin, among others, stand out from the crowd in their treatment of Moroccan, Algerian and Tahitian figures, it is due to having sought to attribute to these figures *their* space rather than imposing that of the artist on them, even if it was only from out of the personal shock that they had received from it. Another way to say this would be to speak of seduction, considering that the term suggests a derailment, an exit from the designated path, instead and in place of a pure and simple appropriation—a seduction, for the most part yet not exclusively, that had played on as much as it was transformed through feminine figures, at least in the case of these two artists.

This work on the images of the Other, bearing the presence of others, as biased as it is by the colonial circumstances of the encounter, resembles what Michel de Certeau called a *heterology*.[13] This is understood as a discourse about the Other that would be as much a discourse on the Other as a discourse of the Other, from out of the Other, in the sense that, refusing the overarching position of scientific objectivity, it would inscribe the conditions and the traces of the encounter and would consequently consent to being deviated and altered by it. Forged at the occasion of a reflection on the conditions of the modern historian's discourse, this notion also applies, according to Michel de Certeau, to ethnology, insofar as, like history, it 'makes difference its object' and gives itself 'the task of rendering thinkable a society in its dimension of heterogeneity' by instituting itself as 'a site of exchange between the same

and the Other, a site of transit'. According to our interpretation, one finds a few good examples of this in Michel Leiris's *L'Afrique Fantôme*,[14] a scrupulous travel log of the Dakar-Djibouti's ethnographic expedition that, under the authority of the French government of the time, was responsible in 1930 for collecting objects, documents and recordings aimed at enriching the collections of the Musée de l'Homme in Paris.[15] Not being satisfied with notations or scientific surveys, Michel Leiris therein reports not only his feelings and the daily activities of the expedition's members but also the conditions, at times violent and often questionable, in which scientific investigation is performed. Pursuing the path of ethnology while giving himself over, as a writer, to a gloriously fictional autobiography,[16] Michel Leiris can be considered in France, if not one of the precursors, at least a herald of what would go on to become post-colonial, and then de-colonial studies, being recognized as such by Edouard Glissant and Franz Fanon with whom he was in contact.[17] Whether it is a question of collective culture shock in the contact with other cultures, in his case especially African and Caribbean cultures, or the exploration of the 'the Babel of the spirit',[18] his constant concern for welcoming the foreigner and the foreign opened the path to a decolonization of minds and bodies. Indefatigable enemy of racisms, signatory in 1960 of the *Déclaration sur le droit à l'insoumission dans la guerre d'Algérie*,[19] fervent admirer of Italian operas and jazz, great friend of Aimé Césaire and Wilfredo Lam, as well as a good number of others, he ceaselessly rubbed cultures against each other in order to make sparks of clarity burst forth from them. A heterology of images can be aligned with this spirit of openness and adventure, like an invitation to decentre the gaze or, better, to allow multiple gazes to resonate together, as dissonant as it might be. From this point of view, even though their research is inscribed into a broader perspective than that of post-colonial studies *stricto sensu*, it seems to us that the work of Phillipe Descola and Hans Belting, the first an anthropologist, the second an art historian, moves in the direction of what, following Hans Belting, we can call a 'cultural comparison of the gaze'.[20]

One of the present stakes of images could be this: how to account for the transformations of space in relation to the movements of all types which configure it, to record not only the changes that affect it but also that which resists such movements, what comes to pass through them and what fails to come through. Within this optic, which seems to us to notably be that of several contemporary photographic artists, such as Sophie Ristelhuber or Jananne Al-Ani, images act less as maps than as provisional positions taken above the flux of the world or as records of passage from one state of the world or culture to another, from one genre to another, from one life rhythm to another. In the present context of globalization, the risk is all the more immense given the triumph of consensual clichés, exemplified by big brands which dominate

the world market and do not fail in their marketing strategy to appropriate a local inflection in their production, under the form of what we call in Frenglish *cotumisation* (customization).[21] The art market does not avoid the temptation of attracting, via large festivals and international galleries, a wealthy clientele in favouring the portion of artistic productions presumed to respond to their taste. One hardly knows if the Romanian artist Dan Perjovschi who included in one of his works, shown at the Biennale d'Art Contemporain de Lyon (2009), the inscription, among others, 'I love Francophonie,' was serious or ironic. Whether he was serious or ironic in not writing in French or his own language, he nonetheless reveals, in the form of a paradox, a massive phenomenon in the art world manifest in the tendency to seek the shortest path towards international clients: knowing English. There is of course nothing wrong with the fact that English is the language driving the dissemination of information regarding this work, but the fact that it becomes, without any other reason than that of accessibility, the expression of the work itself may pose a problem, particularly whenever it is a question of films or videos for which the sonorous image is an essential raw material. Images are not by nature dedicated to the service of domination and the standardization of the commodity, contrary to the thesis defended by Guy Debord in *The Society of the Spectacle*, which views, in the generalized reign of the image, the supreme stage of the commodity that would render humanity a passive consumer instead of a living agent. The reign of the image is a myth become commonplace; we ought to recognize that if there are images that have an anesthetizing effect, then there are others, more than we generally acknowledge, that produce an aesthetic effect, indeed an 'esthesic'[22] effect, which awakes sensibility and incites thought. The former, which aim for the sensational rather than sensation and derive consequently from an aesthetic of shock destined to stultify sensibility and to paralyse thought, are opposed by the latter which, let us call them 'counter-images', appeal to the gaze, listening and reflection.

NOTES

1. Michel Foucault, *Manet and the Object of Painting*, trans. Matthew Barr (New York: Tate, 2009).
2. Gilles Deleuze, *Francis Bacon: The Logic of Sensation*, trans. Daniel W. Smith (New York: Continuum, 2003), 50.
3. Georges Canguilhem, *The Normal and the Pathological*, trans. Carolyn R. Fawcett (New York: Zone Books, 1991), 33. Philosopher, epistemologist and historian, Canguilhem notably was the director of Michel Foucault's thesis *Folie et déraison. Histoire de la folie à l'âge classique* (1961).
4. Jacques Rancière, *The Politics of Aesthetics*, trans. Gabriel Rockhill (New York: Bloomsbury, 2015), 15–25.

5. See, for example, his text 'Painting in the Text' in which he relates Gauguin's new pictorial vision to his analyses of the critic Albert Aurier. Jacques Rancière, *The Future of the Image*, trans. Gregory Elliot (London: Verso, 2007).

6. Denis Diderot, *Diderot on Art: 1: The Salon of 1765 and Notes on Painting*, trans. John Goodman (London: Yale University Press, 1995).

7. Eric Alliez, *Défaire l'image. De l'art contemporain* (Paris: Les Presses du Réel, 2013).

8. Patrick Vauday, *Faut Voir! Contre-images* (Paris: Press Universitaires Vincennes, 2014).

9. Of course, Japan was never part of the French colonial empire, neither directly nor at a distance, but it offers a particularly interesting example of the encounter between different aesthetic cultures.

10. Victor Segalen, *Essay on Exoticism: An Aesthetic of Diversity*, trans. Yael Rachel Schlick (Durham: Duke University Press, 2002), 17.

11. Edward Said, *Orientalism* (New York: Vintage Books, 1994).

12. Gilles Deleuze and Felix Guattari, *A Thousand Plateaus: Capitalism and Schizophrenia, Volume 2*, trans. Brian Massumi (Minneapolis: University of Minnesota Press, 2005), 482.

13. Michel de Certeau, *L'Absent de l'histoire* (Paris: Maison Mame, 1973), 173–77.

14. Michel Leiris, 'L'Afrique fantôme', in *Miroir de l'Afrique* (Paris: Gallimard, 1996).

15. Directed by Marcel Griaule, the mission would last from May 1931 to January 1933. Leiris served as its secretary-archivist.

16. Entitled *La Règle du jeu*, it was inaugurated by the publication in 1939 of *L'Age d'homme*.

17. Regarding Leiris's evolution in virtue of this subject, his transformation from a romantic vision to a political vision of colonial Africa, we refer to Jules Jamin's text which reprises the title of Michel Leiris's article 'L'ethnographe devant le colonialism' ('The Ethnographer Confronting Colonialism') appearing in 1950 in *Les Temps Modernes* no. 58, and in *Leiris & Co*'s catalogue de l'exposition *Leiris & Co*, organisée par le Centre Pompidou-Metz (Paris: Gallimard/Centre Pompidou-Metz, 2015), 254–57.

18. Michel Leiris, 'Glossaire, j'y serre mes gloses', in *Brisées* (Paris: Mercure de France, 1966), 11.

19. Known under the name of the 'Manifesto of the 121s', it was published in the press in September–October 1960.

20. Hans Belting, *Florence and Baghdad: Renaissance Art and Arab Science*, trans. Deborah Lucas Schneider (Harvard: Harvard University Press, 2011). Also refer to the comparative approach to images of structuralist inspiration in *La Fabrique des images. Visions du monde et formes de la représentation*, ed. Philippe Descola (Paris: Musée du quai Branly, Somogy Editions d'Art, 2010).

21. Frenglish is the equivalent of the informal French term *franglais* that designates words or turns of phrases that have been borrowed from, or modified by, the use of and proximity to English. In this case, the French noun *coutume* has been transformed into the substantive 'cotumization', following the English distinction between 'custom' and the substantive 'customization'. [TR]

22. This adjective qualifies the intensity of sensation.

Acknowledgements

Patrick Vauday extends his gratitude to Gabriel Rockhill who had the generous idea of welcoming this book into his series, to Jared Bly for the acuity of his translation work and to Irina Vauday for her attentive rereading of the manuscript, without of course forgetting the Université Paris 8 for their support.

Jared Bly first would like to warmly thank both Patrick Vauday and Irina Vauday for their assistance in the preparation of this volume. Patrick was indispensable in answering crucial questions about his text and also in aiding the often perilous hunt for citations that were difficult to locate. Irina carefully read the drafts of each chapter, providing an initial proofread and offering many useful suggestions for the translation of challenging idioms and uncommon turns of phrase. He also would like to thank Gabriel Rockhill—whose 2014 Critical Theory Workshop in Paris 2014 facilitated the encounter from which this translation project was born—both for his support during the nascent stages of this project's proposal and, in general, for his role as an intellectual advisor and mentor. In addition to these key players, the following individuals deserve thanks for their input and/or assistance at various stages of this project's completion: Janae Sholtz, Dan Wood, Adil Marazouki and Karen Beebe. Finally, Jared would like to thank his friends, colleagues and professors at Villanova University for their continual support and for providing an intellectual community in which a project such as this one could at all be made possible.

Introduction

Philosophy's quarrels with the image constitute a very old affaire. Truth be told, these disputes are at philosophy's origin, incessantly marking and haunting its history. The image was philosophy's Other with and against whom it constituted itself through the power of truth, the equivalent of the 'evil genius' imagined by Descartes in order to assert thought's capacity to escape from the enchantment of deceptive appearances. Plato had already imagined a gloomy cave in which people clung to the solitary company of shadows, a very 'strange picture' in the words of Glaucon who heard such a description from the very mouth of Socrates himself. Descartes goes even further, and thus, in the depths of his chamber heated for a rough German winter by his 'stove', his metaphysical reverie invents the extraordinary fiction of a painter who, 'no less powerful than deceitful, has employed his whole energies in deceiving me'[1] so much that 'the heavens, the earth, colors, figures, sound, and all other external things are nothing but the illusions and dreams of which this genius has availed himself in order to lay traps for my credulity'.[2] Enclosed in the darkness of a room that sounds suspiciously like a painter's *camera obscura*, Descartes projects a spectacle world reduced to the trickery of a divine yet malicious stage director and entirely ready to credulously succumb to the charming sway of colours, figures and sounds, he tears himself away from them at the last minute in order to say 'no to your splendid head' (Paul Valéry):[3] 'and let him deceive me as much as he will, he can never cause me to be nothing so long as I think that I am something'.[4] It is thus in this way that the subject subtracts the certainty of its existence from a world reduced to the inconsistency of an image. It is therefore in opposition to the fallacious image of the evil genius, initially erected as a consistent world before being troubled by resolute doubt, that the solid ground of truth is reached. Thought is won against the absorption by and belief in images—but

how could this be? they are nothing but images!—and if the lure of these 'agreeable illusions' subsists in the ruins of a disillusioned dream, this would only amount to allowing oneself, for better or worse, to being carried away by them. For Descartes, as it was for Plato, the power of thought is liberated only in opposition to the power and the instantaneous magic of images, the relics and the residue of our beliefs and our spontaneous adherences. Seductive, captivating, fascinating or repulsive, the image, in a word, does not think.

Philosophy is now free from the seduction of the image-idol, the *eidôlon* that produces the mute astonishment of appearances, yet always returns to this idol in order to rid itself of the bewitching charm of appearances. Nevertheless, philosophy has not settled accounts with images, the *eikones*, from which we derive the word *icon* in English. These are images that show themselves as they are without at all concealing their artifice or their human origins. These images are poetic and consequently not archeropoetic (not made from human hands) as are shadows and reflections that, as ephemeral as they are captivating, haunt the surfaces of waters and the material world. These images confess themselves and are exposed just as the subject of the *cogito* situates itself in the assumption of its thinking act. Such images would pose an entirely different problem to philosophy than that of the image-idol of belief in which the subject is corrupted and lost. Narcissus is emblematic of this debacle and this intrigue. The essential point of this myth is not so much the narcissism that, as the modern vulgate invites us to think, would take for its hero the solitary and proud lover of himself, but it is rather the capture by image and its own aspiration that is not recognized as such. Before falling in love with himself, Narcissus first falls in love with an image that he confuses with the presence and the flesh of another. At his expense and in the wake of the image's stultifying effect, he goes on to learn that this image is nothing more than his own reflection. However, it is beyond this misunderstanding that painting begins, because it is painting that first and foremost concerns us (not exclusively, however) in the pages that follow. The reason for this is that the fabrication of images in painting, its *poïesis*, does not dissimulate its operation, in this case the activity of its effacement to the advantage of depicting things without leaving traces in the form of lines and colours, blots and pigments, supports and frames that display its artifice and cosmetic enhancements. There is a kind of *cogito* of painting that plays on appearances, instructing us how to allow ourselves to be surprised in order to all the better rediscover ourselves there. If painting is a trap, then it is a trap which reveals the world of appearances that we must experience in order to grasp its laws, changes in perspective and effects on us. In distinction from philosophy, which tends to condemn painting in the tribunal of truth, painting invests in the phenomenal world, splitting it into a sensible exhibition that accounts for its forms, metamorphoses and ambiguities.

Aristotle was probably the first philosopher to recognize within human-ity's taste for representation, *mimesis*, the operation of a thought entering into proximity with the world by way of images: 'The reason of the delight in seeing the picture is that one is at the same time learning-gathering the meaning of things, e.g. that the man there is so-and-so'.[5] Far from reduc-ing the figurative pictorial image, contra Plato, to a lovable yet dangerous illusion feigning a reality that does not belong to it, Aristotle elevates the image up to the rank of an attentive, scrupulous viewpoint that distils and extracts the essential form of beings. The image feigns the thing only in view of its recognition and presentation of it, in the purified characteristic of its form and in its proper essence; imitating is not copying, simulating is not dissimulating—it is the production of resemblance through the extraction of the type that configures the object represented: 'That man there is so-and-so'. Knowing [*connaître*] means being born [*naître*] into the essential, in the style proper to the thing represented, making it into what it is submerged amid the diversity of the world. To counterfeit a thing suggests making it appear in its being, by situating it in its proper place in the order of the whole and through design [*le dessin*], understanding its effort to be what it is, its purpose [*son dessein*]. In making the image into a plane of being immanent to the thing through which the unity of form is identified by the organic play of elements arranging it, Aristotle undoubtedly opens the image to a rationality which consists in initiating us into the intelligence of the life of forms. The image is not the misleading double dreaded by Plato; rather, it is the illumination that traces the pathways into the teeming anarchy of the phenomenal world. In other words, the image is the rationalization of the sensible which would find its modern extension in phenomenology. In Plato, there is probably a function of the image distinct from the sophistic counterfeit of appearances, yet, in an inverse movement to that of Aristotle, it exists only to appreciably translate the idea into the abstract language of pure form or allegorical representation. The allegory of the cave, this 'strange picture' in words of Glaucon, is the exemplary illustration of a sensory given [*un sensible*] integrally ordered towards articulating and enunciating the idea, inasmuch as it is made only from the words and the narrative that project it into the mind of the reader.

Aristotle's opening nevertheless finds its limit in the genealogy attrib-uted to the image: the affiliation with the recognized idea revealed by the formal imprint on the represented thing and the analogical dependence on the presented thing to the idea. Thus, the drawing of a rose extracts its form, allowing it to be identified as such according to the deictic paradigm that sub-ordinates a designated singular being to the generality of a type, that is, the rose. The image therefore remains dependent on an ontology that puts it at the service of recognition and the identification of essences. To state it briefly, if the image is not the image of a singular thing in the sense that it would be the

double or copy of it, or simply an identical reproduction, then it is even less the configuratory model of the thing which leads diversity back to identity and multiplicity back to unity. It is significant in the *Poetics* that Aristotle privileges the picture in order to better think pictorial *poïesis* under the much broader category of representation, abandoning to ornamental insignificance and to purely sensible accordance of what 'will be due to the execution, the coloring, or some similar cause'.[6]

In subsuming the image and painting under representation in order to produce the double condition of their elevation to the rank of art, the Aristotelian reduction raises two questions. The first is knowing whether the image is partially linked, in some sort of essential way, with representation, or whether the image can untangle itself from representation in order to take on functions other than that of a reproduction in the sense of a recognition of forms, being what notably prevents it from playing an exploratory role and from creating other possible worlds. As for the second, it is a question of knowing if painting owes nothing to the image and can break out of it in order to present itself in the autonomy of its creative gesture. In response to the first question, it is necessary to assert that images are not indispensably conditioned by representation. They can be and often are something other than characteristically recognizable and normative configurations governed by the imperative of form. They can be prophecies or visions of other worlds or even approaches to the formless and to the dynamic traces of emergent forces, allowing both the living world and material milieus to function. Form is reproductive in the sense that it tends towards its own conservation. The freeing of the image from the stewardship of representation is thinkable under the condition of decoupling it from the organic form with which our habits have been forced to associate it. This does not come down to releasing the prey of the real to the shadow of an uncontrolled phantasmagoria; rather, it extends the register of the real beyond the perceived towards unperceived connections, and privileges a similar movement of exploration into nascent forms and relations at the expense of the recognition of stabilized forms. In this perspective, the image reproduces the real less than it reproduces the real in light of original relations. The response to the second question concerning the relations of painting and of the image is subject to a double consideration. First off, painting is not and cannot be a pure and simple practice closed in on itself, uniquely concerned with inflecting its attributes. Much more than this, painting constitutes the very stakes of being within the tense relation to the alterities of the material and human world. In other words, painting opens to a transversal of the limits of common experience and, beyond this, to a displacement that transforms us and facilitates movement. Second, it is because images contribute to the game of redistributing forms and reconfiguring relations partially linked, well beyond the figurative restriction, to painting.

In short, the image is that which is within painting that exposes it and makes it available to something other than itself, turning it resolutely towards an unforeseeable outside. To cite but one example, Jackson Pollock's oeuvre is only an oeuvre of pure painting because it inaugurates a new relation to space wherein, ceasing to be the invariant receptacle of the evolution of bodies, space generates itself, as in dance, from its own movements and energy.

For the thought of the image to exit from the ontological impasse which refers it to a mimesis of appearances on one hand, and to an imaginary projection of the subject (as in the work of Sartre) on the other, it is fitting to substitute the question of the image's being ('what is an image?') with the question of an activity and a creation [*un faire*] proper to images. What do images do? What new effects do they produce, and what kind of operations do they make possible that words are unable to accomplish? It is consequently a question of passing from an ontology *of* the image to a pragmatic of *images* that thwarts the dualism of the subject and the object and, along with it, the paradigm of the mirror. The image is a surface and a confrontation in the order of the visible that shapes, configures and contracts disparate elements. Before being a reproduction or a projection, the image is a plane of connection that *creates* the relation between elements that compose it. A portrait can resemble its model quite well by imitating its appearance or by expressing its interiority, yet, first and foremost, it is nothing less than this which makes visible a certain disposition of traits composing its architecture. Neither a written report nor a type of moulding, the image is, from a Deleuzian perspective, a quasi-cartographic process that reveals what happens or can happen between the components of a visage, between the mass and frame of a body, and, with its allure, its manner of being towards space. In opposition to the figurative dimension which privileges form, this is a regime of images that we could call interstitial, which is herein explored through works of art as much pictorial as photographic and cinematographic. Evoking spacing, breach, reserve and separation as mediation, the interstice, from the Latin *interstare*, meaning 'to hold oneself between', expresses a dimension of images that is as operative as it is susceptible to being opened.

If images, from the aesthetic point of view of their effects and affects, are a production of space and unforeseen configurations between things and beings, then, from the poetic point of view of their conception and their elaboration, images are furthermore the result of a co-production. This is one of the reasons that speaks in favour of an approach to the arts, in Bachelard's sense, by way of a reworked and disfigured concept of the image in light of artistic practices. A philosophy of images and a theory of the arts cannot today ignore what one might call a visual amphiboly that reveals the permeability of the arts with one another and with images from non-art, advertising, comic books or even urban graffiti. These 'between-images' (Raymond

Bellour), which are not exclusively those of cinema, pass between the arts and apply force to their boundaries in order to constitute a veritable milieu of transaction and tension between the different imaging procedures of painting, photography, cinema and video.

Finally, it is meaningful to speak of a politics of images because images are not all of equal value. Regarding this subject, it is important to dispel a misunderstanding largely responsible for the modern avatar of iconoclasm, declared in the name of a right of separation between art and those images suited to the propagandist uses of totalitarian ideologies or to the promotional conditioning to the subjugation of the commodity. According to the terms of a distinction introduced by Jacques Rancière, there is ground for distinguishing between a police and a politics of images.[7] Incidentally repressive during moments of crisis in the explicit form of censorship, the police of images is above all translated as the establishment of a positive order that defines the conditions of access to visibility, hierarchizes genres and evaluates styles. Regulating and legislating the domain of common perception, the police of images censors much less than it conforms, distributes and prescribes. A politics of images is understood in the sense of the exception that comes to perturb the reign of perceptive norms by switching between-image regimes and by scrambling and contradicting received identifications. A *deviation* [*écart*] is the appropriate term for this change: it is a sidestep and a displacement that shows things as otherwise and shows something other. At the same time, this indicates a quartering [*écartèlement*] that stretches the scene of the visible to the point of a laceration that discloses its limits, oversights and deceptions. If it has the effect of rendering the invisible visible, it is not in order to accede to a transcendence of the unrepresentable but to give a legitimate place to what is excluded by the very institution of the stage of the visible. This is because the visible is never as pure as phenomenology desires it to be. It is the stage of a complex montage, an apparatus articulated by a system of configuration and nomination which does not make beings, things, places and relations visible without also occluding others. One image always hides another.

NOTES

1. René Decartes, *Meditations on First Philosophy*, ed. Stanely Tweymen (London: Routledge, 1993), 49.

2. Descartes, *Meditations*, 49.

3. 'No', the tree says. He says: No! by the glittering / Of his splendid head, / Which the storm treats universally / As it would a grass-blade! (*Non, dit l'arbre. Il dit: Non! par l'étincellement / De sa tête superbe, / Que la tempête traite universellement / Comme elle fait une herbe!*); Paul Valéry, 'Au Platane / The Plane Tree', in

The Collected Works of Paul Valéry: Volume 1 Poems, trans. David Paul, ed. Jackson Matthews (Princeton: Princeton University Press, 1971), 120–21.

4. Descartes, *Meditations*, 51.

5. Aristotle, 'Poetics', in *Complete Works: Volume 2*, ed. Jonathan Barnes (Princeton: Princeton University Press, 1984), 2318.

6. Aristotle, 'Poetics'.

7. Jacques Rancière, 'Wrong: Politics and Police', in *Disagreement*, trans. Julie Rose (Minneapolis: University of Minnesota Press, 1999), 21–43.

Chapter 1

The Image in the Mirror of Ontology

PLATO: THE IMAGE OR THE UNDERSTUDY OF BEING

In the Socratic game *par excellence* of questions in the form of 'What is X?', images are forcibly the losers, being disqualified in advance by a form of assignation that comes down to nothing short of putting them out of play. We are aware of the Platonic rational behind this: commanded to renounce their identity and to produce the inalterable flash of their connection with being, images are unravelled in the inconsistency of their multiple appearances. From being, images retain only appearance, which fails to keep its promise and veers quite quickly into an illusion. The image is not what it makes us think that it is, the thing that it represents, nor is it what we believe it to be when we see it before us. This constitutes a double trickery that subtracts being from itself in the mirage of resemblance, uprooting it from where it belongs, in the same way as errant flashes upon the reflective surface of polished metals or calm, limpid waters. It even constitutes a triple trickery through its *mise en abyme* [placement in an abyss] via a multiplication as vertiginous as the emptiness of its reflections.

Hence there are three indeterminate determinations of the image that strip it of any consistency with being: non-existence, non-place and non-identity. Contrary to the thing that it represents, the image does not exist, neither inhabiting a proper place nor possessing the identity of an essence; without a resistant body, without recognizable identity, it is uniformly a ghost, a parasite and a simulacra.

The image nevertheless does not spill over into the register of pure and simple non-being. The proof lies in its persistence and its effects, the minutest of which not being the illusion by which the image deceives us despite its inexistence. Plato is the spectacular director (*metteur en scène*) of an

1

impossible and unthinkable conceptual personage that is characteristically bereft of its own being and survives after its being's absence. The image, literally, in-exists and persists, and with Spinoza we might even say 'perseveres' in its inexistence. The inexistence of the image, beyond its inconsistency, its aspect asserting that 'we are quite aware of this . . . but nevertheless', is affirmed in its resistance to speech in the double dimension of the ineffability or impossibility of speaking which does not however cease to elicit speech and the indelibility or ineffaceability that opposes itself to forgetting. As Kant puts it regarding illusion, the image is 'the delusion which subsists'[1] even when the belief in what we continue to see has stopped. It is not a matter of indifference that the example given by Kant is precisely that of trompe l'œil paintings which make a delusion 'subsist', nor probably without some degree of involuntary irony that Kant illustrates this through a painting representing philosophers, a painting that he believed could be attributed to Correggio, but which is most likely none other than the famous *School of Athens* by Raphael, as suggested by Michel Foucault's note.[2]

To subsist is not to resist. If resistance is the facticity of a real which imposes itself on us, the evidence of being, it is the other way around for subsistence, being the remains of a disappearance, a nothing which is precisely not nothing, the appearance between being and non-being [*entre être et non-être*] that surfs among things in the undecidability of a 'maybe' [*un peut-être*]. What does one see whenever a stick is plunged into the water? One might see a broken stick. Furthermore, one believes that it is broken even though this is not the case; beyond the delusion [*dé-illusion*] survives the pure potential of being that demands only to recapture us in the snares of illusion, not without leaving the active trace of a vacillation between the subjection of the real and its shadow. It is as if things doubt themselves in their images. But also it is as if in these images borrowing their semblance from being, a few ghosts strain to come into existence.

Magnificently staged by Ovid, the late myth of Narcissus, caught by the lure of his own image, condenses in an exemplary fashion the drama of the alienation of being through the image which strips it of its reality. Following closely the proceedings of Ovid's version, the Narcissus of antiquity appears less narcissistically in love with himself than with the image itself. Ovid is indeed the sole ancient author to underscore that Narcissus's love goes first to the image as such[3] and that it is only in the second instance that he ends up recognizing himself there.[4] To the love of the self is opposed the love of the image in which the self does not return in the mirror without having been first transfigured by the image. There exists a force of the image that possesses its own power of transforming represented objects; as Louis Marin thus writes, 'The image's efficacy would hold less to what it represents, what it renders visible, than to what presents itself in it and by it through beauty'.[5]

The image does much more than reflect the world, because it sublimates this world in lending the flash and the concentration of reflective surfaces to it and gives objective form to the dreamed object of desire. Before being a victim of himself, Narcissus is first a victim of the image's power of seduction. In this eminently tragic version of the myth, Narcissus is less guilty of preferring himself over the nymph Echo than of being a victim to his 'addiction' to the image at the expense of a real being. The shimmering image's enchantment conserves its power to play on the glimmer and consistency of being in the false being of appearance and, through this, keeps the promise of its mastery instead and in place of opening onto being. In reflecting the fraudulent perspective of a possession insubordinate to its law, the image exposes the one who therein falls for the misapprehension of being.

If all things have their proper place, natural or not, then the image is utopic [*ou-topos*], lacking a receptacle or context where one can find or get ahold of it. Thus, it is a non-place from which a mirage can produce itself everywhere and nowhere; parasitic and erratic, the image shimmers on the surface of reflective bodies, delocalizing the places that it transports in its reflections, dislocating the ordered space of perception and transforming the cosmos into a lawless chaos. Following Gérard Simon's remark,[6] this subversive power of the image, with which the ancient literature of metamorphoses, unlike Plato, was enchanted, does not have its source, as it does for us moderns, in humanity but in the very order of the things that unbind one another and fool us in the intra-worldly game of their appearances, like a kind of irony of the natural order miming its own upheaval. There is a danger in images that carries the threat of disordering [*dé-s-ordonner*] the world and of confronting the anarchy and the formlessness of a chaos which would expose the unpredictability of successions, figures and forms. Moreover, there is the threat, more hidden, of a partial opening to other possible worlds, to a contingent plurality of orders.

The metamorphoses of reflected things in the proliferation and the aberrant variations of their luminous shine, making them appear other than themselves and at the same time multiple, complete the ruination of the identity-unity of images and generate the dread of a reign of a dispersed and disparate multitude with neither monarch nor model. Deceptive, seditious and unchained, Plato detects a disconcerting power in images that casts doubt on the substantial and measured order of being. Hence we understand his violent reaction to the attempted power-grab of a people lacking a law of images and the severity of his prescriptions for supervising their usage in the public space of the city.

Images are nevertheless not entirely threatening for Plato, at least neither all to the same degree nor in the same manner. The natural images erring on the surface of the world just discussed, the shadows and the reflections

of all types that divide the world and disperse it, have their place in the first segment of the famous dividing line at the end of the Republic's book VI, schematizing and ordering the different degrees of relation to being:

> Then, take a line cut in two unequal segments, one for the class that is seen, the other for the class that is intellected—and go on and cut each segment in the same ration. Now, in terms of relative clarity and obscurity, you'll have one segment in the visible part for images. I mean by images first shadows, then appearances produced in water and in all closed grained, smooth, bright things, and everything of that sort. . . . Then in the other segment put that of which this first is the likeness—animals around us, and everything that grows, and the whole class of artifacts.[7]

Furthest from being but within its order all the same, these images thus participate in being. Plato designates them with the name *eikones*, in the positive sense of image-copies which still retain something of their model despite distorting it. These images hold on to their original by a kind of physical link, like signs or traces reflecting a highly diminished flash. They deceive us only if we separate them from their cause and allow them to be considered in themselves as the things that they are not. From out of icons, images projected by their model, these images can become idols devoted to the adoration of appearances and their facetious twists and turns. We recognize the situation of the strange prisoners in the allegory of the cave in which connecting the icons with their cause is revealed to be sufficient for diminishing their prestige. The shadows and reflections are chained to their cause, the objects represented, and it is possible to climb back up by degrees from copy to copy to the integral being that bestows form and life upon them.

Although well before Plato's era, a tradition of Greek[8] origin reported by Pliny the Elder attributes to Butades,[9] a young Corinthian maid, the distinction of inventing drawing, confirming the relation with being that Plato recognized in the natural *eikones:*

> It was through the service of that same earth that modelling portraits from clay was first invented by Butades, a potter of Sicyon, at Corinth. He did this owning to his daughter, who was in love with a young man; and she, when he was going abroad, drew in outline on the wall the shadow of his face thrown up by a lamp. Her father pressed clay on this and made a relief, which he hardened by exposure to fire with the rest of his pottery.[10]

When we are aware of the determinant role in Platonic thought that love plays in aspirations towards being, we cannot help being struck by the convergence between the priestess Diotima's revelations to Socrates in Plato's *Symposium*[11] and the mute eloquence of Butades's loving gesture. In the same way,

one cannot be oblivious to the analogy of this nocturnal Corinthian scene to theatre of light and shadow in Plato's cave. Far from a demonization, and in spite of its minute quantity of existence, the projected shadow is by no means considered a fraud deriving from the duplicity of the simulacrum but an authenticate copy according to nature, closest to the original whose sensible signature it bears. What Butades's gesture reveals at each step as she traces his outline, a process that we imagine to be slow and applied so as not to lose the slightest detail of the contour of the beloved's shadow, is none other than the presence of this being outside of himself, his insistence in the shadow that still clings to him in the contiguity of space and the simultaneity of the instant.[12] We follow here Jean-Christophe Bailly when he observes that the shadow of Butades's lover 'is his appearance, as it belongs only to him, of him alone, as it allows despite everything the appearance of the one who casts it, as it is the form that the appearance takes',[13] not without noting, a bit further on and in a Platonic tone, that 'the shadow takes place without effort and without will, and the connection that it has to its "model" is such that it erects itself as the model of the relation'.[14] By literally embracing her model's outline, the amorous young Corinthian's gesture is not yet, properly speaking, a drawing; it is still a contact with being through a shadow,[15] gathering the lover's presence in the erotic effusion of a caress. Although the spectre of the lover's possible death in departing for war hovers before us, the shadow is not yet that of absence but rather the pure vivacity of this being, his overabundance and his presence in what is other than him. It is literally and in the strongest sense of the words *his survival*.[16]

Of course, Plato does not go as far or in the same direction in his ascent from the dark depths of the sensible towards the luminous source of intelligibility. He mocks the pantomimes of shadow games and the ridiculous efforts of the cave's prisoners to divine the laws of succession and refuses to see what shadows and reflections stylize and intensify in the presence of the being with which they are granted only the most remote connection. The fact remains that there are, from Plato's perspective, a propriety, proportion and common measure between these degraded copies and their model. Following an indication in the *Symposium*,[17] we might think that sculpture, at least reduced to the artisanal practice of moulding, could have been more favourable to Plato than painting because, as Gérard Simon thus observes, 'It permits better than any other the realization of a double, this copy faithful to his dimensions and his proportions of which Plato speaks in order to oppose it to the distortions of the illusionary arts'.[18]

The intersecting but undoubtedly divergent viewpoints of Butades and Plato regarding the shadow line of being set out a path towards another type of image that Plato takes great care to distinguish from natural images or the *eikones*: these are the images for which he reserves the name *phantasmata*,[19]

from which the English word 'fantasy' derives and to which they are unrelated since instead of designating 'an intimate vision without objective existence', they refer, according to a remark of Gérard Simon, to 'the perception of an inner-worldly visibility that has the consistency of a material object—a colossus or a painting'.[20] If the former images are understood as secondary and subaltern, they no less emanate from being. It is entirely different for the latter, as in sculptures and paintings, which are merely the simulacra of being, proximal but without relation despite their resemblance to it. Their original difference in nature does not exclusively find its origin in human artistic products and is much more related to their mode of production, finality and efficacy. Plato defines the *image-phantasma* less by the artifice of its production, perfectly legitimate whenever it takes nature for a model in the case of sculpture which casts a mould of the original or even in the case of a type of painting which makes things appear in themselves as such than by the distortions that the artifice forces the model to undergo in order to accommodate it to human perspective and taste. Instead of offering things to human perspective as they are in themselves and in their place, the *phantasmata* fabricate subterfuges that create the illusion of their presence at a distance and their familiarity with us. To the *eikones*, representations according to being, Plato opposes representations according to man, the consequently anthropomorphic *phantasmata*. The latter images subvert the good relation subjecting the copy to the original, a relation that governs the copy's form and existence, by surreptitiously autonomizing and valorizing the image and its effects at the expense of the being that ought to regulate it. The image's great danger is to undermine the reign of being through the counterfeit which is permitted to break free of being's supervision, allowing its doubles to uproot being in the pleasure that one discovers there. Pascal would recall this whenever he would ridicule 'the vanity' of painting which flaunts the copy in defiance of the original.

It is the autonomous reign of the image, not without ambiguity as we shall see, that Butades's creative gesture initiates. We could perhaps see in the delicate trace of the shadow's outline the upsurge of a form, a sensible being expunged of its materiality approaching the purified invariance of the idea which as such could have found forgiveness in Plato's eyes. It is probably the case that what we could call, sticking to a visual dispositive [*du dispositif visuel*], the profile of the sensible would have been more admissible to him. Yet this gesture accomplishes something else in sketching out the separation of the image from its living source. If the shadow remains dependent on the model that animates it and displaces itself in it, then the image deposits itself on to a support conserving it and lending it material consistency. But, free from the model from which it is detached, the image does more than protect the trace of an origin: it gains an autonomous existence which is offered to

the anonymous gaze. Thus, it ceases to be, like the shadow, a simple follower of its master in order to become its own insignia that will be gazed upon for itself. It is in such a way that the mimetic restitution of the image surreptitiously brings about the erasure and the forgetting of the original. Moving from the shadow that bears presence to the image that breaks with it, one accedes to the level of representation that is superior to recollection since it sustains the illusion of apparition. If Butades's amorous gesture is a creation beyond simple imitation, it is because it tends towards a recreation of the beloved's presence that traverses absence. In this sense, the image is exactly the inverse of the shadow; it ends up preceding the being from which it nonetheless appears to derive. This is what Plato will condemn: painted images engender the simulacra of presence, presences or figures whose presence will be absent.

Once again it is not a question for Butades of a traced effigy, a quasi-photographic, luminous imprint or a skiagraphy wherein the image's ambiguous adherence to its model subsists, as if, having been in direct contact with the model, it transmits its own aura, or, having been in its shadow, it guarantees its continued being. The duplicity of the origin myth that the troubling anecdote reported by Pliny bears does not escape the notice of Jean-Christophe Bailly: 'At the origin of painting, the shadow is like a guarantee which the painting loses, which it must lose in order to emancipate itself, if only by making this lost origin into its authority'.[21] Everything takes place 'as if' painting's fabrication of images had needed this certificate of its origin in being precisely in order to be able to detach itself from being and manifest its own power. With this paradox, and declaring its proximity to being through its translation and its appearance in figural resemblances, painting all the more betrays being and liberates itself from it. Resemblance is therefore the alibi and the mask of dissemblance and difference; the 'as if' of resemblance, the 'as if it were being itself that it is intended to present', affirms with and against being the power of semblance. The perversion of the father-being by painting's appearance [*perversion du père-être par le paraître de la peinture*]: how ironic that what painting leads us to believe to be imitation is, in fact, creation.

The ambiguity rendering Butades' invention so very charming is definitively resolved for Plato by painting. It is that painting no longer proceeds from the mimetic metonymy of being to its transfusion in shadow and reflection but from its *raptus* [seizure]. The painter no longer operates through attentive debits and deposits with respect to form, rather she acts like a thief who covets and appropriates for herself what does not belong to her, that is to say, in an unknowing fashion, in order to avoid being exposed and consigned to it. Withdrawal, diversion and the rapture of being are the grand affair investigated by the Platonic court. We already saw how painting is guilty of

　　　　　　　　　　　　　　Chapter 1

deploying being by way of its appearances in order to, through distortions pleasing to the eye, accommodate human taste instead of faithfully bearing witness to it. This license, already bearing within itself the seed of the image's emancipation, reinforces itself through its mode of producing effects. Painting, among other effects, can make an illusion out of all things while only being familiar with each through the surface of its appearance. After all, this is what mirrors do, being relegated by Plato to the deepest part of the cave while adorning its walls. Still worse, unable to be tolerated in the cave, is the unpretentious way in which painting gives birth to its images from the subterfuges of the picture plane's alchemy in order to give them the consistency and variation of bodies: the illusionistic arrangement of lines to simulate spatial depth and the play of colours animating them with the semblance of life. We follow here Jacqueline Lichtenstein's lesson whenever she notes, apropos of Plato's approach, that it derives its most general condemnation from 'cosmetics':

> Painting is the cosmetic art par excellence and by definition, in which artifice exercises its seduction in the greatest autonomy with regard to reality and nature. Pictorial activity does not merely modify, embellish or make up an already present reality whose insufficiency could be revealed if its ornaments were removed, like a woman without her makeup. Behind the layers of paint used by the painter to represent forms in a picture nothing remains, just the stark whiteness of the canvas. No reality hides beneath the colors. If we are bent on finding a reality we should look elsewhere beside or outside the image but not beneath it, for painting hides or covers nothing. *It does not present us with an illusory appearance but with the illusion of an appearance* whose very substance is cosmetic. Unlike other forms of adornment, this one does not exceed reality by adding ornaments that mask its nature: it takes its place by offering an image whose nature is entirely exhausted in its appearance, a universe that is the pure illusory effect of an artifice.[22]

Painting, neither a supplement nor a falsehood but pure artifice consisting of nothing other than semblance produced by its techniques, is accused of producing a reality effect lacking the very reality key to sustaining it, a stance without substance one might say, or, rather, since a stance evokes some sort of fulcrum that would anchor it, we might call this an evanescent charm with neither place nor materiality that could be seized upon. We can conclude with Jacqueline Lichtenstein that 'in denaturalizing appearance, painting thus realizes the essence of ornament that consists in being without essence'.[23] Its autonomy is such that the rapture of being by painting has the effect of making being itself vanish without a trace. This seductive and mystifying power of painting is at the centre of the famous duel in which the antique painters Zeuxis and Parrhasius engaged according to Pliny's recounted testimony. The former demonstrated his superiority over his rival—having painted grapes

realistically enough to fool the birds—and took advantage of him with a painting of a curtain on a wall that Zeuxis attempted to pull back in order to see what it was hiding. If this apology places emphasis on painting's *mimesis* and equally illustrates the achievement of the two painters, it insists even more so, with Parrhasius's triumph, on the nature of the image as at once both seductive and inconsistent.

The supplementary step in this autonomization of the image would not consist in the satisfaction of producing the illusion of things that exist else-where and through which, via mimetic contamination, they find a kind of security but in the fact that the image induces a reality effect in certain phantasmagoria and visions which would otherwise not have a guarantor in the real. The image would thereby become fully productive of a reality which would come to substitute itself for any given reality. We find an example of this in a passage of Philostratus's famous book *Imagines* that evokes the myth of Phaeton, Son of Helios, who desired to prove his divine ancestry to his dubious companions. He borrows his father's chariot and subsequently loses control of it, drawing at times too close to the vaults of heaven and at others too close to the ground that he threatens to consume. He was hurled into River Eridanos after his father was forced to reduce his chariot to splinters in order to avoid the destruction of the universe. Here is the connection that Philostratus gleans from this:

> Golden are the tears of the daughters of Helius. The story is that they are shed for Phaëthon; for in his passion for driving this son of Helius ventured to mount his father's chariot, but because he did not keep a firm rein he came to grief and fell into the Eridanus—wise men interpret the story as indicating a super-abundance of the fiery element in nature, but for poets and painters it is simply a chariot and horses.[24]

Among the philosophers who offer an allegorical interpretation of this *fabula*, Philostratus probably has in mind Lucretius who evokes this section of the myth in *The Nature of Things*.[25] It is important that Philostratus mentions a difference of opinion between the philosophers, with confounded tendencies, and the poets and painters. His remark underscores the force of painting, whose praise in the book's prologue inscribes it, contrary to Plato, in the register of truth: 'Whosoever scorns painting is unjust to truth'.[26] Painting's force makes true and believable what it displays through the play of its lines and colours, to such a point that Philostratus does not hesitate to make it into a divine invention: 'For one who wishes a clever theory, the invention of painting belongs to the gods—witness on earth all the designs with which the seasons paint the meadows, and the manifestations we see in the heavens'.[27] The reversal of perspective in relation to Plato is complete: instead of

painting being only a simulacrum of immutable being, it is a being that results from a creation by divine painting and dons the colourful flashes of appearance. Even if Philostratus does not go so far as to praise the simulacra, he inverts the secondary relation of the image to being in order to lift the image up to the rank of a creative power which provides for being, successfully consecrating its autonomy. Its power is such that it can give the consistency of reality to mythical fables. From here to the treatment of the real as an image, there is without a doubt a step that Philostratus is unable to take, inasmuch as he demonstrates how myth borrows its figures from reality yet assumes its risk. At the extreme limit of his passionate evocation, gifted with having set into motion the scene that he simultaneously invents while describing it, do we not see the outline of a painting taking shape which would keep record of our fictions and, further still, would present them like the unfolding of a film?

> And at his fall the heavens are confounded. Look! Night is driving Day from the noonday sky, and the sun's orb as it plunges toward the earth draws in its train the stars. The Horae abandon their posts at the gates and flee toward the gloom that rises to meet them, while the horses have thrown off their yoke and rush madly on. Despairing, the Earth raises her hands in supplication, as the furious fire draws near her. Now the youth is thrown from the chariot and is falling headlong—for his hair is on fire and his breast smoldering with the heat; his fall will end in the river Eridanus and will furnish this stream with a mythical tale. . . . As for the women on the bank, not yet completely transformed into trees, men say that the daughters of Helius on account of their brother's mishap changed their nature and became trees, and that they shed tears. The painting recognizes the story, for it puts roots at the extremities of their toes, while some, over here, are trees to the waist, and branches have supplanted the arms of others. Behold the hair, it is nothing but poplar leaves! Behold the tears, they are golden! While the welling tide of tears in their eyes gleams in the bright pupils and seems to attract rays of light, and the tears on the cheeks glisten amid the cheek's ruddy glow, yet the drops trickling down their breasts have already turned into gold.[28]

When the power of painting is such that it communicates its *energeia* to the one describing it and gives eyes to readers to allow them to visualize what they are unable to perceive, does painting not become the substitute of being transported outside of itself and shining with presence through the eloquence of words? At this limit, which transforms it into what it is not via the tenacious illusion of its effects, at this point of intensity that excites speech to produce colours, painting rivals the living; if what casts a shadow is alive [*vivant*], overshadowing others in making its mark, then is an art not supremely alive [*vivant*], even excessively alive [*survivant*], in ceaselessly projecting its force through the eloquent shadow of words? Such is the *ekphrasis* of

Philostratus's text that, as one might say, 'performs' the painting in the sense of the accomplishment of its effects whose definition we borrow from François Lissarague:

> Philostratus' compendium of images derives from the ancient literary genre of *ekphrasis* that consists in describing an object and more particularly the motifs that festoon an object. Thus the figures covering the 'Shield of Achilles' are evoked by Homer at length and their description founds the genre. Most often, *ekphrasis* applies to an elaborate object, a weapon or an embroidered article of clothing for example, or to a work of art, a painting or a statue. The *ekphrasis* seeks to showcase the virtuosity of the artisan or the artist who produced it, to animate the work through speech; to translate through words the effect which it produces on the viewer.[29]

If, under the guise of a eulogy of painting, the *ekphrasis* of the *Imagines* turns surreptitiously to a praise of words possessing the power of projecting into the minds of readers insofar as it succeeds in forcefully summoning the painting in its absence after undergoing its initial shock, then one could equally see in its performative description, and also its prescription, the accomplishment of the essence of the image, just as Jacqueline Lichtenstein says that ornament is devoid of this essence. Whether the painting is present in its absence or exists beyond itself in the minds of those who saw it or believed to have seen it like the readers of Philostratus, this is what testifies to the force of painting: not only does it have the power to simulate being but it also survives, living again in us by inscribing its figures there for quite some time, if not forever.

One of the paradoxes of Plato's hunt for the counterfeiters of being is, in the end, to reinforce the power that this pursuit believes to be warding off. Admitting the image only as a follower, in a secondary role or as an understudy doomed to exalt the model's virtues, Plato is led to denounce the imposture of images striving for the lead role. To the first belongs the merit of resemblance and of the good copy, to the second the disgrace of simulating a resemblance and filiation with being. But the fact that the understudy can throw its pursuers off the trail, being able to produce being's effect without coinciding with its cause, introduces the suspicion that it can itself be constituted according to the model of the false, which would lead to an originary groundlessness on which the image could find ground and to a regime of images possible only on the ground of the emptiness of being. The dichotomy between the *eikones* and the *phantasmata* does not resist the perversity of images that, even in the form of good copies, end up corrupting the reign of being. The similarity of copies to the models from which they seem to proceed does not actually overshadow the institution of the model by way of a production of similarity on the part of the copies. Portraits wherein we admire the resemblance to

their models without knowing the slightest bit about the originals demonstrate this. Thus, far from being a copy, the famous portrait of Descartes by Frans Hals creates the original that familiarized us to him: an original copy that we rushed in turn to again copy.

What Platonic philosophy rejects with all its force: the production of the model by the copy rather than the inverse. The iconoclasm, which is not Platonic but is nourished by Plato's severe speculation on being, will deduce the radical consequence that being's integrity comes at the price of the excommunication of images perpetually suspect of idolatry. The Platonic effort to save images that support being—the *eikones*—without substituting themselves for being—like the *eidôlona*—will find a relay in the Christian theology of the Incarnation. Nevertheless, this effort must not eclipse the common conception of the image that subtends and commands the dichotomy between good and bad images. Arriving as either true or false from out of the thing, they are always images *of* something as well as made *in its image*. Images can be false only because they are thought to emanate from the things themselves and represent them in truth, not only as more or less faithful copies but as veritable examples, in the sense that, following its etymology, the example conserves the model while reproducing it. Plato shares this conception, as Gérard Simon notes, with the ancient *epistêmê* of *mimesis*:

> For an ancient to represent, it is to represent what is, it is not to allow others to see what, in its interiority, a subject perceives of the exterior world, nor to give expression to its momentary, singular point of view, it is rather, if one wanted to signify the truth, to show the things in the themselves, in their place; or rather, if we aim only for the appearance of truth, it is to create the illusion of the presence of things and to practice the art of imitation, which can be refined (or corrupted) in the art of false pretenses.[30]

If the image threatens to ventriloquize[31] being, it is because, from the outset, it is thought of as its understudy. As Gérard Simon suggests, it is this reification of the image as a double of being that prohibits, not the thinking of the image according to the specular model of a reproduced thing, but according to a dynamic of creative action and relation that puts into play the imagination of the subject of representation. From the image's object and from the image as object we are sent back to the subject who produces it.

SARTRE: THE IMAGE OR THE NEGATION OF BEING

The deception of the freeze frame [*l'arrêt sur l'image*] is to impose a false view on the image that consists of reducing it to the state of an object. The paradox is that the view of the image is precisely what presents an obstacle

to the comprehension of its meaning. The image is neither a thing nor a lesser thing, neither vestige nor relic; it is a relation, not a relation concerning a thing but a relation with a thing, a certain fashion of relating to it. Sartre is the first to have rigorously and brilliantly demonstrated this. As one commonly says: 'I don't see the connection'[32] [*je ne vois pas le rapport*]; the problem of relation is that it does not see itself [*qu'il ne se voit pas*].[33] There is a good reason for this: if a relation does not grasp itself, it is formed and is lived in the aperture of an original experience. It is true for Sartre, in this case a faithful disciple of Husserl's phenomenology, that the characteristic of all consciousness is to be intentional, that is, a vector signifying something other than itself: 'All consciousness is consciousness of something'.[34] If consciousness is not a box or storage space containing representations, then it is not representation but a lived relation to the world, others and itself in accordance with diverse modalities and tonalities. Perception is thus the perception of something external in its own environment and in its own place. What appears as a complete truism is actually much more, since to perceive is always to perceive more than what we effectively see; insofar as perception imposes itself on me, not only by its unchosen, singular physiognomy but also through everything in it that escapes me and its relations with other things, the perceived object overflows outside of itself and makes an introduction to the world in which it takes part. There is no perception without participation in a pre-existent world whose every precept, according to the effectively adopted point of view, shrouds and keeps an inexhaustible promise.

The philosophical break with 'the moist gastric intimacy'[35] of a consciousness internalizing the world through its representations avoids the major weakness of theories which derive the image from perception by reducing it to the state of a copy or faint trace of the latter. From the moment that everything is representation in the interiority of consciousness, how in effect is one to distinguish the image of the percept, if not with the weak argument, empiricist in origin, of a difference in intensity? With regard to the image, Sartre reproduces the radicalism of Bergson's gesture apropos of memory, that of the leap separating and distinguishing once and for all imaginary ambiance, as intense as it may be, from the perceptive present, as weak as it may be. The image is simply not of the same nature as the percept; it is not seen [*elle ne se voit pas*] and, despite the appearances which inscribe it in the sphere of the visible, we must nonetheless say that it is fundamentally invisible. The Sartrean thesis on the image is not that it is of the world, but, according to Baudelaire's formula, reprised in English and with which he titled one of his prose poems, 'Anywhere Out of the World';[36] in other words, it is negation. The image affects only in appearance and in a secondary fashion the texture of the materiality of the thing and the percept. The image's fabric is in reality spun from the imagination for which it is merely a repository in the real. The

great error of philosophies of the image before phenomenology is to have severed the image from the imagining intentionality that alone furnishes its meaning.

Insofar as it is not my intention to elaborate Sartrean philosophy for itself, which would demand that the originary character of the imagination and the resulting destitution of its old role as a faculty[37] be brought to light, and insofar the status of plastic images is of interest to me, I propose to elucidate the Sartrean paradox of the image's invisibility[38] from out of his aesthetic theory of painting sketched in *The Imaginary*.[39]

In *The Imaginary*, published in 1940, Sartre develops what he calls in the subtitle 'a phenomenological psychology of the imagination'. How does this pertain to pictorial experience, being only marginally evoked throughout the work and the object of a direct yet brief examination in the second part of the conclusion? Sartre explains that if, on one hand, he was incapable of eluding the question of the work of art and, notably, the case of painting, given its narrow dependence on the imaginary, then he was, on the other hand, equally incapable of fully treating the subject without writing another work which would be uniquely consecrated to it.[40] But if the painting's dependence on the imaginary explains its presence as an example among other productions of the imaginary, alongside photography, caricature and hypnagogic or mental images, then it does not explain its loud presence, indeed in a certain fashion its excessive presence [*sur-présence*], in the concluding section of the work: this preferential treatment indicates the importance that Sartre attaches to it, as an essential consequence of his entire enterprise and even, *in fine*, as that which such an enterprise was destined to produce.

What is at stake here? Across a phenomenological investigation as passionate as it is extremely detailed, Sartre announces his thesis concerning aesthetics and the status of painting [*la peinture*]: 'We are led to recognize that in a picture the aesthetic object is an irreality'.[41] In the style of a phenomenological procedure, we 'recognize' what we already knew without knowing it, what we already knew through experience without being able to make it the object of an explicit knowledge—most likely the fault of prejudices altering the pure meaning of aesthetic experience and its essence, and, in particular, the fault of the prejudice nourished by the constitutive ambiguity of every painting, which is offered to us disguised as a thing that it is absolutely not. In effect, the grand lesson of *The Imaginary* is that the image is not a thing; it is something other than a thing. It is a relation, a form of consciousness that aims at the world in a very particular manner through which it irrealizes it.

Yet what is a picture [*un tableau*] if not an image made thing, transportable and transformable? It is not only because the image/thing confusion is carried to its extreme in painting that Sartre tries to dispel it, but also that he finds the opportunity to overturn in favour of his thesis an example which is

unfavourable to him: there is nothing closer to the thing than painting and yet nothing so distant. The Sartrean theory is at bottom a possible philosophical version of Magritte's famous picture: *The Betrayal of Images* (*This Is Not a Pipe*): this is not a picture but an image, not a thing but an imaginary. The picture's aesthetic reality is not in the material that it presents but in the irreality it represents and incarnates; the picture is a real that represents an irreal—in other words, a product of the imagination borrowing its means from reality in order to give itself a bit of existence.

Sartre's effort thus aims at a reintegration of pictorial experience into the field of the imaginary, which consequently effaces the fictive boundary between the mental image and the plastic image, between what English, in distinction from the French language, distinguishes as *image* and *picture*.[42]

What is a picture [*un tableau*]? It is a Janus Bifrons! The term *picture* [*tableau*] etymologically has a double meaning: both object and subject, real and imaginary, subjectile and subjective, designating as much a panel of wood as the paint [*la peinture*] that covers over it and represents something. As a thing or an object, it has all the properties of a material thing: spatiality, reversibility, mutability, exchangeability, a worldliness and so on. As an image, it has all the properties of the image: subjectivity, intentionality, docility, poverty and otherworldliness. The picture-object has a front and a back because it is of the world; the picture-image does not have any of these because it is outside the world, the pure product of the imaginary and human desire. Sartre demolishes the idea according to which the work of art would be a world, or at least another world, because the imaginary world does not exist. To imagine is not to posit another world; it is to deny and irrealize the given world in tearing it free from the constraints of its reality in an emancipatory act. This is completely different, consequently, from a destruction that, by nature, can take place only in the world. To the pre-existence of the world which resists and infinitely exceeds us, the imaginary opposes its flight and its negation of the real.

We are wrong to pass off the difference between the real and the imaginary as a difference between the ordinary character of the former and the extraordinary, fabulous or monstrous character of the latter. The real object and the imaginary object can resemble one another like two drops of water (referring to Magritte's pipe, if it isn't a pipe, what is it then?) without ever being confused with one another. The difference is not in essence but in existence; one exists and the other does not. The difference is, to use Pierce's term, indexical rather than iconic. The object *of* the image, what it represents and that for which it aims in its absence, and the *object in the image* do not exist in the same manner. If the former exists in spite of itself, then the latter exists only through a subject.

We are seemingly quite close to Plato but, in fact, quite distant from him. While Plato sees in the image a stuttering or a sterile redundancy of being, Sartre sees the manifestation of the existent affirming itself through an act of negation that posits the irreality of the imagined object. The object 'in the image', according to Sartre's formula and intending not to reduce the image solely to resemblance, is not a double of its referent without first being active negation, willed as such, of its existence, facilitating its availability in the imaginary.[43] Where Plato only saw a pathetic simulacrum of the object, Sartre sees the subject's essential expression, hollowing out being in order to inscribe in the void its desire to be; the negation of being positively transforms into an exposition of the existent.

Let us come to the essential consequence for the analysis of aesthetic and pictorial experience that demonstrates a veritable incompatibility between imagining and perceptive consciousness. Applied to the picture, this suggests that one cannot accommodate the picture's material reality—the canvas, the pigments, the smears of paint, the colours—and its aesthetic dimension at the same time: 'What is real, we must not tire of affirming, are the results of the brush strokes, the impasting of the canvas, its grain, the varnish spread over the colours. But, precisely, all this is not the object of aesthetic appreciation'.[44] Sartre clarifies by way of the example of a portrait of Charles VIII: 'So long as we consider the canvas and the frame for themselves, the aesthetic object "Charles VIII" does not appear'.[45] It is therefore either one or the other, the picture or the painting, the picture or the representation, but never in any case both at once.

Against his gut intuition and not without irony, Sartre offers in the course of his analysis an example of the consequences of the image's reduction to the imaginary in the same cavalier fashion, to say the least, with which he treats Charles VIII's portrait placed at the Museum of the Offices in Florence. What portrait, made by whom and on what date? We will never know because this portrait of Charles VIII is probably imaginary. If several exist, to my knowledge, they will not be found in any of Florence's museums. In a small book[46] dedicated to Satrean philosophy, Colette Audry does not hesitate to attribute it to Jean Fouquet, who could only have painted, even though this is not the case, an infant Charles VIII, since he was born in 1470 while Fouquet died in 1480. We are, by contrast, familiar with Fouquet's famous portrait of Charles VII found at the Louvre, a fact that Sartre could not avoid pointing out. Alongside Henri Maldiney's vote of confidence for Sartre's attribution, about which Sartre says nothing, we could also think of Jean Clouet,[47] the painter of a famous portrait of Francis I found at the Louvre. Clouet officially entered the French court in order to become the king's painter in 1516, after possibly working at the court of Charles VIII (Charles VIII, 1470–1478,

and Jean Clouet 1485–1541) although nothing proves this, especially not a portrait of Charles VIII by Jean Clouet that does not exist. Could he have confused this portrait with *Francis I on Horseback* (1540) by the same Jean Clouet, found at the offices, which, apart from the fact that it is neither a portrait properly speaking nor even of Charles VIII, does not correspond to the description that Sartre attempts to give it, which speaks of 'those sinuous and sensual lips, that narrow, stubborn forehead'? Finally, there exists a painting by a Florentine painter, Francesco Granacci, painted in 1518 and entitled *Entrance of Charles VIII into Florence*, but it is not a portrait but a crowd scene in which the king on horseback is barely visible, and, moreover, it is located at the Pitti Palace. If Charles VIII indeed found himself in Italy from 1494 to 1497 in order to conquer a part of his territory before being chased out, the source of Granacci's picture, then it is more than probable that the portrait of which Sartre speaks is a product of his imagination and the confusion of his memories rather than the actual work of a painter.

In a sense, even Sartre's error ironically, or any case humorously, confirms his thesis, since we witness directly through it the subtilization-irrealization of the picture by the imaginary, making use of it as an *ad hoc* illustration of Sartrean aesthetics as it suits him. If it is a question of saying that there is no creation of images without imagining intention and imaginary activity, whether they are, moreover, conscious or unconscious, then one can only adhere to Satrean analysis: we do not perceive an image without, in a certain way, imagining it; otherwise we are no longer dealing uniquely with a mere thing, canvas or sheet of paper. From this point to the conclusions regarding the indistinction between mental images and plastic images, which would only be, according to Sartre's term, an objectivated *analogon*—that is, a shadow or a ghost—there is a step and perhaps even a leap that must be avoided. Indeed, it appears difficult to reduce painting to its imaginary dimension and realize the object (the picture) that the painting itself is, in spite of everything, by the sole recourse to the imagining intention (the image). After all, contrary to certain affirmations of Sartre, we are not free to see in the invoked portrait of Charles VIII the person who we would like to see, and even though we could try to see this person, we could not see him without departing from the traits of the figure imposed by the picture. We can fashion ourselves an image of someone who we have never seen, but this image is not of the same sort as the image-object in art. In other words, to imagine and to regard a notably artistic image are two experiences of a different nature.

The interest of Sartrean analysis is to raise the image from the status as a quasi-thing by extracting it from the world of objects in order to resituate it within the intentional life of the mind. Where Plato saw painting's scandalous aberration and duplicity troubling the identity of the real and the nature of the true, Sartre establishes a difference of nature and intention between the

picture's reality as a material thing belonging to the world and its aesthetic value which expresses imaginary life and takes a position in relation to the world. Through this optic, even if it contributes to the formation and the definition of the image with its material and pictorial properties, the picture can only efface itself before the image. A ghost born from the imagination, the image must leap in certain way on the back of the real, exhibiting certain analogical properties with it in order to be able to take form and incarnate itself. The image drains the life out of the picture's material in order to give a bit of consistency to its spectral existence. The sole difference between the ghost of the mental image and the picture is that the picture is not reducible to the image; it is like a residue, a vestige of the real that subsists, not beneath the image because it does not have an underside, but next to it or in spite of it. The real's irrealization lessens the picture's existence in proportion to drawing vitality from it.

This concept explains how, for Sartre, painting remains marked by a stroke of idealization. The pictorial image veils with beauty the real and, initially, the real of painting itself which is only present to give its material to the image. When the real of painting irrupts once more, the magic of the imaginary becomes inoperative. The image sublimes the real of painting, and painting lends its material to the operation of sublimation. For Sartre, the meaning of painting is outside of painting which can only be representation, a visible *analogon* of an invisible meaning seeking to incarnate itself in it, outside of its subject matter and its materials. Painting's body, deprived of meaning and spirituality, is partially redeemed by the image that strives to incarnate itself in painting without nevertheless fully arriving there.

Making the image into a relation with the world and the production of the imaginary fails to remove it, as far as I can see, from the perspective of an ontology, as negative as it might be. The substitution for the *image of the object* with *the object in the image* does not liberate it from its connection to a reality that fails it and whose absence it bears in a yearning for being destined for dissatisfaction. The imaginary, in this sense, feeds off the void of being of which it is the manifestation and for which the image comes to act as a supplement or, at least, attempts to act as one.

We find an illustration of the supplementary function of the image in the very personal analysis that Barthes dedicates to photography in *Camera Lucida*. In this work, explicitly dedicated to Sartre's *Imaginary*, Barthes claims a filiation with phenomenological analysis and displays an ontological preoccupation for the singular essence of the photographic image. Through successive approaches intent on adequately circumscribing what constitutes, according to his own admission, the object of a *jouissance*, he extracts a series of invariant traits constitutive of photography. First, it is the referential

transparency that, in distinction from painting, brings one directly into the presence of the photographed subject:

> A specific photograph, in effect, is never distinguished from its referent (from what it represents), or at least it is not immediately or generally distinguished from its referent (as is the case for every other image, encumbered from the start, and because of its status—by the way in which the object is simulated). . . . By nature, the Photograph . . . has something tautological about it: a pipe, here, is always and intractably a pipe.[48]

Explained in such a way and combined, moreover, with the threadbare support that disappears in digital photography, the difficulty of focusing on the snapshot itself becomes evident, whether in terms of its materiality or its composition: 'Whatever it grants to vision and whatever its manner, a photograph is always invisible: it is not it that we see'.[49] In the end, it is the contingency of the snapshot which envelopes the thesis of existence: this *was* unessentially what this *is*. The photo's indexical value, which authenticates an existence and an instant, outweighs its iconic value of guaranteeing a resemblance. The photograph presents in a quasi-hallucinatory fashion what is no longer present, as Stanley Cavell writes: 'The reality in a photograph is present to me while I am not present to it; and a world I know, and see, but to which I am nevertheless not present (through no fault of my subjectivity), is a world past'.[50] Its strange paradox is to draw in close to that from which photography forever distances and separates us, as Barthes testifies, through an exacerbated consciousness of the irreversibility of time and the irremediability of loss. But must we conclude from this that it is a question of an eidetic invariant of photography or of one of its various modalities among others, even if it is the most widespread?

The thought of the image in the plurality of its aspects and the multiplicity of its effects forces us to break free from the ontological paradigm driving the investigation into the essence of the image, even if it is a negative one as it is for Sartre, in order to move on to a pragmatic perspective. For the question 'What is an image?' it is suitable to substitute another question: 'What does the image do?' in order to analyse the 'creation' proper to the image or images. It is not a question of envisaging the image in a kind of confrontation with being that transforms it into its rival (Plato) or its negation (Sartre), but, rather, of approaching it from an oblique perspective, from a profile view that accounts for its mode of operation. Through this optic, the image is no longer the image *of* the object (Plato), neither is it even the singular relation of the subject *to* the object (Sartre), but it is the relation *between* things.

NOTES

1. 'Illusion is the delusion which subsists, even though one knows that the supposed object is not real.' Immanuel Kant, *Anthropology from a Pragmatic Point of View*, trans. Robert B. Louden (Cambridge: Cambridge University Press, 2006), 41. It is significant to note that Vauday references Michel Foucault's French translation of this text *Anthropologie d'un point de vue pragmatique* (Paris: J. Vrin, 1988), 34. [TR]

2. Kant, *Anthropology from a Pragmatic Point of View*.

3. Giorgio Agamben notes this well: 'not directly in love with himself, but with his own image reflected in the water, which he mistook for a real creature'. Giorgio Agamben, *Stanzas: Word and Phantasm in Western Culture*, trans. Ronald L. Martinez (Minneapolis: University of Minnesota, 1993), 82.

4. On this point, we follow the analysis of Hubert Damisch commenting closely to Ovid's text: 'It is only the moment when he will cease himself to speak in third person about the being that he sees and desires but cannot possesses (*sed quod videoque placetque/Non tamen invenio*) in order to address him directly and attempt to convince him to join him (*quisqus es, huc exi*) and to stop fleeing (*Quove petitus abis?*) that he will finally recognize as such his image in the mirror (*Iste ego sum; sensi nec me mea fallit imago*)'. Hubert Damisch, ('D'un Narcisse l'autre' in *Nouvelle Revue de Psychanalyse*, Spring 1976, 118).

5. Louis Marin, *Des Pouvoirs de l'image* (Paris: Seuil, 1993), 38–39.

6. Gérard Simon, *Archéologie de la vision* (Paris: Seuil, 2003), 48–49.

7. Plato, *Republic*, trans. Alan Bloom (USA: Basic Books, 1991), 190.

8. In reference to this subject, see Jean-Christophe Bailly, 'La scène originaire du mimétique', in *Le Champ Mimétique* (Paris: Seuil, 2005), 39–40.

9. Butades in this case can refer to both the ancient Greek clay modeller and his daughter, the young Corinthian maid in question.

10. Pliny the Elder, *Natural History Books XXXIII–XXXV*, trans. H. Rackham (Cambridge: Harvard University Press, 1938), 371–72.

11. Plato, *Symposium*, trans. Seth Benardete (Chicago: University of Chicago Press, 2001), 41–42.

12. Jean Jacques Rousseau, 'Essay on the Origin of Languages', in *The Discourses and Other Politics Writings*, trans. Victor Gourevitch (Cambridge: Cambridge University Press, 1997), 248.

13. Bailly, *Le Champ mimétique*, 44.

14. Bailly, *Le Champ mimétique*, 51. Vauday's emphasis.

15. Bailly, *Le Champ mimétique*, 51.

16. See also my analysis of Rembrandt's *The Anatomy Lesson of Dr. Nicolaes Tulp*: Patrick Vaudey, 'Vers Des Images Sans Corps?', *Revue Pratiques* 31 (February 1993).

17. Plato, *Symposium*, 40.

18. Gérard Simon, *Archéologie de la vision*, 56.

19. Plato, 'The Sophist', in *Plato: Complete Works*, trans. Nicolas P. White, ed. John M. Cooper (Cambridge: Hackett Press, 1997), 253a–56c/275–79.

20. Gérard Simon, *Archéologie de la vision*, 49.

21. Bailly, *Le Champ mimétique*, 53.

22. Jacqueline Lichtenstein, *The Eloquence of Color: Rhetoric and Painting in the French Classical Age*, trans. Emily McVarish (Berkley: University of California Press, 1993), 43. Vauday's emphasis.

23. Lichtenstein, *The Eloquence of Color*, 43.

24. Philostratus the Younger, 'Imagines: Book 1', in *Philostratus, Imagines. Callistratus. Descriptions. Loeb Classical Library Volume 256*, trans. Arthur Fairbanks (London: William Heinemann, 1931), 45–47.

25. Lucretius, *The Nature of Things*, trans. Frank O. Copley (New York: W. W. Norton, 1977), 122.

26. Philostratus, 'Imagines', 3.

27. Philostratus, 'Imagines', 3.

28. Philostratus, 'Imagines', 47–49.

29. Philostratus, 'Introduction', in *La Galerie de tableaux*, trans. Auguste Bougot, ed. François Lissarrague (Paris: Les Belles Lettres, 1991), 2. For the text of Philostratus, I have consulted the English editions; however, Vauday cites from the editors introduction of the French edition to which the aforementioned citation corresponds. [TR]

30. Gérard Simon, *Archéologie de la vision*, 50–51.

31. In French, the verb *doubler* can mean to double, as in duplicate, and also refers to the cinematographic technique of dubbing (*le doublage sonore*), which suggests something like the ventriloquism of being.

32. This is a common phrase employed in quotidian French. [TR]

33. The verb *voir* ('to see') also signifies, especially in a familiar register, 'to understand.' Thus Vauday is playing on double meaning of being seen and being understood, suggested by the common usage of this verb. Thus an equally correct, albeit more Germanic, translation would be that relation 'does not understand itself'.

34. Jean-Paul Sartre, 'Intentionality: A Fundamental Idea of Husserl's Phenomenology', trans. Joseph P. Fell, *Journal of the British Society for Phenomenology* 1, no. 2 (1970): 4–5.

35. Sartre, 'Intentionality', 5.

36. Charles Baudelaire, *Paris Spleen*, ed. Thomas Cole (New York: New Directions Publishing, 1971), 99.

37. Refer to my article 'Sartre: L'envers de la phenomenology', in *Sartre contre Sartre, Rue Descartes/PUF* 47 (2005): 8–17. If Sartre inherits from Husserl the idea that the imagination is, according to Baudelaire's expression, the reign of the faculties that permits the apprehension of essences independent of any position of existence, then he goes even further than Husserl, or in another direction in any case, in positing the very act of the existence of any consciousness whatsoever as fundamentally the power of the negation of the given world: 'It is as absurd to conceive of a consciousness that does not imagine as it is to conceive of a consciousness that cannot effect the cogito.' Jean-Paul Sartre, *The Imaginary: A Phenomenological Psychology of the Imagination*, trans. Jonathan Webber (New York: Routledge, 2004), 221.

38. François Noudelmann is perfectly right to speak about an 'iconoclastic definition of the image'. (*Sartre: l'incarnation imaginaire* [Paris: L'Hamattan coll. L'ouverture philosophique, 1996], 17.)

39. Let us specify that there is precedent for distinguishing between Sartre's aesthetic theses in his philosophical works and his critical analyses of singular works marked by nuances that are dissimilar and even occasionally appear contradictory.

40. Sartre, *The Imaginary*, 188.

41. Sartre, *The Imaginary*, 189.

42. In English in the original. [TR]

43. Rousseau offers a good example of violent extraction of the given world by the imaginary.

44. Sartre, *The Imaginary*, 188.

45. Sartre, *The Imaginary*, 189.

46. Collette Audry, *Sartre et la réalité humaine* (Paris: Seghers, 1966), 21.

47. Henri Maldiney, *L'art, L'éclaire de l'être* (Paris: Comp'act, collection Scalène, 1993), 273.

48. Roland Barthes, *Camera Lucida*, trans. Richard Howard (New York: Hill and Wang, 2010), 5.

49. Barthes, *Camera Lucida*, 6.

50. Stanley Cavell, *The World Viewed: Reflections on the Ontology of Film* (Cambridge: Harvard University Press, 1979), 23.

Chapter 2

Aesthetics: What Images Do

THE PROCESS-IMAGE

The image is not a relation *with* things; images make and create singular, imperceptible relations *between* things, like currents or forces that pass through them in order to unite or repel them. It is not the case that the point of view of those who created them are not therein expressed; however, such points of view would be trivial, lacking any specific revelation regarding the state of natural, social or metaphysical beings. What is interesting [*L'intéressant*] in the image is not the reflection of a situation or the expression of its author's psychology; it is the intervention (*intervenire* [Latin]—to come between), the coming between things in order to give rise to a new configuration, new relations or a new sensibility. It is necessary to stop seeing in images a counterfeit [*une contrefaçon*] or a manner of seeing [*une façon de voir*] in order to envision them in the processual dynamic of an invention of relations. What images create, the way in which they are able to affect us, is largely linked to what they do, to the way in which they facilitate new connections from which new precepts proceed. Beyond the specular image and imaginary speculation, or rather in breaking with these categories, there are intercalary, scalene and oblique images, tracing diagonals, lines of force, tensions and alliances in which unforeseen possibilities of ordinary perception are actualized. Contemporary art is from this point of view revelatory in its manner of proceeding through interference, in the form of installations or interventions rather than via representation. There are probably images that merely reproduce a fixed state of things, arresting their movements in order to make them conform to a recognizable cliché; however, the image as an intervention between things is precisely the contrary of a freeze-frame [*un arrêt sur image*], being instead its mobilization within hitherto unforeseen

23

arrangements. We would be quite wrong to say 'wise like an image'.[1] This would neglect to view images as agitated and insane, traversed by various movements, both slow and rapid, delicate and violent, restrained and explosive, and as that in which something happens, a thing comes to pass, as passage-images. Let us refer to the paintings of Georges de La Tour wherein gamblers, frozen in the immobility of wax models, exude or project lustful, disconcerted and conniving looks more rapidly and piercing than daggers [*Le Tricheur à l'as de carreau, Le Reniement de Saint Pierre*]. The clarity of the eyes in de La Tour's work: these are eyes that propel themselves outside of their sockets in order to hit their mark, spying always on the lookout and moving within the closed and tranquil space of a familiar scene. This is also the suggestion of the chiaroscuro of his paintings, which mistrusts the calm of appearances, quiet poses and soft lights or, rather, at once slackening off in order to suddenly receive the singular pain of an assassin's gaze, whether loving or ridiculing. Following the prejudice of the image-thing that Sartre justly defends, there is precedent for putting into question the prejudice that concerns the immobility of images in order to at last perceive movement in images and movement through images, not only in the movement-images of cinema but in all images.

Gilles Deleuze is the philosopher who provided the basis for a pragmatic aesthetics which allows for the thought of the action proper to images. I refer in particular to the text that he wrote in homage to François Châtelet: *Pericles and Verdi: The Philosophy of François Châtelet*.[2] Although images are not explicitly at issue in this text which charts a map of François Châtelet's inventive and plural rationalism in the domain of historicity, and even if one believes that it deliberately takes distance from images with the final reference to music, an art without image *par excellence*, the text offers the means for thinking them. This follows from the passage where Deleuze defines his understanding of a 'process of rationalization', which seems to me to translate into an aesthetic of images:

> Notice that reason is not a faculty but a process, which consists precisely in actualizing a potential or giving form to matter. Reason is itself a pluralism, because nothing indicates that we should think of matter or the act as unique. We define or invent a process of rationalization each time we establish human relations in some material form, in some group, in some multiplicity. . . . Consider the case of sonorous matter. The musical scale, or rather a musical scale, is a process of rationalization that consists in establishing human relationships via this matter in a manner that actualizes its potentiality and it itself becomes human.[3]

Reason is not a judging or normalizing faculty but, from an Aristotelian perspective, the act which effectuates the virtualities of a diversity by inventing the syntheses and alliances necessary for its existence and its becoming. It is

not juridical, univocal, ordering and sanctioning but rather political, polyglot, organizing and instituting. Following the Latin etymology (*ratio*, calculation but also relation), Deleuze sees in reason a process that produces relations allowing for a humanization, literally and figuratively one that allows various matters to enter into resonance; this process consists in finding a law of composition and common relations between heterogeneous elements. The human being is thus a hyphen [*un trait d'union*], the operator who actualizes the possible encounters between the disparate components of a diversity, an inventive *bricoleur*, spoken of by Lévi-Strauss, who creates new usages and new possibilities for life. It is this generic, operative schema that allows us to think about what is at stake in the images of the plastic arts.

PAINTING OUTSIDE OF ITSELF

The Invention of the Landscape

Before potentially setting a diversity into motion, an image begins by organizing it in charting a singular map. Let us take the example of the landscape. In distinction from the land [*le pays*] itself, which is an indivisible unity erected in the stability of a geographical real (the territory with its boundaries), in the historical imaginary (the common past) or in cultural symbolism (language and derived institutions), the landscape [*le paysage*] is an aesthetic intervention into the land [*le pays*]. It would be an error to believe that the landscape is only an extract from the land, a fragmentary, pre-existent point of view that was merely awaiting its painter, given that, in reality, the landscape is historically a painterly invention (fifteenth century). What is the difference? It is not as if one could imagine the subjectivity of a pictorial view opening a window on to nature or on to the city in opposition to the territorial map's objectivity or to the floorplan of a house. It is the inventive creation of connections within the spatial plane of visible elements that enter into composition with one another in order to form a view of the whole. It is necessary to treat the window as an operator that opens a plane of vision, composes lines of force and organizes blocs of space. But in distinction from the window, properly speaking, the picture frame is a mobile operator of the construction of a view that arises in order to play on the tension between the painting's edges, lines and the relations of size between its elements. In one of Rembrandt's etchings, *Landscape with Three Trees* (1643), one is struck by the extraordinary opening of space in a frame of highly reduced dimensions, as if Rembrandt had compressed the space in order to better make it flee out of sight towards the edges, forcing it to spill over the frame and offering it to the view of the three trees leisurely hanging over the right side.

The expanding organization of space from out of the vast tumultuous void of the sky, occupying three quarters of the scene, is supported by a process that composes the heterogeneity of the organization of traits in the figuration of disparate elements (trees, ground, human figures, buildings, sky, clouds, rain) with the homogeneity of a graphic backdrop. A kind of reticulation of space is added with the discrete punctuation of windmills, of men working in the fields and the edifices of the distant town, like signals made at a distance resisting the dispersion of space. This is an example of what Deleuze calls a creation of human relations between some material forms [*des matières quelconques*]; Rembrandt humanizes the land by creating in a fragment of space and time singular affinities and sympathies between the visible components of Dutch space. It is the function of art to open new paths between things and new zones of sensibility and complicity. Far from reflecting reality and fixing it in a vision which takes possession of it, the images that matter are those which create reality, slipping into it in order to make it available to other configurations and other dreams.

The Stain or the Image without Image

The example of the landscape nevertheless must not make us think that art ought to be humanist and would consist in giving a human face to things. We would probably see in painting, whatever the genre or subject happens to be, an infinite variation on the theme of the portrait that would essentially be its paradigm. Everything would be a portrait, the still life and the landscape, scenes of ordinary life and historical and mythological frescoes, details and vast totalities, Van Gogh's 'shoes' and Courbet's *A Burial at Ornans*; everything would be a portrait because painting's essence would be exposition, an apparitional face (*figure*) exposed to recognition, turned towards us, showing itself like in portraits wherein one glimpses a face turning back and looking at us over its shoulder; every painting would be this turning-back [*ce retournement*], this orientation [*cette tournure*] that makes all things arise out of themselves. This is the strong hypothesis suggested by Jean-Luc Nancy in 'The Look of the Portrait' where, after having shown in the portrait the production, in the strong sense, of the human subject's autonomy, he envisages its extension to whole of painting: 'If every subject is a portrait, then every painting is perhaps a face and a look'.[4] It is true that we can see in the landscape [*le paysage*] a visage [*un visage*], a reflection of the organizing gaze and the expression of the moods of inner life, in the flash of still life the eye itself of things, in the frame of this clock the enigmatic face of time and in every painting a mask from which the gaze takes shelter. Yet we can just as well invert the metaphor to see the visage in terms of the landscape [*le visage en paysage*], the eye in iridescent stone and time as a deserted

beach of sand. We can desire to find humanity everywhere just as we can also just as well grow weary of this and aspire to a world a bit less 'too human' (Nietzsche). To humanize a given matter is not to produce it according to the image of the human and to an anthropological model; rather it is to place it in a state generative of its relations to other matters and to itself, to virtualize it in order to make it to enter into composition, tension, variation, resonance, dissonance and so forth. We can take the example of painters who, in depicting various textiles, invented the formula of their composition and their visual texture (Van Dyck, Rubens, Delacroix, etc.). I prefer the example of an absolutely non-figurative painter whose works lend themselves much less than others to anthropomorphic projection.

This painter is Pierre Soulages. Rather than analyse one of his works whose precise evocation in his absence or in the absence of its photographic reproduction is at the very least perilous and vain, I will cite a very beautiful text of his in which he relates the matrixing experience of his work:

As a child, from the window of the room where I would do my schoolwork, I could see on the opposite wall a tar stain. I enjoyed looking at it: I loved it.

It was, at about a meter and a half from the ground, a kind of an enormous black splash, a trace probably leftover from the broom of a worker who had paved the street. It had a unified part, a calm, smooth surface connecting with other more accidental parts, marked at once by the irregularities of the matter and by a directedness that dynamized its form; the outline had a round edge and, moreover, had several excrescences, partially inexplicable and partially possessing the coherence that the laws of physics imparts to the appearance of liquid stains projected on to a surface. I read there the viscosity of the tar, but also the projection's force, the drippings due to the wall's verticality and to gravity, and additionally related to the grain of the stone.

The conjunction of all these elements made up the richness of this form and its coherence as well, provoking the movements of my sensibility. I found an orgasmic pleasure [*jouissance*] there. All of it had rooted itself in the world's thickness. One day at noon, even though I looked distractedly from the other side of the street, the stain had disappeared. In its place there was a rooster, a rooster with raised hackles partaking in a hallucinatory truth. Everything was there; the beak, the comb and the feathers. Disturbed, surprised, for an instant I wondered what kind of unsavory trickster had transformed what I loved in order to make it into the image of a rooster. I crossed the street. Arriving a few meters from the wall, the apparition vanished: the stain was once again there with its true thing-like quality, its transparencies and opacities, its skin which had so well endured the wall's unevenness. It was with happiness that I found it again, full of the life and the richness that the image had occluded. I even had fun allowing the rooster to reappear in order then to possess the force and have the pleasure of making it disappear: the apparition of a rooster, it was the misappropriation and the banalization of a reality.

Whenever, much later, I learned of Leonardo Da Vinci's use of old decrepit walls in inventing pictorial character scenes, I saw right away the point to which my adventure with a stain on a wall was opposed to this way of letting the imagination wander off in this direction.[5]

The inequality of the stain with itself—unity and irregularity, smoothness and wrinkled texture—the form's irregularity—round and excrescent—the textural variation—viscous and dynamic—the composition and the tension with the wall's materiality and verticality, all of these elements are the perception/invention of the relations of the stain and the wall with its virtualities. These relations sketch out what would blossom in the painter's oeuvre, notably in his 'beyond-black' (*outre-noir*) period: a rhythm in which matter enters into resonance with itself and with the surface that welcomes it, setting space into motion.

The painter again sees the child that was interested in the stain for itself and in itself and in no way whatsoever interested in having it feed into his visions or reverie. He does not make use of the stain in order to transform it into something other than itself; on the contrary, he allows himself to be grasped and captivated by it in order to wander through the deployment of its proper space, embracing its dynamism and taking pleasure in its texture. The child probably does not yet glimpse everything that the mature painter is made to see after affirming his vocation; however, the retrospective clarity and staging signify that the future work was able to release a latent meaning. In the last instance, it is the painter's work that takes notice of the stain in unceasingly remaking it, deploying it and overexposing it in all its variations.

It is clear, in the story as in the work of Pierre Soulages, that it is a question of sensation. It is no less clear that it is not a question of a sensation reduced to a simple affect or to subjective adequation but a thoughtful sensation in and through which matter is situated in such a way as to open itself and expose itself. Sensation, at first only a modificatory affect of the lived reality of a subject experiencing either pleasure or pain, becomes an affect that mediates the powers [*les puissances*] of matter. In such an experience, it is the excess of the perceived sensation itself that indicates the crossing of the subjective limit towards an exteriority that exceeds and includes it; such is the abduction of the subject by the object. This feeling beyond feeling, overflowing categories and the articulations of discourse, calls without a doubt for another mode of expression that differs from the figure or the phrase. We understand in these conditions that the formula that occurs to Pierre Soulages for the purposes of bringing out the stakes of his painting is 'neither image nor language'.[6] He understands by this a type of painting that, without refusing the meaning that one is always free to give it, does not reduce itself to this meaning, a type of painting beyond interpretation and resistant to it. It is necessary that painting shows the object that it desires to be and that it fashions, despite everything, an image out of its objective character in order to submit its evidence to the

gaze; otherwise it would merely be one thing among other things. Painting needs the image to open the object, for its deployment outside of itself and its exposition, however an image that is not the expression of a subject but that of the object itself, and in certain way, one that occurs through the object itself. Pierre Soulages's thought would reveal less the absence of the image than another regime of the image striving to be the immanent expression of space, matter and light.

Does not Soulages's fascination with the tar stain in effect come from the fact that he sees it deploy its own space with its splashes, stretching itself and relaxing like a living skin on the surface of the wall, animated by all the accidents of its texture and playing on shadow and light? It is not a question of the imitation of things in painting because it is a matter of accomplishing its dynamism and its singular and concrete mode of being. Painting only abandons the figurative in order to attain the register of images without image, by which we must understand that images, because they are without resemblance nor the promise of figuration, are uniquely in the position to produce an unforeseen *jouissance* from a tar stain on a wall.[7]

Portrait without Resemblance

The portrait would be another example. Spontaneously, we associate it with the idea of resemblance, the portrait being made in the image of its model, yet, as Jean-Luc Nancy puts it, 'It does not resemble an original; rather, it resembles the Idea of resemblance to an original or is itself the "original" of the resemblance-to-itself of a subject in general, a subject that is each and every time singular'.[8] The portrait does not resemble—usually we have never seen its model—it creates resemblance. It is in his portrait by Franz Hals that Descartes resembles himself; it is the exit outside of the self which relates him to himself. The philosopher's portrait splendidly turns against his philosophy because the relation to the self passes through the exposition before the other. Psychoanalysis says nothing less than this whenever, referring to Lacan and his famous 'mirror stage', it shows the subject projecting the fragmentation of its internal life into the unified image of itself that the mirror and the other's speech sends back.[9] Far from the image resembling, it is the subject that resembles its image with which it more or less identifies. If, as Hegel had observed,[10] the portrait resembles more than its model, then it is not simply the case that the portrait expresses the model in the sense of lifting it out of its obscurity; rather, the portrait concentrates the model into the unity of its sensible manifestation. As Deleuze says, the portrait creates a human relation between the human being and oneself by resembling in the singularity of a surviving figure the disparity of its appearances and its moments. It is not imitation but expression, that is to say, creation. The portrait's paradox is to create the figure of a subject that it is supposed to imitate. The portrait

gallery is there in order to prove this. It is the type that establishes the relation to the self in which the singularity of each subject comes to inscribe itself, each portrait reproducing the type in which the difference between figures asserts itself. It is the subject's difference in the indifference of the genre.

The portrait is not only the generic production of a subject according to its image; it is inflected according to the varied modalities of a spectre extending from the head to the visage. Under the effect of X-rays, the horrors of the concentration camps and with everything exposed to the omnipresent lens of photography, is it always the case that the portrait in modern times oscillates between two obsessions: that of the head deprived of a visage and that of the visage that survives mass extermination? The distinction comes from Deleuze and Guattari who oppose the organic quality of the head, which extends the body, to the sociality of the visage turned towards the other and towards the community.[11] The head is desirous of a body where forces, coming as much from the inside as the outside, come to play and clash, whereas the visage shimmers like a plan or a 'map', as Deleuze and Guattari claim, in which society's signs and marks come to inscribe themselves.[12] The dissolution of the head and the visage, the relation and the non-relation between the two, is operative in Bacon's paintings. This is, if one prefers, disfiguration, on the condition that one understands it properly: it is not a violence done to the humanity of the visage but the tearing-away of the mask that hides the forces and the upsurges of the head. Bacon's portraits thus resemble more than any others, despite their apparently brutal dissemblance. Bacon curiously achieves this unmasking on the basis of photography, being the art *par excellence* of envisagement [*l'envisagement*] and a surface of inscription for social traits, yet he only utilizes this surface to shock the photograph, to make the visage move and to efface its traits, like the photo-booth self-portraits that the painter himself captured. It is a question for him of getting at the visceral mug [*la trogne*],[13] indeed at it's very core [*au trognon*], which supports as well as resists the composed appearance of the visage.[14] What remains when the visage is effaced? From Munch to Bacon, passing by way of Bonnard (*The Boxer*, self-portrait 1931) and Giacometti (the sculptor), the response is the same: it is the head or the portrait without traits.

It is therefore most likely the case that *the cry* was a *topos* of twentieth-century painting. It is the case of course for Munch and Bacon, with the latter's affirmed ambition to paint the 'cry',[15] but also definitely the Picasso of *Guernica* who renders in X-ray the petrified figure of a mother bewailing the loss of her child and whose description seems to have been anticipated by Georges Bataille in the following passage of a text from 1930:

And on important occasions, human life is still bestially concentrated in the mouth: rage makes men grind their teeth, while terror and atrocious suffering

turn the mouth into the organ of rending screams. On this subject it is easy to observe that the overwhelmed individual throws back his head while frenetically stretching his neck in such a way that the mouth becomes, as much as possible, an extension of the spinal column, in other words, in the position it normally occupies in the constitution of animals.[16]

Bataille and Piscasso show in the cry the vital force that fuses the head to the rest of the body in order to, in the literal sense of the term, ex-press [*ex-primer*] the animal distress of human life, our total and final rebellion. But it is necessary to see in the cry more than a simple motif renewing pictorial representation by drawing from the tragedies of the century. It is even more a question of a veritable mutation that, for painting, returns to pragmatically throw into question the dominance of the visage as a coded form of expression. If, following Jean-Luc Nancy's lesson evoked earlier,[17] the portrait was the presentation of the subject to herself through what exposes her to the other, her visage, the cry of twentieth-century painters signifies a piercing and a tearing of the surface of the painting-visage [*la peinture-visage*] in order for the human head's resistance to intrusively emerge. Between the cry and headstrong painting [*la peinture têtue*], there is not only the declared impossibility of doing portraiture in the era of massacres and of mass disfigurements, there is additional research conducted under the social sign of the visage and its banalization by mass photography of another humanity of the human being, one which would render us 'capable of painting the mouth as Monet painted a sunset' (Bacon).[18] Bacon was fascinated enough by photography, becoming the currency of the image's universal exchange, to rebel against it and begin exploring the head that resembles in excess of the resemblance of the visage.[19]

PHOTOGRAPHIC PROSE

The Perplexity of the Visage

There is the effacement by painting of the visage of painting [*du visage de la peinture*], yet also there is the return of the visage in contemporary photography.[20] This return is not the result of a function neglected by painting, except in its role in the social representation of a person (identity photos, souvenirs). Rather, it is the result of an interrogation and an identity game, a *mise en abyme* of the subject in the multiplicity of images that represent him or her. If the head has a relation to the body's forces and energies, the visage is, for its part, the relation of the subject to itself, the Other and the socius. As Marx in a related fashion said of human language, the visage is essentially a relation turned towards (Jean-Luc Nancy) or abandoned to (Lévinas)

the Other. A surface of expression, the visage is a palimpsest that bears the marks of a personal history fixed in a physiognomy, even being transpersonal through the genealogical marks of a lineage[21] and, no less, is revelatory of a social group, a lifestyle or an era. The photographs and films founded on the principle of an era's visual reconstruction teach us, at the very least, about one thing: the historicity of the visage. The restitution of the visage illuminates its mode of production. Olivier Blanckart disguised as Jean-Paul Sartre (*Moi en Jean-Paul Sartre*, 2000) creates, beyond a simple parody, the historic production/composition of the image of the intellectual in the 1960s; his subject is not Sartre but the code that subtends the style of Sartre's image. It is remarkable that contemporary photography often treats the visage in the double modality of monumentality and seriality and almost always under the aegis of an overexposed and decontextualized banality, such as in portraits made by Thomas Ruff and Valerie Belin which present enlargements of faces (210 × 165 cm in colour and 161 × 125 cm in black and white) captured frontally with a neutral background adhering to a quasi-anthropometric protocol. With monumentality, the duly framed shot rivals the painterly portraiture of the past; however, the oversized visage saturating the frame absorbs and effaces the body that could have been placed at a distance. The subject's circumstantial and distanced representation is replaced by its neutral and cold overexposure. Deprived of interiority and history, the visage crudely and flatly assigns the subject to its objectivated image, as if the visage had gone over entirely to the side of its image and was nothing more than what the photograph exhibits, pure surface without depth, pure visibility without opacity. Yet this reduction of the visage to a statement, as obscene and stupefying as it is impressive, aims less for the objectivation of the photographic subject than for the compromise of the spectator's relation to photography. Frontally exposed to the photographic exposition, the spectator feels the discontent of the integral exposure to which the image submits him or her. The subject is no longer, as in classical portraiture, the one who produces himself or herself in his or her own image but the one who is produced by the image in reducing him or her to objectivity and the strangeness of appearance.

The presentation of the visage in portraiture series that mobilizes an absolutely identical point-of-view protocol introduces another inflection, that of difference. The classic pictorial portrait implied the difference in itself or through itself of the represented subject who, by exhibiting itself, produced the difference of its absolute originality. The subject of the portrait *made* a difference there, *its* difference, in the sense that the cogito includes as a subject the one who states that he or she is a subject as a subject of a speech act. With the placement of faces in a series according to a standard framing, the subject is no longer *its* difference or the relation to itself in the 'myself' of the subjective exposition. Rather, it becomes a simple differential variable of the series.

There is *this* image as much as it distinguishes itself from *that* image or from *this other one*, exactly like in the police procedure of identifying suspects in a series of photographs before the observation of a witness. The substantial subject cedes its place to the superficial and differential subject.

Metamorphosis is another modality of the visage's placement into a photographic series, interrogating identity in the triple dimension of the relation to self, to others and to social roles: recording the work of time on the facial dial, variations in mood in relation to the other and equivocal resemblances beneath dissemblances.[22] The principle of the series is thus one of miniscule difference that separates the self from its resemblance in order to compromise it through other resemblances. The temporal and expressive metamorphoses (Rineke Dijkstra, Roni Horn)[23] or those affecting the distribution of social and sexed roles (Lawick et Muller)[24] undo the simple unity of the subject in order to create out of it an unstable relational complex, as if the subject were unceasingly taking leave of us. The I is not only an Other; it is a changing and mutating crowd in which the subject falls out of sight, disperses itself in the mosaic of appearances and passes into the imperceptible by sliding between its images. The impossible identification of the figure in the variation and superposition of its images opposes identity like in the visual riddles in which a form is hidden among other forms which lend it its composite parts. If the mosaic-visage becomes one of the common locales of contemporary photography, it is less for intoning the refrain of a diversity of identities and of a patchwork of cultures than for injuring the image's identitarian function and steering us towards an exploration of its diverse facets and tremors.

The Unusual

Photography is the art that might fully justify the Platonic condemnation of the *mimesis* of appearance if, however, it were actually what Plato claimed to see there: a servile reproduction that elevates common perception to the height of a cognitive and aesthetic paradigm. Baudelaire spearheaded the Platonic trial of photography, in which he saw only a naturalism and a positivism, these two versions of fatalism that Nietzsche would quickly denounce. In his brilliant indictment, Baudelaire reproaches photography for clipping the wings of the imagination and the Idea without which the world entirely loses its meaning and is ruined in the 'positive triviality' of the commodity's reign. The poet's parallelism between the reign of the 'cold demands of cash payment' (Marx) and the reign announced by photography does not lack pertinence, especially whenever, echoing the philosopher's analysis, it sees a disenchantment translating into a de-symbolization of the world. With the substitution of singular economic exchange in the place of the complex symbolic exchanges of older societies, we are henceforth finished with the

possibility of the world's dependence on the Ideal that once gave it meaning; nature is no longer a forest of living symbols speaking in hexameter, it is only a resource sold by the square metre at a very low price. Photography, as Jean-Marie Schaeffer remarks, is for Baudelaire the absolute negation of art, being oblivious to art's symbolic dimension and dissolving the possibility of recreating the world through the spirituality of symbols.[25] Rather than opening the world to a murmuring infinity of symbolic analogies, photography's sterile reproduction reduces this world to silence and to the barbarism of brute facts.

But is photography a reproduction and is it only that? According to Jean-Marie Schaeffer, who writes about photography before the digital age:

> It is the image of something, it is therefore in a certain way always 'second'. But this secondary quality is not related to a foundational point of view: the photographic image may perfectly be an unforeseen point of view without nevertheless ceasing to be founded in 'beings' given in advance.[26]

In other words, if photography is not the epiphany of being, it nevertheless does not reproduce without producing something other than what it reproduces. What it reproduces are the beings, things and places that we always recognize even though we are not familiar with them. But does not literature, in its own way, and figurative painting, in turn, achieve something different? Even though literature and painting gain a foothold in the common, ordinary world with words and figures in order to bring the readers or viewers on board and get the fiction off the ground, photography, in particular, only creates the new and the never-seen [*jamais-vu*] with the already-seen [*déjà-vu*]. How is this possible?

In the first instance, this affair relates to space. The photographic cliché foregrounds in space unforeseen circumstances and relations between elements that we are perfectly able to identify in other ways, hence, photography's frequent impression of familiar strangeness. It is the same and it is not the same; dissemblance takes up residence or else exploits a gap at the very heart of resemblance. Muybridge's famous shots that he had constantly in front of him, revealing to a stupefied public that horses in mid-gallop do not touch the ground, are in this regard a veritable revolutionary insight brought about this new technology. Showing what we do not see in what we see in fact, these photos demonstrate that, far from being limited to the development of the depiction of appearances, photography participates in a new vision that breaks with the classical mode of representation characterized by a decentring of the gaze. One of the extreme figures of the perturbation of the space of everyday encounters takes the form of *the unusual*. The oeuvre of Philippe Ramette offers a gratifying and concentrated example of this. In this work

which plays on visual paradox and the perceptive habits linked to the vertical ordering and the distribution of bodies in space, everything is 'true', and by this we understand that there is not one detail that is not borrowed from ordinary reality, but at the same time nothing is true, thanks to ingeniously camouflaged dispostives permitting, for example, a man in business attire to have an entirely impossible posture while floating at the end of a rope several metres above the ground or striding along in the same pose under the ocean. Falsified reality appears, unbelievably and impossibly true, with all the precision and transparency of the real testimony of which the photograph is capable. The history of photography is marked by a predilection for the unusual and, more generally, for the accidental element of unforeseen encounters and alignments, whether orchestrated by the gaze of the photographer or themselves imposed on such a gaze.[27] André Gunthert has shown that the rise of snapshot photography was brought about more due to research into the unusual than to the race to capture the instant that it supposedly immortalizes: 'More than a representation of movement—a strictly impossible task for the fixed image—the snapshot fixes a repertoire of surprise and accident, one which will find its extension in the twentieth century as well as the photojournalism of the Nouvelle Vision.'[28] If it is not necessarily tragic, the accident is a fortuitous product of a joyful or unfortunate encounter that does not realize any essence and signals no destiny. Outside of sense by definition, the accident expresses a relation with the pure state of arbitrariness and effectuality that is nevertheless included through its consequences. Beyond the unusual and the accidental, the photograph captures and records unseen and unexpected relations that modify and inform our gaze; in this regard it has an unreplaceable documentary value that facilitates the recognition and the cartography of an unfamiliar and unsuspected reality. Photography's *studium* [element of interest] is not, despite Barthes, to be neglected.

The Anecdote

Making the never-seen [*jamais-vu*] from the already-seen [*déjà-vu*] also concerns a relation with time. Baudelaire's reproach of photography paradoxically clashes with his cult of modernity which implies a new way of experiencing time. Obsessed by mechanical resemblance and the visual moulding of the photo, Baudelaire remains insensitive to its temporal dimension, to what Walter Benjamin called magnificently 'the tiny spark of contingency, of the here and now, with which reality has (so to speak) seared the subject'.[29] But it is true that Baudelaire was still searching in the brief flash of the ephemeral, characteristic of the feverishness of modern times, a reflection of eternity that was unable to be furnished by what one must call the banality of photography. Photography is not exclusively this, but it is first and foremost

this: a common art with a marked penchant for any sort of subject, place or moment whatsoever. The banal is characterized as being without a notable character; it teaches nothing except what one already knows or what one has already seen; hence, as Barthes noted, a frequent impression of photography, the most commonly practised, is one of a retelling without an increase in informative value, without *studium*, without value other than that of an observation. Reinforced by its reproducibility to infinity, the photographic image's 'already-seen' strains towards paroxysm. This lack of documentary interest, however, does not deprive it of value and can even contribute its augmentation. The solution to the paradox is found in the snapshot's relation to time that has less the sense of a certificate of resemblance than that of a 'certificate of presence' (Barthes). It no longer has the value of the representation of an essence but rather as presentation of the contingency of an existence whose temporal occurrences, as discreet as they may be, create each time originality and novelty: always and the same, its subject is at once always other. This is what photography stages in the banality of visible resemblances : the living relation to time in the double dimension of the irreversibility of death and the surging forth of creation; in exposing its subject to time, photography offers the subject, in a single movement, the opportunity to resist this temporality and to produce oneself within it. With photography, art no longer saves us from time but delivers us to it. The eternity previously guaranteed by the masterpiece to the select few cedes its place to fifteen minutes of fame democratically promised to everyone by Andy Warhol.

Following the remarks of Benjamin and Barthes regarding the *stigmé* [prick, punctuated moment][30] of the photographic instant, Warhol's promise of an art for everyone, photography would therefore be, rather than a document, a *monument* commemorating the life of everyone. Yet the word (monument) is burdened by a symbolic weight that is too heavy to approximate the new relation that photography inaugurates with time. On one hand, despite contemporary forms of monumentalization which play on very large formats and stage-craft, photography parodies the monument rather than taking up its function. This is visible at times in Warhol's screen printed portraits for the exhibition of vanity, and at others in giving minor subjects an air of grandeur in order to interrogate their historical and social function. On the other hand, the insistence on photography's effect of presence charges it with a power of ontological revelation that fails to exude the impression of lightness and distracted presence, as is often the case for the majority of subjects photographed unaware. An object found, an instant stolen away, the photo rarely has the weight of necessity and hardly counts for anything more than a chance encounter. Ridiculous and anecdotal, without the substantial weight of being nor the intelligible thread of a history, Jean-Marie Schaeffer is right to bring together these faults for which it is so often reproached with photography's

active aspect in which he sees, not singularly but among others, a 'secular art' maintained in the prosaic register of a profane life having absolutely no need of salvation to be appreciated.[31] More than a document or a monument, the photo above all would be a *momentum*, a moment and a collection of assemblages [*un recueil des agencements*] of the contingency of everyday life in the proper sense an art of the anecdote, from the Greek *anekdota*, meaning something unexpected. It is this sensitivity to the fortuitous instances of a life without transcendence or promise that nourished in the last half of the nineteenth century the reciprocal influence between photography, impressionist painting and that Japanese art of printmaking which celebrates the ephemeral pleasures of the free-floating world (*ukiyo-e*).[32]

THE IMPURITY OF CINEMA

Montage

Then what about cinematographic images? The relation is no longer created in the image but between the images, or, rather, if the relation is still within assemblages of material (light, space, bodies) situations and persons in the shot, the relation passes above all through a montage of images. Even concerning the first point, the filmic image presents a marked difference with respect to the pictorial image and the photographic snapshot: it is ceaselessly mobile. This is what Deleuze calls the 'movement-image': 'Cinema does not give us an image to which movement is added, it immediately gives us a movement-image'.[33] A static shot is never immobile; micro-movements of bodies and light variations ceaselessly recompose it beneath the eyes of the spectator who receives a living impression. In giving life to matter and to space, in scrutinizing the changes that imperceptibly affect them, cinema shows a world always in movement, a becoming in duration: 'For the first time, the image of things is likewise the image of their duration.'[34] One can speak of a regime of the cinematographic image in the way that one speaks in physics of regimes of movement, either slow or violent, linear or vortical, or in mechanics, how one speaks of the differences of regime in a motor; the shot composes differences of speed between these elements. The simplest example, and probably the most common, is of a sequence shot taken from the position of a mobile object, an automobile or a train that one calls a tracking shot; in the foreground, closest to the camera participating in the object's motion, there is an indistinct flux taking off at high speed, violently marked from time to time by the fugitive silhouette of a telephone pole, a passer-by or another vehicle; in the background, the rapid scrolling of the proximal landscape that we only have time to distinguish and watch pass by, all the way

up to the most distant edge where space seemingly becomes desensitized in a quasi-immobility. Relations of speed are an essential component of the shot's animation, playing as much with the dimensionality of space—closed or open space—and/or the number of people present as with its surprise effects (depending on whether the movements are predictable or not). What counts for the landscape [*le paysage*] counts for the visage [*le visage*]. From a tracking shot on a landscape, we can be brought back to the visage behind the window who contemplates it and to the parade of thoughts and affects that can be read there; the visage too has its rhythms and its regime differences which play with relational variations between expressive traits: sadness, thoughtfulness, reverie, relaxation, anticipation, desire, consternation, joy and so forth.

Cinema certainly occurs in the sequence of images, not as a succession and continuous modulation recording the chrysalis of the real, but as an assemblage of a spontaneous and concerted montage of shots. Filmic images only communicate with one another through the framework of shots ordering their relations.[35] The cinema-machine, Dziga Vertov's ciné-eye which strove to break the image free from human vision in order to transform it into the auto-revelation of the real, always follows the gaze of the cineaste. Even if he films randomly, it will always be in order to signify something.[36] Deleuze remarked that two images sufficed for opening between them the possibility of a story, or according to Jacques Rancière's term, a 'fable'.[37] If one image will never abolish the chance of an apparition [*Si une image n'abolira jamais le hasard d'une apparition*], two images will suffice to initiate the imaginary logic of story that will inscribe itself, barring any unexpected and intermediary events, between the beginning and the end of an action. Cinema links the poetics of revelation to the drama of action, the movement in the image with the movement that passes from one image to the other. The constitutive impurity of cinema is already in this alteration of the image's pure givenness through another image that sends it off on adventures of sense and whose famous effect is given its first instantiation by Koulechov.[38] Although made from a single stationary shot, the Lumière Brothers' *The Arrival of a Train at Ciotat Station* offers proof from the outset: it ties a poetic of manifestation, the tiny Provençal station along with those who are waiting on the quay, together with an evental framework, the arrival of the train moving forward in the shot until it devours the space and the light enveloping the scene and, indeed, evokes terror in the first spectators.

The Arrival

What arrives with cinema is the event, that is, that which exists, in a sense, always off-screen, making the here-and-now communicate with an elsewhere, one scene with another. But what arrives with the entrance of Lumière

Brothers' train at the station is not merely the modern poetry born from the encounter of a secular landscape's beauty with the blind and brutal power of the locomotive, it is also the arrival of the eventuality of the event and with it the arrival of a happy or unhappy story of which it is the announcement. In this way, cinematographic modernity, as Jacques Rancière notes, reconnects with a very old taste for stories at the risk of interrupting these stories with poetic stasis and ecstasies which deliver the gaze to the pure appearance of things and beings. In keeping open interstices for the gaze's vistas within the knots of its intrigues and its adventures, cinematographic modernity accomplishes what Lessing believed to be forbidden in the representational arts, the fusion of the intelligible narrative (*muthos*) and the sensible spectacle (*opsis*).[39] Or, to be more exact, it is because 'classical' painting has done nothing else but this, subordinating the plastic representation of the sensible, for example, that of the body, to the meaningful articulations of a story whose illustration it organizes. What is paradoxically novel in the fable's return is not only, according to Jacques Rancière, the thwarting of the aesthetic regime's modernist utopia and its pretention of holding to the highest degree of realism an art without history and without words,[40] but that the fable returns as the real itself, along with the impossibility of escape, for the panicked spectators of the Lumière Brothers' film who witness the train barrelling towards them. Neither literature nor painting in the aesthetic age had foreseen this. Manet, without a doubt, invented the indifferent perspective of the third eye. *The Execution of Emperor Maximilian* (1867) and *The Balcony* (1869) are here, at the same time as the invention of the photograph and before the invention of cinema, to testify to this fact. But nothing therein announces the arrival of the real in the image characteristic of the cinematographic revolution.

If the Lumière Brothers' film is the primal scene of cinema, it is less so chronologically than for reasons pertaining to sense. The primal scene is not the first in time; it is the mirror-scene in which the future can retrospectively see its announcement and its departure. There are at least four reasons to see in this arrival scene cinema's point of departure, already containing several of its virtualities. The first is that *something happens to* [*qu'il arrive quelque chose à*] the image itself, to its movement and its own vibration, modulating it in duration and making it live, this is the realism of the image. Second, *something arrives in* [*qu'il arrive quelque chose dans*] the image: the train coming from afar progressing towards the foreground and traversing it from end to end; the opening to an outside which divides the image and relates it to what is off-screen. The third is that *a sequence makes one anticipate other images*, already aspiring beyond the initial shot towards a story. The fourth is that, owing to the reality of the image, to its content from a precise camera angle, *an emotion comes to the spectator* [*il arrive une émotion au spectateur*]. Even in a scene that seems somewhat like a documentary, the

imagination and the 'direction of the audience' (Hitchcock) play their part. The primal scene is as realist as it is imaginary, incarnating the imaginary as it imagines the real. It is impossible here to cleanly divide the imaginary from the real or the historical document from mythology. The second impurity of cinema, after the contamination of the image by the image in montage, is that it invents a new relation between the real and the imaginary in which the real is at the same time fiction and document: 'Every image is to be seen as an object and every object as an image'.[41] In becoming image, the real transforms itself into cinema.

The Sound of Images

The silence of *The Arrival of a Train at Ciotat Station* is probably not foreign to the panic unleashed by the first public projection of the Lumière Brothers' film; deprived of a sonorous ambiance which would announce it and identify it, the manifestation of the real in its image only becomes more foreign and more poetic. It is understood in these conditions that the advent of sound and speech in cinema was able to pass as the restauration of the ancient regime of theatre for the benefit of the Hollywood entertainment enterprise. For certain individuals who uphold a cinematographic purism, the intrusion of sound and speech came to harm the image's power of immediate revelation and signified a return to the ancient hierarchy fettering the image to the prestige of the narrative and drama's unpredictable events. Yet, as André Bazin remarked, if the revolution of the talkies was less aesthetic than technical,[42] then it must be held to be an accomplishment of cinema rather than its destruction. Defending the brilliant thesis of the anteriority of cinema as an idea, that of an 'integral realism' aiming for 'the reconstruction of the perfect illusion of the outside world in sound, color and relief'[43] during the historical phases of its technical realization, André Bazin comes to see in these latest examples not the alteration of a purportedly pure essence but the progressive actualization of an idea's force in the search and the invention by trial and error of structures that will allow this idea to become reality:

> The primacy of the image is both historically and technically accidental. The nostalgia that some still feel for the silent screen does not go far enough back into the childhood of the seventh art. The real primitives of the cinema, existing only in the imaginations of a few men of the nineteenth century, are in complete imitation of nature. Every new development added to cinema must, paradoxically, take it near and nearer to its origins. In short, cinema has not been invented![44]

The joining of image with sound, far from being it's perversion, is the third constitutive impurity of cinema. To the purification which extracts pure, identical essences from out of themselves and to the modernist myth of a pure,

autonomous art that feeds off its own materials, cinema opposes a practice of 'impurification' that moves through mixtures of materials, compositions of movements, the montage of images and the duality of the audible and the visible.

The sound/image coupling which, in the first instance, accomplishes the realist myth of cinema quite quickly comes to contest it. To the sound connecting with the image, which synchronizes in the shot gesture and speech, or noise and the visible scene on the screen, the soundtrack will add another function: the relation to an invisible off-screen from which the noise of an engine or the words of a character originate. It can serve realism in suggesting the scene's borders and playing a complementary role to the image. In a dialogue unfolding in a café, the cineaste establishes the decor through sound ambiance rather than showing it, dispensing with the boring alternation between a shot/counter shot of the protagonists by framing the individual on whom the cineaste wants us to focus our attention. But playing on a dramatic tension or a suspense between visible space and invisible space, sound can break narrative continuity and contiguity by introducing into space and into familiar temporality the disquieting element of another scene, causing them to spill over into the universe of fantasy or the fantastic. In Luis Buñuel's *The Criminal Life of Archibaldo de la Cruz,* this is the case for the scene involving a pretty woman killed in the bourgeois apartment by a stray bullet fired by rioters from the street off-screen; the uncovering of her thighs by the fall will precipitate for the child, as much a witness as an actor, in this scene, through his fantasy, an entanglement of desire and murderous impulse that his mature love-life will go on to ceaselessly repeat. The off-screen's irruption makes the visible scene communicate with the invisible theatre of the child's unconscious. In Jacques Tourneur's *Cat People* the noises and the shadow of the wandering beast that we never see nevertheless gives the off-screen a present and impressionistic reality which we can never confront. This is worse than the resistant reality against which it is always possible, one way or the other, to generate an action or a reaction. In these two examples, sound comes to multiply the off-screen reality of the imaginary and unsettle its reassuring appearance.

Another function of the soundtrack plays on the desynchronization between the sound and the image, producing a critical gap in relation to the realist illusion. This is the hilarious effect produced by the famous scenes of Stanley Donen's *Singing in the Rain* in which we see a romantic duo thrown off by inopportune noises monstrously amplified by microphones and the slippage of the soundtrack attributing the woman's voice to the man and vice versa. Unless, as in the case of Jacques Tati, this function proceeds by way of an 'underscoring', a clean cut of the sound that turns against the scene that it is supposed to animate and signify in order to empty it of all its

meaning; in *My Uncle*, this is the ridiculous noise from the water squirting out from out of the small garden, the extremely sonorous fall of the plastic pitcher bouncing on the kitchen floor or the irritating clink of the secretary's or the hostess's high heels; or in *Playtime*, there are the long groans of the armchairs and sliding glass doors. It is not by chance that, in *Playtime*, there are an abundance of scenes viewed or perceived through windows: reducing gestures and words, deprived of their meaning, to a simple visual and sonic pantomime. These scenes transform life and seriousness into a spectacle, as burlesque as it is caustic, that translates into a disruption of the social fable.[45] But in these scenes wherein the soundtrack takes on the critical function of turning against the belief in the image, the ironic vision of modernity is, in the last instance, less important than the production of another image, one that is more distracted, lighter and certainly funnier. This is the production, in short, of a poetics that allows this image to live and be shared differently. Tati proceeds like a cartoonist using tracing paper behind which the materials, the figures and the assemblages of the originals fade out in order to then squeeze out of them by subtraction, addition, accentuation and recomposition a renewed image of reality.

NOTES

1. 'Être sage comme une image' is an idiomatic construction that could be roughly translated as 'to be as good as gold'. A literal translation is rendered here for the purposes of conceptual and lexical coherence. [TR]

2. Gilles Deleuze, 'Pericles and Verdi: The Philosophy of François Châtelet', trans. Charles T. Wolfe, *The Opera Quarterly* 21 (2006): 716–24. The first version of this text was given in the series rendering homage to François Châtelet organized by the College International de Philosophie.

3. Deleuze, 'Pericles and Verdi', 717.

4. Jean-Luc Nancy, 'The Look of the Portrait', in *Multiple Arts: The Muses II*, trans. Simon Sparks (Stanford: Stanford University Press, 2006), 225. Translation modified. [TR]

5. Pierre Soulages, *Image et signification* (Paris: Rencontre de l'école du Louvre, La Documentation Française, 1984), 269.

6. Soulages, *Image et signification*, 274.

7. This analysis partially reprises a text published in Italian: 'A che cosa fa pensare la maccia di pittura?', in *Ai limiti dell'immagine*, ed. Clemens-Carl Harle (Macerata: Quodlibet Studio, 2005), 199–209. I risked proposing the idea of an image without image or empty image in *La peinture et l'image. Y a-t-il une peinture sans image?* (Nantes: Plein Feux, 2002), 32–35.

8. Nancy, 'The Look of the Portrait', 233.

9. Jacques Lacan, 'The Mirror Stage as Formative of the I Function as Revealed in Psychanalytic Experience', in *Ecrits*, trans. Bruce Fink (New York: Norton, 2006), 75–82.

10. G. W. F. Hegel, *Aesthetics: Lectures on Fine Art*, vol. 1, trans T. M. Knox (New York: Oxford University Press, 1988).

11. 'The head is included in the boy, but the visage is not. The visage is a surface.' (Gilles Deleuze and Felix Guattari, *A Thousand Plateaus: Capitalism and Schizophrenia*, vol. 2, trans. Brian Massumi [Minneapolis: University of Minnesota Press, 1987], 170). Translation modified [TR].

12. Deleuze and Guattari, *A Thousand Plateaus*, 171–72.

13. *La trogne* is slang for 'face', similar to 'mug' in English. Here I have rendered it 'visceral mug' in order to capture the raw and unmediated character suggested by the remarks of Vauday, Deleuze and even Bacon himself. [TR]

14. We refer to Deleuze's *Francis Bacon: The Logic of Sensation*, trans. Daniel Smith (New York: Continuum, 2003).

15. David Sylvester, *Interviews with Francis Bacon: The Brutality of Fact* (London: Thames and Hudson, 2014), 34: 'I did hope one day to make the best painting of a human cry.'

16. Georges Bataille, 'Mouth', in *Visions of Excess*, ed. Allan Stoekl (Minneapolis: University of Minnesota Press, 1985), 59.

17. Jean-Luc Nancy, 'The Look of the Portrait', 233.

18. Sylvester, *Francis Bacon*, 98.

19. Bacon evokes his connection to photography in the second interview with David Sylvester on pp. 67–68.

20. Regarding this theme, see Dominique Baqué, 'L'Impossible Visage', *Artpress* (November 2005), 317.

21. Roland Barthes, *Camera Lucida*, trans. Richard Howard (New York: Hill and Wang, 2010). '[T]he photograph sometimes makes appear what we never see in a real face (or in a face reflected in a mirror): a genetic feature, the fragment of oneself or of a relative which comes from some ancestor' (103).

22. Baqué, 'L'impossible Visage', 42–52.

23. Rineke Dijkstra photographed a young woman at intervals of a few months in order to capture the changes. Roni Horn multiplied the portraits of a young woman coming out of the water.

24. Lawick and Muller, playing with digital 'remorphing', transform through imperceptible variations a woman's portrait into that of her partner and inversely as well.

25. Jean-Marie Schaeffer, *L'image précaire. Du dispositif photographique* (Paris: Seuil, 1987), 176–77.

26. Schaeffer, *L'image précaire*, 199.

27. Jean-Marie Schaeffer goes in this direction in his analysis of a photograph by Robert Frank: '[T]his photo is a scandal, neither moral nor metaphysical, but rather physical and logical at once.' (Schaeffer, *L'image précaire*, 204.)

28. André Gunthert, 'La Révolution de l'instantané photographique 1880–1900', in *Cahiers d'une exposition 15* (Paris: Bibliothèque nationale de France, 1996), 9.

29. Walter Benjamin, 'Little History of Photography', in *Walter Benjamin: Selected Writings Vol. 2, Part 2, 1931–1934*, trans. Edmund Jepcott and Kingsley Shorter (Cambridge: Belknap/Harvard University Press, 1999), 510.

30. Jean-Marie Schaeffer's term, from the Greek *stigma*, meaning 'blemish' (stain) or 'sting'; instantaneity would be the sting of the instant. (Schaeffer, *L'image précaire*, 186.)

31. Schaeffer, *Image précaire*, 212.

32. On this subject, refer to my article: 'La photographie d'Est en Ouest. Echange de clichés et troubles d'identité', *Diogène* 193 (2006): 62–74. Also see my book: *La Décolonisation du tableau* (Paris: Seuil, 2006), especially the third section, 'Résonance de l'impressionisme et du japonisme: Monet', and Chapter 3, 'La photography, le japonisme et l'impressionisme'. *Ukiyo-e* is a Japanese term that signifies an 'image of the floating world'. This term names the Japanese artistic movement of the Edo era (1603–1868) comprising of not only popular painting styles and original narrative forms but also Japanese stamps engraved on wood.

33. Gilles Deleuze, *Cinema 1: The Movement-Image*, trans. Hugh Tomlinson and Barbara Habberjam (Minneapolis: University of Minnesota Press, 2013), 2.

34. André Bazin, *What Is Cinema: Vol 1*, trans. Hugh Gray (Berkeley: University of California Press, 2005), 15.

35. 'Cinematographically, what "informs" images and articulates them with one another is that in them we detach as a shot.' (Pascal Bonitzer, *Le Champ aveugle. Essais sur le cinéma* [Paris: Cahiers du Cinéma/Gallimard, 1982], 17.)

36. Jacques Rancière, *Film Fables*, trans. Emiliano Battista (New York: Berg, 2001), 1.

37. Rancière, *Film Fables*, 1.

38. Bonitzer, *Le Champ aveugle*, 17.

39. Gotthold Ephraim Lessing, 'Laocoön: An Essay on the Limits of Painting and Poetry', in *Classic and Romantic German Aesthetics*, ed. J. M. Bernstein (Cambridge: Cambridge University Press, 2003), 25–129.

40. Rancière, *Film Fables*, 1.

41. Bazin, *What Is Cinema*, 15–16.

42. Bazin, *What Is Cinema*, 23.

43. Bazin, *What Is Cinema*, 20.

44. Bazin, *What Is Cinema*, 21.

45. We borrow this idea from Jacques Rancière who speaks about the burlesque as 'derailing every fable'. (Rancière, *Film Fables*, 12.)

Chapter 3

Poetics: Making Images

MANET: PAINTING AND NEW IMAGES

The Image in Painting

Images have the reputation of being easy [*facile*], easy to capture when it concerns photography, easy to make since nothing is invented when it concerns imitative drawings, easy to imagine compared to the effort of thought, easy to gaze upon whenever reading or listening demands sustained attention. Images are facile [*facile*], etymologically that which makes itself [*qui se fait*] (*facere*, 'to make' in Latin), coming forth with ease, without the resistance of thought or matter, without the transformative work of passing from the formless to the form or from one form to another. One term summarizes all of this: the *cliché*. In the technical language of printing, the cliché is the relief matrix of a text or image that allows its reproduction into a large number of copies. Before being a figure in which the visible takes shape, the image is reproduction. All the same, and to the benefit of the reader's comfort, the newspaper's copy is different from that of the relief matrix, since the image does not reproduce its model without unburdening itself from its material form. The facility [*la facilité*] of the image additionally moves through the eclipse of its material, endowing it with the instantaneous magic from which the illusion of reality is born. Louis Marin noticed that the power of images is less part of their resemblance than of their beauty and the polish of reflective surfaces which sublimates the crudeness and irregularity of matter.[1] The reproduction image would thus proceed by way of a double sleight of hand, that of the represented real whose illusion would only be tolerable or enjoyable on the condition of erasing its rough patches and that of the image whose efficaciousness demands the effacement or the concealment of its own materiality.

This sublimation of matter was the characteristic operation of representative painting and was celebrated to the extent that it was able to produce the illusion of matter's absence. Its paradox was to have to work to conceal, in the fabrication of images, the material processes whose presence would have been perceived as a violation of the ideal of beautiful representation. Of course, if the painting's material effacement in the representative regime is something completely impossible, then this process must be understood in the moral sense of 'keeping out of sight' or 'shying away' [*s 'effacer devant*], a way of acting or a modality of practical knowledge, an elegance consisting precisely in the dissimulation of materials and technical procedures, an art of producing a non-production in appearance. For aesthetic experience, there is hence the chiasm of representative painting formulated by Ernest Gombrich: either it is the image or else it is painting. Either the viewer is attentive to the image, to the representation and to the meaning that it conveys while the painting in its materiality thus withdraws outside of the field of attention; or else the viewer focuses on the canvas in order to observe its pictorial properties, the textures, colours, brushstrokes and so forth, and it is the image that pays the price. This is the pictorial ambiguity that the term 'picture' [*tableau*] itself summarizes, at first designating a wood panel before then designating the immaterial space of representation for which it became the material support. 'Recall that a picture—before being a battle horse, a nude woman or some anecdote—is essentially a plane surface covered over with colours assembled in a certain order':[2] referring to this famous definition of Maurice Denis, Gombrich maintains that 'to understand the battle horse is for a moment to disregard the plane surface. We cannot have it both ways'.[3] Following Gombrich, the realization of the image as image, and probably as the presentation of an imaginary at the same time, has for its condition the repression of painting's materiality.

Georges Bataille adopts the same presupposition but in order to go in the opposite direction in his interpretation, according to him characteristic of the modernist turn in painting, of Manet's oeuvre:

> In others besides Manet we can discern the transition from narrative, anecdotal painting, that is a 'real and imagined spectacle' to pure painting—'patches, colors, movement.' . . . But Manet was the first to practice the art of painting taken for itself alone, what we call today 'modern painting'.[4]

Far from contradicting Gombrich, Bataille confirms his sentiment by explaining the pictorial revolution at the end of the reign of representation and narrative as a benefit to the new reign of pure painting for which the painterly model is only an opportunity for the deployment of the proper powers of pure painting. This is what Zola, the defender, friend and model for the painter,

already noted: 'You needed a nude woman and you chose Olympia, the first to arrive; you needed light and luminous splotches, and you added a bouquet; you needed black splotches, and you put a cat and an African woman in the corner'.[5] Being servile to the image in representative painting, modern painting would emancipate itself from its tutelage and would strike out on its own: 'Painters, certainly Edouard Manet who is an analytic painter, are not preoccupied by the subject tormenting the crowd above all, the subject for them is a pretext for painting, whereas for the crowd the subject alone exists'.[6] Painting would no longer efface itself before its subject; henceforth it would come before the tableau in order to make itself visible within the materiality of the picture's components and processes. This constitutes a passage from an idealism of representation to the materialism of craftsmanship, a passage from transitive painting to an intransitive painting that encapsulates Bataille's formula: 'Olympia . . . is the negation of mythological Olympus and everything it stood for'.[7] This echoes another historical transformation that saw industry and standardized products supplant the chisel and the workshop in which the ideal of the masterpiece had been fabricated. When Malraux writes that 'what Manet brings out, not in a superior fashion but in an irreducibly different manner, is the green of the *Balcon*, the pink smear of the dressing-gown in *Olympia*, the raspberry smudge behind the black corsage of the little *Bar des Folies-Bergère*',[8] he opposes the colours of modern chemistry to the ancient alchemy of representation, the stridence of pure tones against the harmony of figures.

Yet it is not so simple nor as clear-cut as all this. If one admittedly returns to the exclusive disjunction between image and painting or between representation and materiality, it is because the creation of the work, as well as its reception, has not been adequately considered. It is Manet's work through which one sought to glimpse the rupture of modernity which paradoxically illustrates this idea. Not only, as Bataille observes, has the representation of a 'real or imagined spectacle' *not* vanished from Manet's painting, but the work directly feeds off of it. To convince ourselves, let us take a look at *Before the Mirror* (1876) whose subject is a scene of intimacy: seen from behind, there is a half-dressed woman looking at herself in the mirror who we surmise to be close to a window judging from the presence, on the right, of a shimmering white curtain and a stream of cold, transparent light that inundates the space of the picture [*le tableau*]. The painting, indeed the gesture of the painter following Bataille's idea, manifests itself in brushstrokes, the marks of the paintbrush, the overflowing of colours from the barely sketched outlines, the flattening of the planes on the surface of the picture; the subject and the figures are about to be submerged in the overlapping of brushstrokes. For example, what is this whitish falling patch tinted with light blue, on the right, parallel to the vertical edge of the picture? From a distance and given the

identifiable context of the scene, one quickly recognizes that this is a curtain, however one that fails to resemble a curtain in not conforming to its stereo-type insofar as it arises from the activity of painting itself and its manner of producing its effect solely through one type of material (in the direction, composition and texture of the brushstrokes, the variation of tones) instead of through a simulation of its reality.

It is true that this was always the case even in the most illusionistic paint-ings, since its *tour de force* precisely consists of an exit from painting by painting. Yet the exigency of the pictorial apparatus of good distance suited for the contemplation of the picture might permit one to sustain the fiction of painting in the absence of bodies or materiality. Manet's contribution is in the collapse of the distance that places the image ahead of the surface and texture of the picture, effectuating, not a reproduction of reality by the image but a production of the image by and within the picture. What actu-ally changes in *Before the Mirror* is that the picture ceases to be the mirror of things in order to become the optical machine that produces their effect. The lacing of the woman's corset is a zig-zagging lattice of strokes, and the same goes for her hairdo which interlaces follicle strands with splotches of paint. The force of this picture is in the interweaving of painting and representation, of the subjectile and the subject; a braiding that makes the picture's various planes communicate; and in its manner of treating its subject who, not unintentionally, is a woman neither completely nude nor completely dressed, but between the two. Far from being reduced to either its materiality or to representation, the picture plays the role of a dynamic matrix that makes the figure visible in painting and the painting visible in the figure by a convocation of the gaze that makes them emerge from out of one another.

On this basis, the alternative theorized by Gombrich no longer functions. We can apply to Manet's picture, expressly against Gombrich, what Richard Wollheim calls 'seeing-in', that is to say, 'the seeing appropriate to repre-sentations permits simultaneous attention to what is represented and to the representation, to the object and to the medium'.[9] The seeing-in proper to aesthetic experience is signalled by the ability to see something in another thing. Wittgenstein too calls this 'seeing-in', according to the aleatory figures that we see tracing themselves in a simple stain or in a cloud:

In Titian, in Vermeer, in Manet we are led to marvel endlessly at the way in which line or brushstroke or expanse of color is exploited to render effects or establish analogies that can only be identified representationally, and the argu-ment is that this virtue could not have received recognition if, in looking at pictures, we had to alternate visual attention between the material features and the object of the representation.[10]

Inspired by psychoanalysis, this is what, in his own way, Anton Ehrenzweig had anticipated in *The Hidden Order of Art*. He contrasts in this book a superficially conscious and discriminating vision belonging to simple perception which relies on the alternatives of figure/ground and representation/medium with a deep unconscious and synthetic vision that sweeps up these alternatives or 'scans' them in order to fuse them together:

> The complexity of any work of art however simple far outstrips the powers of conscious attention, which, with its pinpoint focus, can attend to only one thing at a time. Only the extreme undifferentiation of unconscious vision can scan these complexities. It can hold them in a single unfocused glance and treat figure and ground with equal impartiality.[11]

The image does not transcend painting like the idea in the Aristotelian tradition which creates form and gives meaning to the formless, any more than it plays the role of a foil to pure painting. The image comes into being in the space of the picture at the point at which it encounters the picture's materiality, capacities and forms.

Painting Seized by Photography

Images come from painting, from within painting; this is what every painter who speaks about their practice observes about it. Nevertheless it would be an error, one very close in the end to the formalist interpretation of the modernist turn, to believe in a self-referential or self-consuming painting that merely feeds off itself. Manet was unsatisfied with allowing his work to feed off of the spectacle of an era, one beloved for its fortunes, both large and small, as well as for its misfortunes, for the purpose of pulling out from it images that are new as much by their subject matter as by their treatment. He was thus sensitive to the attraction of other images that compose and condition the visual landscape of his time. Concerning references to artistic tradition, art historians have insisted on the role of popular imagery in the stylistic formation of the artists of pictorial modernism; we know, for example, that Courbet's *Burial at Ornans* is partly inspired from a very well circulated idyllic image, *Napoleon's Funeral Procession*[12] and that Manet's *The Fifer* was inspired from a tarot card representing the Buffoon (today known as the Joker).[13] But photography is the truly new image of Manet's time. It was new, but very quickly became familiar to painters who, as Delacroix and Courbet inform us, perceived it's utility for their paintings, if only in the form of a dictionary of images that they can draw upon. But in distinction from his two great forefathers, Manet did not place the photograph at the service of painting, but introduced it into his painting in form of a new gaze and a

new vision of reality. Among the painters of this time, there were those who rebelled against photography, those who exploited it and those who took it in by trying to translate it in their work through properly pictorial means; Manet is of the last variety.

It is curious that neither Malraux, who nevertheless demonstrated the major role played by photography in what he called *The Imaginary Museum*, nor Bataille had the slightest suspicion of this. Bataille was nevertheless not far off but was too concerned with illustrating his thesis about pure painting detaching itself from representative anecdote and conquering the independence of its territory. It was not conceivable for him that painting received a part of its energy from another species of image; without even considering photography's taste for anecdote and realism, painting took the reins of an ancient power of stewardship. Commenting on *The Execution of Emperor Maximilian* also with Goya's *Third of May*, the inspiration for Manet's picture, in the background of his concerns, Bataille writes this:

> Manet deliberately rendered the condemned man's death with the same indifference as if he had chosen a fish or a flower for his subject. True, the picture relates an incident, no less than Goya's does, but—and this is what counts—without the least concern for the incident itself.[14]

The indifference of a painter to his subjects: Bataille reveals what from the outset shocked his contemporaries, who wilfully recognized Manet as a genius of still-life painting but reproached him for not knowing how to animate his simplified and frozen figures like mobile figurines, 'an oil painter of the idyllic' [*un imagier à l'huile d'Epinal*] as Edmond de Goncourt wrote in his *Journal* dating from 19 January 1884. What his contemporaries attributed to a lack of genius, Bataille brings into the register of an absolute art for which all subjects are equal in their submission to the royalty of painting. This is the irony of painting that treats its subjects—whether emperor, flower or fish—with a sovereign indifference in order to better contemplate its own power within them. It is of little import that Manet's still life does not always manifest the indifference that Bataille attributes to it. We incontestably find this difference in a rather large number of his paintings, among which we can cite *The Spanish Singer/The Guitar Player* (1860), *Misses Victorine in the Costume of Matador* (1862), *the Fifer* (1866), *the Balcony* (1868–69), *The Luncheon* (1868–69), *Portrait of Eva Gonzales* (1870). It is here that photography intervenes. If, as Jacques Rancière has indicated, the egalitarian treatment of subjects and objects resulting from the de-hierarchization of genres is a constitutive trait of the aesthetic regime of the arts, then photography, as a universal procedure for treating every visual given, is its highest realization; whatever they happen to be, every subject is therein translated

into the black-and-white range and into the radiant material of photographic paper. As for the noticeable absence of expressivity in photographed subjects, at least during photography's inception, it is partially the result of the constraint, as the time for holding a pose obliges, that forces the subject to make itself into an object and adopt its inertia. Another aspect of photography might be added here: the desynchronization of human subjective time with the mechanical time of the camera, which has the effect of producing mute astonishment and translates into, as Thierry de Duve has so adeptly revealed, the insensibility of the image: 'Manet, who simplified chiaroscuro and discovered how to seize upon the stupor of his models struck by a magnesium flash, made the canvas vibrate with a passion only equalled by the passivity of the photographic image'.[15] Far from signifying a retreat into pure painting, the absence of affects in Manet's pictures testifies to the concern for elevating painting to the height of a new modality of looking at the world initiated by photography.

The Balcony is one example that illustrates this. What it shows is no longer the manifestation and the free expression of an interiority, but the exposure to the anonymous and ordinary gaze of the street and public space, delivered in its final sense by Magritte's picture that replaces the characters of *The Balcony* with coffins (*Manet's Balcony*, 1950). Relegated to a sombre background and lacking depth, the apartment is the bottomless ground that aptly places the three principle figures into view at the surface of the picture where nothing more than their thin and ugly effigies appear. The picture is no longer a gaze nor a window opening on to the world, but a surface of exposition and spectacle offered to various onlookers. In a conference on Manet held in Tunis, Michel Foucault, who indeed insists in the painter's oeuvre on the novelty consisting of creating a 'play of the fundamental material elements of the canvas',[16] makes two important remarks apropos of *The Balcony*. This invites an approximation to photography, even if Foucault totally ignores this aspect. The first concerns the black-and-white treatment in the picture (with the exception of its architectural elements): 'What is more, you see that the whole picture is in black and white with this one color that is not black and white, as though it were the fundamental color, the green';[17] as if at bottom Manet had incorporated a cliché into the architecture of his picture. Here is the second decisive remark:

Rather than penetrating into the picture, the light is outside . . . consequently no shadow, and so every shadow is behind, because, by the effect of back-lighting of course, one cannot see what there is in the room; and instead of having a light-dark picture, instead of having a picture where light and shadow mix together, you have a curious picture in which all the light is on one side, all the shadow on the other.[18]

Foucault shows how the effect of backlighting, responsible for the shadow/ light contrast, doubtlessly exists for any spectator attempting to observe the inside of the apartment from the street. This incidentally points to Manet's concern for rendering what he saw and not what he knew but, as Foucault remarks regarding this picture, only to the extent that the light separates from shadow, the black from the white, without nuance or without creating a 'light-dark picture'. This accentuation of contrast is a characteristic effect of the treatment of light by the photographic apparatus (a more or less rapid diaphragm and emulsion).

The difference concerning the photo is that the picture goes before the photo, so to speak, in forcefully superimposing the stridence of the colour green, the harshness and the density of its material and the solidity of its architecture. The picture opposes the force and the intensity of its presence to photography's fragile appearance and spectrality. Yet, by rivalling photography, Manet's canvas also goes beyond it in order to propose its interpretation: a subject seized by their image and, by it, released from their substance. In this way, the image actually joins the temporality of the world in the process of creating itself. This is the time of the circulation of new images that henceforth populate the world with a profusion of photography and advertisements.

Photography Seized by Painting

It is therefore a question of the seizure of painting by photography and, in parallel, the seizure of photography by painting that inspires the pictorial aesthetic of photographers. Besides the relation of friendship and mutual admiration linking Manet and Zola, there are connections between their works that are significant in this regard.[19] We know of the famous portrait painted by Manet in homage to Zola who defended with panache the scandalous *Luncheon on the Grass* and who always saw in its author's oeuvre one of the pinnacles of French painting in their century alongside Ingres, Delacroix and Courbet. But we know less of Zola's taste for and practice of photography. If Manet tried to rival photography, as the presence of three reproductions of his works, including Olympia, in the upper right-hand corner of the *Portrait of Emile Zola* testifies, and then Zola, who in his youth attempted to become a painter, found a substitute for painting, for which he had no talent at all, in photography. This marginal yet impassioned work often proceeds by a *mise en abyme* of painting into photography. Zola stages a family photography session in a humorous homage to Manet's *Balcony* and composes a photograph with a bouquet of flowers, a framed portrait of Alexandrine Zola by Manet, a bound book and a profile photo of a man, entitled *Still Life with a Portrait of Alexandrine Zola by Manet*.[20] The framing and the bust-style pose of the models in the portraits of Jeanne Rozerot and Alexandrine, while the latter reads one of Zola's works,[21] displays

an evident reference to the pictorial genre of the portrait to the extent of reproducing, in the feigned ignorance of the photographer's presence, the 'absorbement' [*l'absorbement*] that Michael Fried shows to be characteristic of pre-Modern French painting.[22] This term designates a denegation through scenography and the spatial apparatus of the picture in its relation to the viewer in such a way that it presents itself to their gaze as an autonomous, closed world. Insofar as Michael Fried sees in Manet the demolition of this convention through the spectacular frontal positioning of his subjects which call upon the viewer's gaze, let us take, for example, the nude woman in the *Luncheon on the Grass* or *Olympia*, these two photos by Zola testify from this point of view to a sharp disjuncture between the technical modernity of the photographic camera and the conventional aesthetic in service of which it functions. But Zola was able to be much less conventional with his photo of Jeanne who, wearing a white dress under a parasol, moves forward to meet him from out of frame on the road to Verneuil. This is an obvious evocation, as Dominique Fernandez remarks, of Monet's canvases which in this instance unhesitatingly inscribe the photographed subject into the same space as the photographer while indicating what brings them together. This face-to-face and this crossing of gazes implies a possible approximation of Michael Fried's remarks on the space of Manet's pictures and photographic space, because, in the same way that Manet's subjects and his pictures look at the viewer, photographed subjects act like Victorine Meurent in *The Luncheon on the Grass*, staring at the lens and beyond it towards the invisible viewer. This shameless subject of photography and painting, the insolent nudity of *Olympia*, is this not the appearance of the new subject of modernity reacting to the dread of its public exposition by the reversal of passivity into activity? How is one to be subject to the time of integral exposition, when depth spreads itself out over surface, if not in an overinvestment on the surface within the overexposure of the self?

Elsewhere, citations and repetitions of painting by photography are complicated by reciprocal translations of images and words with a literature that forms pictures and creates rebuses. Dominique Fernandez brings up a sentence in *Doctor Pascal* (1893) which translates the photo of Jeanne with the parasol: 'Sheltered a bit by her parasol, she blossomed, pleased with this bath of light as well as with a plant at midday'[23] and in *The Masterpiece* (1886) a passage that directly echoes two of Manet's pictures, *Asparagus* and the *Bundle of Asparaguses*:

Wasn't a bunch of carrots, yes, a bunch of carrots, studied directly and painted simply, personally as you see it yourself, as good as any of the routine, cut-and-dried École des Beaux-Arts stuff, painted with tobacco-juice? The day was not far off when one solitary, original carrot might be pregnant with revolution![24]

Inversely and without reduction, we find in Manet's portraits of Zola, Zacharie Astruc and Theodore Duret authentic messages encrypted in the components and the configuration of the image, dispatches in the form of rebuses directed to their recipients.[25]

Manet reacted to photography, which would take up in his painting the renewed motif of the still life, or, rather, given the vivacity of his disposition, that of the animated life of a flower, an oyster or a lemon. Manet responded to his critics, to Zola who furiously defended him, to Duret who was more reserved concerning what appeared to him as unfinished and hasty elements in Manet's pictures, to one in order to render homage to his acuity in reading his pictures and to the other in order to demonstrate the thought at work in the portrait that he painted of him. Zola transposes the gaze of Manet into his novels and his photos. Neither self-consuming nor autistic, neither servants nor masters, painting and photography react to their reciprocal disruption. Their relations are not to be thought in the register of reproduction or imitation but in that of a replication [*une réplique*]. This is a replication that takes the form of a rivalry of emulation on the stage of representation that aims at improvising new forms of existence and new gazes and in the sense of a seismic aftershock [*une réplique*] for which it is less a question of putting up useless resistance than one of capturing the energy of a tremor which reconfigures the cartography of the visible and invites its reinvention.

PHOTOGRAPHY: THE PASSAGE OF THE NEW

The Time of the Inexistent

If we ask what photographs are made out of, at least in the analogical era, etymology offers a preliminary response: photography is the writing or the etching into things by the light that reveals their appearance in black and white or colour. It might be better to call it, as Jean Marie Schaeffer has proposed, a *skiagraphy*. Photography is first the shadows of the little theatre of existence wherein each thing is seized at the moment of its appearing/ disappearing in the revelatory bath which fastens its appearance, via light, on to a sensible support. Even if this moment that constitutes the magic of the dark room somewhat belongs to the past in the era of digital photography, it is no less essential for the interrogation of the immanent sense of the photographic act. The revolution of which this moment was the harbinger is not actually connected with the realization of the old dream of identical reproduction, the achievement of mimesis through an acheiropoietic technology finally freed from the imperfections and distortions of human vision. This is

certainly not the case since one can, to the contrary, see the materialization of this vision in the camera and it is unclear what would be so revolutionary in concluding with a dream as old as the world of Greek antiquity. The novelty of photography was not its exactitude and its flat realism, denounced by Baudelaire, but its evental character of providing testimony; this novelty, as Susan Sontag writes, applies less as a description of what is than as an authentication of what was: 'Photographs show people being so irrefutably there and at a specific age in their lives'.[26] Resemblance augments the indication of the photographed subject's presence, but it does not create this presence; testimony, before being faithful to reality, is faithful to the event of which it was the contemporary. Testimony is less concerned about being exact than about being believable in multiplying the proofs of its presence before the event. In a similar fashion, photography is not faithful to the appearance but to the 'here and now' of appearing. The former treats aspectuality and the visible, while the latter treats the moment and occurrence, that is, time as that which affects the visibility of a change if not the change in itself implied by duration. As such, photography belongs less to the register of documentary writing, with the exception of intentionally taking on this function in service of a descriptive inventory, than to the order of the monument, under the major form of commemoration or the minor form of an everyday souvenir photo. It is within this double aspect of the banalization/democratization of the monument and the banal statement that the entire oeuvre of Christian Boltanski receives inspiration. Although this aspect is part of his work, it is not a frame delimiting a portion of space like a picture but, first and foremost, an immobile slice of time, a freeze-frame. Rembrandt painted himself at different times of his life in an extraordinary series of self-portraits, yet what it shows corresponds more to the stages of life and to the effects of aging, in short to bodily states, than to moments captured from life in the flow of time. As Bazin, Benjamin, Barthes and Sontag, among others, have indicated, photography's material is time: 'The important thing', Barthes writes, 'is that the photograph possesses an evidential force, and that its testimony bears not on the object but on time'.[27] Photography inscribes space into time and puts the subject's present into the past of our gaze. Photography's paradox is to render the past present as it was there even though it is not: 'The reality in a photograph is present to me while I am not present to it; and a world I know, and see, but to which I am nevertheless not present (through no fault of my subjectivity), is a world past'.[28]

The Spectre

Should we not see here, along with Jean-Christophe Bailly, the modernization of the old power of the image to represent the dead and the living in their

absence, celebrated by the legend of Butades? Is photography not similar to the 'live' recording of the luminous shadow of things as I have previously suggested and is not its function that of a *momento mori* [a reminder of death]? I attempted to show in a chapter of a previous book of mine that this was not the case.[29] Without a doubt an inheritor of the power to summon anew those who are absent, photography is nevertheless at the origin of a new affect and testifies to a new relation to images. It suffices for understanding this to revisit Butades's inaugural gesture. What does she do? She traces the outline of the shadow of her lover's face on the wall, she inscribes him into the matter which gives him his consistency; the beloved's face henceforth will live the life of its material. This is the operation of the picture and also the style of artist who painted it, whose materials are always present to the viewer even in the most illusionistic of canvases; the model lives the life of the picture, the life of the colours and the lines animated by the viewer's gaze. This is the extent to which the picture has the function of immortalizing its model and its creator even more so (if they are in fact known). The act of Rembrandt painting his self-portrait is above all *a* Rembrandt, belonging to Rembrandt, that is to say, as a style in representation. An entirely different paradox is offered by the photo. On one hand, the photo incarnates art's nineteenth-century ambition, echoed by good number of literary works, among them Mary Shelly's *Frankenstein* and Oscar Wilde's *A Portrait of Dorian Gray*, for an art which would become life. This is what Walter Benjamin notices, comparing a painted portrait and the photographic work of David Octavius Hill:

> With photography, however, we encounter something new and strange: in Hill's Newhaven fishwife, her eyes cast down in such indolent, seductive modesty, there remains something that goes beyond testimony to the photographer's art, something that cannot be silenced, that fills you with an unruly desire to know what her name was, the woman who was alive there, who even now is still real and will never consent to be wholly absorbed in 'art'.[30]

This art 'searing' with the life of its subject refers back the effect of the photographic cliché's presence and to its material absorbed and volatized in optical transparency; we are no longer essentially in representation, even if something of it still remains, but in presence. On the other hand, the photo immediately testifies to a lost moment; she is there, the little Newhaven fishwife, and at the same time she is not. She is there *and* not there, the impossible view of that which has vanished. Radically new, the chiasm of a world coming and going illustrates 'the profound madness of photography',[31] allowing one to see what is no longer there.

This disturbance of the relation to time does not occur without evoking Freud's discovery and, in a singular fashion, the unconscious reminiscence at

the origin of hysteria. Recall how, in order to furnish an image of the coexistence of the past and present in the space of the unconscious, Freud compares hysteria to the affect that would seize a twentieth-century Londoner passing before *The Monument* which commemorates the great London fire of 1666 and forces them relive the tragedy once again. Yet the survival of the past in the present finds its most literal illustration in photography, the past and present seeing each other mutually conferred with the same coefficient of reality. It is entirely different with the monument whose function is as much to forget as it is to remember, as indicated by the act of commemoration associated with it and the fact of survival properly speaking. A detail in the Freudian comparison ought to nevertheless retain our attention. Distinct from the hysteric grappling with his past, the melancholic Londoner imagined by Freud in no way lived the scene that moves him. Yet this is precisely the new power of photography which returns to the present what was not lived in the past. With its impressive irreal reality effect, the photo brings out a kind of paramnesia or hypermensia, creating a memory and a trans-individual affect. Nevertheless, it is not a dream-like hallucination wherein the consciousness of the irreality of representation is abolished. Its particular mode is that of the spectre, striving to come back to existence without, however, ever arriving there. The spectre is characterized as a being apparition without body, as a simple envelope, the *pellicula*, like a thin skin or a surface.

The Green Room

The coexistence of the past and the present also recalls Bergson's revolutionary thesis regarding the formation of memories [*du souvenir*]. The photo-souvenir, if correctly named, is the perfect illustration of this by way of two of its aspects. One first encounters here the essential idea in Bergsonism of a difference in kind, and not in degree as empirical psychology would have it, a difference between the past and the present, between the memory and the perception: 'There is not merely a difference of degree, but of kind, between perception and recollection'.[32] This signifies that the difference is not of intensity but of quality, the memory as a degraded and weakened present weighing less than the present itself. The past is less characterized by its age, a pale cliché whose figures blur in memory's distant vapour trails, than by its tonality and inalterability. It is an integral and faithful conservator rather than a scrapheap of antiquated relics, and it is relatively sheltered from the solicitations and urgencies of action except whenever it is called in for assistance, offering itself as an image to contemplation and to reverie. If in the present time rushes by without end, in the past it has all the time in the world to idly roam [*flâner*]. This is the same experience that photography proposes. Despite photography's celebrated referential transparency supporting

the illusion of its objectivity, it never gives rise to any confusion between an always moving reality and its immobilized image, but it keeps in reserve a time within the permanent flux of actions and impressions, a stasis for the gaze and for reverie. This virtue largely compensates for Bergson's reproach that photography cuts duration into successive instants, especially whenever it is able to take hold of the 'decisive instant' in which one can see the contraction of living movement into the eloquence of a moment particularly well chosen for evoking its duration.[33]

But the modality itself of the photo-souvenir is nothing other than the putting into practice of the Bergsonian idea according to which the past, and therefore memory, is not formed after the present but, in fact, at the same time as it: 'The formation of memory is never posterior to the formation of perception; it is contemporaneous with it. . . . The more we reflect, the more impossible it is to imagine any way in which the recollection can arise if it is not created step by step with the perception itself'.[34] When Deleuze writes, commenting on Bergson, that 'the past is "contemporaneous" with the present that it has been'[35] is this not the exact description of the apparatus of photographic capture disconnecting the present from itself in order to fabricate it according its own image? And what does the amateur photographer do if not place themselves at the edge of the present in order to arrest and fix its incessant and transient passage? Through this, they free themselves for a short moment from the present and the ongoing action in order to seize the flight of its image and style, which will conserve it, thus responding to the disinterestedness in which Bergson sees the mark of the pure past: 'To call up the past in the form of an image, we must be able to withdraw ourselves from the action of the moment, we must have the power to value the useless'.[36] From the disinterested interest in the being of the past, François Truffaut laid the foundation of a very beautiful film, *The Green Room,* whose title evokes, not by chance, the photographic dark room, with the exception that he rightly intends to return to it a colour of hope and immortality. In this film, we find a man professionally and personally devoted to the cult of the dead (he edits a newspaper's obituary and transforms his deceased wife's room into a photographic sanctuary), preferring the eternity of the dead to the disorderly passage of the living.

Photography, simple photography, one that does not look at any cost for sensationalism, is therefore not a trace or a relic of the present. Rather, it is the present's gesture and its figuration, or in a word, its signature. For Balzac photography was the gait of modern humanity, and for Baudelaire the black dress of the bourgeois and the allure of the beautiful stranger who passes by in the street.[37] With all due respect to those who will have seen in it only the prostitute of banal realism, photography breaths in the moving air of its time the eternal passage of what does not remain and what, under the name of

'novelty', will become the emblem of modernity. The novelty or the becoming visible of what, in order to be without a name, is nevertheless not without image, an image of that which, in order to be fugitive, does not leave any less of an indelible impression: how did Baudelaire not recognize here *La Passante* and the modern tempo of desire?

CINEMA, DISCOVERY

What is a story? It is the space between the characters.

Claude Ollier, *L'Histoire illisible*

Obviously the art of time, cinema might be even more so the art of space, between, yet also around and beyond the characters: 'The cinematographic image can be imaged of all reality save one—the reality of space'.[38] The actual story, what happens on the screen and what is recounted between the screenings, is the cause of this oblivion into which the cinematographic visible ends up vanishing. Written in view of representation, a theatrical play is conceivable without it; but nothing of the sort is possible for cinema for which no detailed narrative will ever serve as a substitute. The theatre's space is a container and a scenery for the action and the relation between the characters. In cinema, space is a character in its own right. The theatre is too human to be distracted by space, as cinema can be whenever it abandons its characters, suspends the action or the dialogue for an unexpected view of an object, a vista overlooking a landscape or even a misplaced look on a face through a gaze belonging to no one and without judgement. It might be a question of false exits, as is the case with shots heavily charged with symbolism destined to over-signify the meaning of the ongoing action. Yet there is an authentic distraction in cinema that is its respiration and its manner of introducing the world by intervals into human relation.

Off-Screen

Space in cinema is never that which is visible on the screen but an invisible space to which it renders us sensible beyond the screen, an overflowing and enveloping space onto which the shot opens, a space of expectation at the edge of visibility. The screen is no more a mirror than a closed scene; it is a stationary or mobile window which like any true window opens on to the exterior world, to a beyond of the frame. We are familiar with André Bazin's famous formula: 'The screen is not a frame like that of a picture but a mask which allows only a part of the action to be seen'.[39] The screen announces what holds itself off-screen in a reserve of visibility. We have

here a possible definition of the space: it is not what holds itself or what we hold before ourselves in the gaze, but what precedes and exceeds itself in each one of its parts; it is at the same time what is there and what is beyond, the visible beyond the visible outside of itself. Cinema demonstrates through example that space is not a simple juxtaposition or contiguity but, according to Merleau-Ponty's designation, an 'encroachment' [*empiètement*]; like the shadow cast by a character that already inscribes their presence in the visible field before their appearance. Space, in this sense, is in the imminence of an appearing/disappearing on the screen. Although imminence is more evocative of the minimal amount of time still separating us from what comes—'its arrival is imminent', 'we expect it from one instant to the other'—the spatial extension is always assumed to be virtually already there. It realizes as much as possible the cinematographic experience of space and its manner of emotionally implicating the viewer.

It is necessary to restate here Bazin's term of the *event* that, in his unique way yet without dissociating it from the time of the action, he surreptitiously evokes in its relation to space. The event is in all likelihood temporal, it occurs and creates a caesura in the narrative; yet we must not forget that it comes from somewhere. The event in cinema is probably this first and foremost: the arrival, not of someone or something, but of space itself being discovered abruptly or progressively before the viewer's eyes, the virtual visible becoming actual. *The Arrival of a Train at Ciotat Station* is already an example of this: the train comes in from elsewhere; but it is necessary to board the train, like the one in Hitchcock's *North by Northwest*, for example, in order to better realize and see the eruption and the march of the landscape with the rhythm of a travelling shot. Beyond the expectation of some event, cinema's foundational emotion is in this donation of space, a bit of space delivered in its pure state awoken by the experience of a discovery. Cinema as discovery: this is what Bazin's revelatory 'mask' magnificently declares.

An example of a shot saturated with space is the beautiful framed shot used in the credits in Robert Altman's last film, *Last Show*. This is a polished image that passes from photographic realism to what filmmakers precisely call 'a discovery', an element of décor simulating an inexistent space. The shot shows the approach of dusk and the fall of night on a hill. We see what looks like a farm, and perhaps also a cistern, a bush and a metal tower that might be used as a relay to a radio station to whose comforting loquacity one might listen against the backdrop of a peaceful evening. Shot from a slightly low angle and hollowed out by a sound that comes from nowhere, the shot overflows with space, that of the starry sky above the hill and that of the ground extending out around it. This shot, listening to the space that

surrounds it, is the quasi-projection of these sentences of Bazin which oppose cinematographic space to theatrical space:

> 'The theater,' says Baudelaire, 'is a crystal chandelier.' If one were called upon to offer in comparison a symbol other than this artificial crystal-like object, brilliant, intricate, and circular, which refracts the light which plays around its center and holds us prisoners of its aureole, *we might say of the cinema that it is the little flashlight of the usher, moving like an uncertain comet across the night of our waking dream, the diffuse space without shape or frontiers that surrounds the screen.*[40]

Everything remaining in the film, its body so to speak, and even its underbelly, will unfold from the old theatre's speakers from which the musical programme heard on the radio is directly broadcast. Making a passage from the outside to the inside, from the immense American prairie to the confined and encumbered space of a musician's dormitory, from the faraway to the extremely close, from disembodied voices to the bodies that incarnate them, the film opens, in a singular instance, the public, anonymous space which is that of cinema. Evidence indicates that Altman did not randomly choose to make a film starting with a kind of theatre, but did so in order to break through its enclosure, explore its space and reveal its flesh-and-blood actors. Even inside this old human theatre, in every sense of the term, the viewer still discovers a vast world of folds and contractions, composite roles, the collision of bodies and lives, made in the image of the interiors of artist's homes in which the accumulation of photos ends up covering over the walls.

The theatre concentrates space around the stage of which it constitutes the centre, the enclosure in which the characters come and go, only ever leaving in order to come back; the exterior, the 'off' space only has meaning [*sens*] in regulating the circulation of characters and assembling their relations. Theatrical space is a geometric and demonstrative apparatus. The division of roles and the distribution of spaces serve a dramatic logic of action, and in the same way as the geometer protracts one of the sides of a figure in order to demonstrate one of its properties, the dramaturge and the stage director project outside of the stage the space required by the necessities of action. If space is what overflows, exceeding place, then the theatre is defined as the place of representation rather than as world space, a recording box in which everything is tangled and untangled, in which everything occurs and takes on meaning in conformation with the organic rules of Aristotelian poetics. To the centripetal locality of the theatre, cinema opposes its centrifuge. Place is here viewed from elsewhere and always casts its gaze elsewhere in relation to a more or less non-localizable exteriority, as in Wim Wender's *Wings of Desire* (*Der Himmel über Berlin*) in which the figure of angels, with their

compassionate gazes, envelope the lost gazes of humanity in Berlin's metro. Even when it repeats the dramatic conventions of the theatre (the unity of action and of place), cinema is virtually without beginning, nor end, nor definite contours, giving the impression of beginning in the middle of things or in the middle of a world that overflows in every direction. The term that best corresponds to this is not representation, as is the case for the theatre, but *sequence*. Cinema deals with sequence shots; it is a question of a shot inserted into the duration and the continuity of an entire shoot without cuts and thus without editing after the fact, for example, in the long sequence shot at the end of Antonioni's *The Passenger*. The closure of representation and its pictorial or theatrical frame is opposed by the sequential principle of cinematographic movement and space, what one could call cinema's spirit of sequence and flight. There is *sequence*, that is to say, the succession of what preceded and what one did not see, and *consequence*, what will follow from this and what one will not see. The sequence shot follows the action in its continuity; the camera is the detective who follows a strange character from elsewhere for a little while, eventually losing sight of them. Cinema is like the act of tailing, a movement that draws close to the Other and endures their attraction. Film noir is *par excellence* the paragon of cinema. Even in the middle of the day, space is always nocturnal and uncertain there, recalling the famous sequences of crop-dusting planes or the auction room in *North by Northwest*. Its function of masking not only operates in virtue of what is off-screen, its exercise also attains the full extent of the visual field as it is transformed into disconcerting strangeness: Hitchcock's assassin crows (*The Birds*) or the killer's rear window (*Rear Window*). The registers of mastery and totality proceeding from the closed system of representation, inscribed between premises and conclusions, tend to be opposed in cinema by the registers of surprise and aleatory sequence.

Reverse Angle

An emblematic scene: we see a band of 'blue coats' escorting a caravan of pioneers moving through the immensity of a landscape untouched of any trace of humanity; an oscillation between tight shots of the vivacity and the organization of the human cohort and panoramic shots of the land extending out of sight: a contraction-dilation. This is what Deleuze calls 'the Encompasser'[41] which opens a space of respiration and transformation to collective action. This is a world of *outlaws*,[42] solitary trappers, outcasts and savages, a world of vast expanses bounded by the sky and earth. Of all the cinematographic genres, it is without a doubt the Western that best dramatizes the natural relation of cinema to space and to the world as an indefinite milieu opening up beyond the human stage. The off-screen of the Western is the space of every

danger: an immensity in which, losing ourselves, we risk unfortunate, poten-
tially mortal encounters with animals and, especially disquieting, run-ins
with the unpredictable Indigenous Americans. This is a question of Nature,
Animality, the Other or, rather, the Others since, compared to the univocal
law of the 'white man', the Indigenous have a diversity of languages and
customs; these are the three figures of fear that camp at the limits of the zone
policed by the law. This is an ambiguous space where innocence and liberty
are easily inverted into savagery and a threat to life; a space to be conquered
in order to submit it to the moral law and to the regime of property necessary
to the farmers and agriculturalists for the harvest of its fruits:

> These immense stretches of prairie, of deserts, of rocks to which the little
> wooden town clings precariously (a primitive amoeba of a civilization), are
> exposed to all manner of possible things. The Indigenous, who lived in this
> world, was incapable of imposing on it man's order. He mastered it only by
> identifying himself with its pagan savagery. The white Christian on the contrary
> is truly the conqueror of a new world. The grass sprouts where his horse has
> passed. He imposes simultaneously his moral and his technical order, the one
> linked to the other and the former guaranteeing the latter.[43]

There is indisputably something to critique in this historical justification of
the myth of the Western, at the very least the chocking assimilation of this
civilization to the culture of the 'white Christian male'. Nevertheless, the
emphasis falls on the difficult reconciliation of a culture of power and of the
domination of nature and human beings with cultures based on an alliance
with nature.

Following an observation of Deleuze,[44] we nevertheless find in the case of
Howard Hawks an interesting inversion between the space of the *township*
and that of the *land*,[45] between a rather menacing outside and a securitized
inside. This reversion in the apprehension of the off-screen space is at the
centre of *The Big Sky*. A Frenchman from Louisiana enters into a contract
with the Blackfeet Tribe of North Dakota's high plateaus in order to engage
in fur trade. In order to avoid being noticed by the company claiming a
monopoly over this market, a market to which the Blackfeet are still not
beholden, he sets out with his assembled team to go up the Mississippi in a
sailboat as means of hauling cargo. In order to speak with his partners, he
relies on a beautiful Indigenous woman whom he is returning to her father,
the chief of the tribe, and about whom the film tells us nothing else. She is
the desired and forbidden treasure that this rough group of men must protect
in order to secure the success of their enterprise. This inverse Western on
the water, without horseback riding on dusty trails nor furious hand-to-hand
combat, makes the city space of New Orleans the menacing site from which
they must escape in a magnificent, nocturnal scene of setting sail veiled in fog

with the muffled voices of the team members speaking multiple languages. The river is the path of liberation in the midst of territories under the thumb of fur-trading companies. This cunning geography offers the image of another relation with nature, no longer one of conquest and appropriation, but of contemplation and pathfinding, in which evasion thwarts confrontation and expropriation. The river is also the unfolding of the earth under the sky, *the big sky*,[46] its opening and its fluidity discovered across enclosures and frontiers, in movement rather than territoriality. It is, moreover, the ascent into the off-screen of American space unfolding across the ancestral homelands of the Indigenous. This is the fiction's return to the violence of history and its process of reparation that seeks to restore dignity to the Other whose culture and humanity have been denied. The slowness, the difficulty and even the impossibility of this enterprise is commensurate with the inflicted wrong that cinema alone, in the utopia of a retro-fiction, is able to correct rather than repair. Howard Hawk's film recreates the territory as the inverse of effective history. It goes up the river of forgetting to its source to produce a different image: that of a timid Indigenous woman who finds, simultaneously along with her tribe, her proud rank of a princess. This is an image of a people who is not merely the object of a colonizing gaze but who can, in the parting scene with their dignity rediscovered, return to their original perspective following a ritual and commercial exchange. This is a mythical scene, a retouched photo no doubt, but one which declares, in this commerce of gazes and in the equality of the cinematographic shot/reverse-angle shot, what the real encounter of the Europeans with the Amerindians would have lacked. In order for another step to be taken in this direction, it would be necessary to wait for Terrence Malick's *The New World* wherein the Indigenous of the East Coast are present for the arrival of the first English ships. The new world of the Promised Land in fact shelters other worlds, other manners of world-making, and the off-screen virtually contains the reverse angle that history, soon to be followed by its cinematographic legend, rushes to neutralize in assigning the gaze of the Other to the closed space of the reservation.

Affected Space

Space in cinema is often reduced to the spirit of places, the metaphysics of the desert (David Lean, *Lawrence of Arabia*), the romanticism of the lake in the pensive shadow of the mountains, the solitude of a land battered by winds, the disquieting strangeness of urban nights (Martin Scorsese, *After Hours*), the banality of neighbourhood life bustling with its familiar murmur, sombre passions drifting off to sleep in the village or in provincial tranquillity (Claude Chabrol); or it is reduced to a milieu that expresses as much as it determines the destiny of its characters, a rural gesture, a proletarian life,

the bourgeois scene, the aristocratic party, the nomadism of oddballs, the world of journalism, fashion or the dance hall. The former falls under a poetic of space and the regime of metaphor, the latter under social realism in the regime of metonymy. The spirit of place diffuses throughout space, in what it illuminates as much as in its context, and it permeates the characters expressing it and interpreting it, acting as the song of the earth that charms and haunts bodies and minds; it is a geography of resemblance that harmonizes places, bodies and disparate social groups. The milieu is moreover a setting that recounts the life of its characters by means of a description of objects and the configuration of places, a silent history that over a long period of time settled down, became ensconced and solidified into a material frame that ends up dominating and regimenting the lives of characters. Although these two approaches to the social and of the landscape to space are indisputably a force in cinema, they do not belong to it properly speaking. We already find them at work, as Jacques Rancière[47] has shown, well ahead of cinema's invention in the procedures of the great nineteenth-century novel, whether in Balzac, Flaubert or Zola. In these conditions, and without at all giving up on thesis regarding the impurity constitutive of cinema, what is it in cinema's treatment of space that belongs to it alone?

As a tentative response, let us examine the film *Rosetta* (1999) by the Dardenne brothers. We are in the realist vein of social chronicling, centred on the precarious life of a young girl on the edge struggling to maintain the course of a normal social existence. The living conditions: a poor trailer park on the outskirts of town—the milieu: an alcoholic mother debaucherously abandoning herself—the conditions of existence: cold, hunger, promiscuity and the incessant search for odd jobs that allow for survival—all of these elements are within the reach of the techniques of the novel, which invented them well before their transmission to cinema. The plot and the moral drama are the stage of a conflict between the bitter and unending struggle for existence and recognition by the Other driving Rosetta to err and betray the boy who alone brings her support, affection and, in all likelihood, love. The ambiguity of this behaviour can be itself read both in the light of a Brechtian parable opposing to the militant idealization of the poor the immortality not of an act but of a condition making morality an impossible luxury, just as it can be read in light of an ethics bestowing dignity upon the poor by not depriving them of their singular responsibility for their own contributions. All of this could still make up the material for a novel or a short story. However, what only occurs in cinema and what the Dardenne brothers' film shows is the character's relation with space, the manner of inhabiting it and moving oneself through it, their negotiation of obstacles, their proper movement with its speed and its rhythms, in short, their manner of 'being in space, of being for space'.[48]

Cinema alone renders space lived, the hodological space of phenomenology in opposition to the abstract and homogeneous space of geometry which is constructed and projected by a singular living being in order to resolve the problems that she confronts. The shoulder camera and tight shots following Rosetta indicate precisely this; what we could see as a simple procedure is nothing other than the putting into action of the young girl's field of vision and her preoccupation; the struggle for survival, the incessant urgency, the extreme solitude and the impossible abandon, the dangers and obstacles to avoid, the absence of visibility beyond the narrowest range and the most proximal space which makes her like an animal backed into a corner on its guard, all of this finds its most appropriate expression in this film. Rosetta dwells in space only to the extent that she trustingly moves through it according to paths determined in advance. She poses herself without ever resting, lets her exhausted body collapse like a momentarily useless heap, cuts across streets and pathways, avoids doors and passes under metal fences. She 'traces' and carries her space along with her, a hard block thrown like a projectile through a social space that is nothing less than a minefield and a hunting ground. With a contraction of space deprived of the off-screen and the Other's reverse angle shot and with a body folded into itself, impermeable to emotion and the Other's contact, Rosetta's life is deprived of a world, a world to which she could, as unlikely as it is, abandon herself.

Concerning French filmmakers, Eric Rohmer is among those who insisted adamantly on cinema as 'art of space',[49] notably bringing attention to the essential role of space in comic films. Comparing the worlds of Charlie Chaplin and Buster Keaton, each haunted by the theme of solitude, he astutely points out the difference in the relation to space of which they are both the expression:

> Solitude for Chaplin, even specially translated by the famous images of *Circus* and *Gold Rush*, is ever only that of the human being in an indifferent society, whereas the isolation of beings and objects appears for Buster Keaton as the nature itself of space; isolation expressed in particular by the theme of a coming and going movement—everything being 'referred' continually to the self—by brutal falls, prostrating spills onto the ground, and the clumsy grabbing of objects that slip away or break, as if the exterior world in its very essence were unsuited for being 'grabbed'.[50]

Chaplin's world remains fundamentally human in its lack of humanity and Charlie's problem does not pertain to the objects that he often demonstrates a stupefying virtuosity in handling, including his famous cane. His problem is with the inhospitality of a society that constrains him to order shoe soles as appetizing sandwiches; inhuman, his world is nevertheless not dehumanized. His laughter is proof of this, being the laughter of revenge. With Buster

Keaton, we are on the side of a humanization of nature through laws and human industry; his world is less inhuman or dehumanized than infra-human or a-human. Eric Rohmer's term, isolation rather than solitude, says it well: this is the human being's isolation relative to the things eluding their grasp, or the isolation of things in relation to each other, in a world where things communicate with each other and, concerning humanity, come to replace a space of incommensurability and separation in which catastrophes are the rule of the day and the adjustment between humans and things is always miraculous. This world is evasive such that human beings can never place it in front of them in order to fashion from it an object of their labour and of their acumen, a world of indifference and apathy. Buster can do no better than whenever he renounces all will power in order to insert himself, as thing among other things, into the dynamic of a material flux, into a pre-existing wave—the tornado in *Steamboat Bill, Jr.*, the locomotive in *The General* or the rockslide in *Seven Chances*—and draw from it the energy for his extraordinary velocity. Buster Keaton is the first surfer in history. Rejecting planning and decision, his world is that the occurrence and the abandon to pure movement for itself, a world in which the problem to solve is not, as it is for Chaplin, that of injustice but that of exactitude [*la justesse*] and adjustment [*l'ajustement*] to the course of things.

The work of Jacques Tati proposes another comic variation of the relation to space. *My Uncle* juxtaposes two spaces that do not meet, the space of the consumerist modernity of the sixties represented by the parent's villa and the father's factory, the reign of domestic and industrial automatons and the space, inhabited by the uncle, of a more traditional way of life characterized by odd jobs and handicraft. The former is imported from the American 'New World' into the modernizing conjuncture of France's *trente glorieuses*,[51] and the latter is inherited from the long history of 'old Europe'. This is an opposition between an organized, functional and automated space, one that Jean Baudrillard has shown to obey the ideal of productive order even within the domestic sphere of consumption,[52] and a disconcerting space of irrationality exemplified by the hilarious ascent up the stairs of the uncle's building. This is a juxtaposition of a space without repose or history enchanted by humanity's harmonious adaptation to its milieu in which, just like the advertisement of the time, objects obey the user's every word, with a cobbled-together space made from detours and nooks without any immediately legible utility, a juxtaposition of a 'clean'[53] ambiance without conflicts, only experiencing problems pertaining to operating instructions, with a diffuse atmosphere of incomprehensible habits. This is a juxtaposition, finally, of the transparency of a world of signs with the opacity of a world of experience. 'Everything communicates!' the mother is delighted to bring the 'latest fashion' to her villa; for her this interjection condenses the rift between the functional habitation of space and her 'poetic' dwelling. She proclaims the integral

visibility and functionality of every relation between places, people and objects, including utterly useless gadgets. Submitted to the practical imperative of utility and the commodity, the functional milieu programmed by technical discourse is ignorant of interstices, ruptures, layering, spaces of play and loss. This milieu detests downtime and useless gestures, and it reduces speech to its social function.

Yet Tati goes beyond the opposition between the abstract social space of the great modern cybernetic machine and the human space of the old neighbourhood by interposing between these two a poorly defined and disaffected space, a vague, uneven terrain that is used at once as a shortcut for children circulating between the modern bourgeois neighbourhood and the more popular old quarter, as a playground for these children and as zone free from errant dogs.

This interstitial space cuts into the other two. It is not a specific milieu with its own rules of occupancy and circulation but a nomad space open to the freedom of movement and to the social mixing of encounters which does not exclude occasional violence. Moreover, it is hardly seen on the screen as if Tati had attempted to create a reserve of invisibility; an off-screen on the screen of which we only discovers the edges whenever the children take refuge there or appear *en masse* in order to irritate the adults with various naughty tricks. This frank and indistinct zone, the domain of the children and the dogs, constitutes the heart of the film. It is this space that reveals itself beneath the town's checkered space, with its juxtaposition of different neighbourhoods with their social types, their particular codes and specific comedies. Seriousness and aloofness are claimed by one and gentlemanly nonchalance by the other, yet there is another space, a wild space before and after humanity that envelopes in a breakaway shot the old neighbourhood, still sleeping and overrun by dogs, with an infinite sadness.

Hence Tati's film has four styles of relating to space with quite different movements and speeds. There is the functional style of the bourgeois modernists who toys with beings; each movement, each word is assumed to be appropriated and measured reactions to a situation that governs them. We could also speak of a behaviouristic style. This is the nonchalant style of the uncle and his friends of the old neighbourhood, characterized by gestural rhetoric and the proliferation of postural and speaking figures. There is the swarming style of the children punctuated by cries and sustained accelerations. Finally, there is the erratic style of the dogs with their unchartable and bifurcatory trajectories.

The Body Screen

There is no cinema without actors, and an actor is first and foremost a body. The bodies of actors is the subject of cinema. But what is a body in cinema?

What is a body on the screen? The great comic geniuses just evoked, Chaplin, Keaton, Tati are across all of their films forever associated with their bodies, their postures and silhouettes, being the veritable visual signature of their presence on screen and in our minds. To name them is to make them immediately appear according to their branded image. But it is necessary to recognize that the comic actor's body tends towards perceptible abstraction in the purity of their silhouette that can be reduced, for example, in the case of Tati, to a tall fellow with pants that are too short, a pipe stuck into the right side of his mouth and a little hat; it is what he carries with himself that we always recognize. The comic actor incarnates a type more than he plays a character; yet a type is a stylized body to the extreme whose manner of being and mode appearance on screen always conform to what is implicated by their type. As a type Charlie appears above all through his resemblance to himself in a given film or situation, from which there are a series of Charlies, *The Bank, The Immigrant, Modern Times* and so forth, in which his invariant character serves to reveal different situations. If the comic actor is not the best example for responding to the question of the body on screen, it is because their bodies coincide too much with their images to teach us something that we do not already know.

In the theatre the body is also present, in a sense it is even more present than in cinema since the actors are in the same space as us to a certain extent, provided that we abstract from the convention separating the stage from the audience. A fire in the theatre, for example, would have an effect as bothersome for the actors as it would for the spectators. Nevertheless, the modes of presence of the body in the theatre and in cinema are not at all similar for several reasons. The first reason, taken freely from Stanley Cavell who lingers for quite some time over this question, is that the relation of the actor with the character is inverted: 'For the stage, an actor works himself into a role; for the screen, a performer takes the role onto himself'.[54] In the theatre, the character pre-exists the interpretation and it is the actor's responsibility to incarnate him or her, that is to say, essentially to put their body and their expressivity in service of the character in order to produce the typical traits before the spectators. There is no absolute need for them to possess the role's physique, if, at the very least, they know how to assume the posture of the character's body, literally giving it and attributing to it the appearances that will make their characteristics and their relation to the world sensible. In a theatre troupe, there are certainly specializations, but they nevertheless belong more to the type of performance that the actor has mastered than to his or her physique. In Aristotelian vocabulary, we would say that the theatre proposes a 'type', that is to say, a model and a generous patron with its own logic, one that the actor is responsible for particularizing via an exemplary incarnation. The theatrical actor's register is that of representation and the

exploration of the role. They will either play such a role well or poorly, either making it more profound or revealing its particular aspects without the role ever being confused with the actual actor.

In discussing types in cinema, it is necessary to understand them in the popular sense, inverse with respect to scholarly acceptation: a type is no longer a characteristic generality but a singular individual. For example, there is Arletty who, like no other, says, 'Atmosphere, atmosphere, do I look like a damn atmosphere?'.[55] She does not understand at all how to vanish into the crowd. It is significant that in this legendary scene we retain from the character only the actress who plays her. The actor is the type and her work consists, following Stanley Cavell's observations, in adapting the character to her manner of being. In the theatre the actor must produce the body which will appear in the garb of character, and in the cinema the actor retailors this garb so that it fits them; in the former case, the actor is devoured by the role, in the latter the actor vampirizes the role itself. We hence observe the essential role of the actor's body whose presence and manner of being have a directly expressive import. The actor's body in question here is not, of course, their concrete body, not their 'flesh and blood' but their image projected on the screen. This explains the necessity of casting in cinema in view of evaluating the potentialities of the projection of the actor's body and the practice, much more frequent in cinema than in theatre, of writing roles in accordance with the style of actors. In cinema, it is not even necessary to be an actor for this to be the case; it suffices that the body projects a character's density and the possibility of a story. The drama in the theatre seeks an incarnation and the actor aspires to create this in their role. In cinema, it is the inverse: a singular body calls forth the space and the story that will recount it.

What is a body on the screen? First, it is what makes a screen out of light, a rather sombre and dense smudge, a mute mass that carries the weight of sentiments and the passage of emotions, a seismograph of imperceptible movements, here a tension or stiffening and there a relaxation, an abandon or even a distraction, a flight. Next, a silhouette arises, that is to say a writing, a style that signs a manner of being into a singular space, a manner of taking possession, of furtively sliding into place or even of therein making oneself visible; this is ease, elegance, discretion, restraint, importance, presumptuousness or so many other different styles. Finally, there is an energy, a potential for action and a quality of movement which follows: softness, slowness, violence, rapidity, prudence, nervousness and so forth.

Jean-Paul Belmondo and Jean Seberg in Jean-Luc Godard's *Breathless* exist as the attraction-repulsion of two contraries. The film constantly borrows from American film noir with its legendary fetishes—huge limos, Ray-Bans, ball caps, the posters in front of the movies, photographs of Humphrey Bogart—and even in its form borrows from the American 'road movie'

genre; Paris itself is filmed in an American style with quick travelling shots in which Parisian touristic symbols rush past: the Eiffel Tower, the Arc de Triomphe, the Grands Bouvelards, the Champs Elysées. Regarding this film, Godard said that it was a story without a thesis [*un sujet*] until he became interested in Belmondo: '*A Bout de Souffle* [*Breathless*] is a story, not a thesis. . . . I was looking for the theme right through the shooting, and finally became interested in Belmondo. I saw him as a sort of bloc to be filmed to discover what lay inside'.[56] What is important in this film is not the (intentionally) conventional story with its excess of clichés culminating in the finale sequence with the death of the bad boy; Belmondo overacts the gangster role in the casual style of an American star at ease in every situation. In this cinema that imitates cinema, where people are from the outset characters and roles and adventure is the obligatory law of a genre, Deleuze notes that the predilection for 'making false' and the cliché are at the service of a new realism,[57] one that finds a truthful inflection in falsifying the codes of cinematographic representation. An example of this would be the applied and forced grimaces that Belmondo makes at Jean Seberg when he is about to die. But if we do not believe in Michel Poiccard as a gangster character, how are we not to believe, by way of contrast, that the actor Belmondo is constantly justified in his way of playing on the false? Godard no longer believes in characters but he believes in actors to the extent that he brings truth to the screen through their presence. The character becomes a pretext to hunt down a truth that is no longer spoken in drama or intrigues, nor in the way in which drama is put to the test of a thesis, whether love, jealousy, death, betrayal and so forth, but passes through the un-said and the sidelines of the story, in the delivery of a speech, the phrasing of a voice, in the singularity of a gesture, a posture or a movement, in everything that the body shows without putting it into words. Belmondo no longer incarnates a character, he brings a manner of being to the modern world without having a story to tell and without a plan. It is an unemployed, definite body that invents itself little by little as situations are encountered. The reason for which he represents modernity so well is linked to his aptitude in always being an actor in an arbitrary situation not of his choosing who finds the movement and the reply [*la réplique*] suitable to responding to manifestly absurd circumstances, and who, contrary to Anna Karina in *Pierrot le Fou*, always knows what to do and what to say in a world deprived of necessity. Yet appropriating for oneself a necessity that does not exist, that of proudly being and existing despite everything, is audacity strictly speaking and it is this that Belmondo brings magnificently to the screen.

Faced with the Belmondo 'bloc', we see a gracious Jean Seberg with her shifting moods like a kind of elastic ball prone to bounce around unpredictably. 'You are a coward', 'I am stupid', 'That's disgusting'; against Belmondo's cutting and decided audacity, she continually opposes the echo and

suspense of a question: 'What is *dingue*?', 'what is *dégueulasse*?' or even a veil of doubt: '*je ne sais pas*'. He is the world, if only one of clichés wherein film noir heroes operate. She is the mirror where he is ruined in the uncertainty of his reflections, where the sharpness of action comes to lose itself in the opacity of words. Through his fashion of filming them and staging them, most notably in the long sequence in Patricia (Jean Seberg)'s apartment, Godard plays on the contrast between the physical styles of the two actors, between Belmondo's nervous and athletic body and Seberg's delicate curves, between frenetic movement and melancholic reverie, between action cinema and a pensive portrait in the style of Renoir. The dissymmetry between masculine and feminine, and the charm of their contrariety, comes to be joined to the anamorphosis of a world undone in its reflections and its burlesque echoes.

NOTES

1. Louis Marin, *Des Pouvoirs de l'image* (Paris: Seuil, 1993), 18.
2. Maurice Denis, 'Définition du néo-traditionalisme', in *Théories* (Paris: Hermann, Miroirs de l'art, 1964), 33.
3. E. H. Gombrich, *Art and Illusion: A Study in the Psychology of Pictorial Representation* (Princeton: Princeton University Press, 2000), 279.
4. Georges Bataille, *Manet*, trans. Austryn Wainhouse and James Emmons (New York: Skira, 1983), 50. Translation modified.
5. This comes from an article of Zola that appeared in *La Revue du XIX siècle* cited by Dominique Fernandez. Dominique Fernandez, *Le Musée d'Emile Zola* (Paris: Stock, 1997), 95.
6. Fernandez, *Le Musée*, 95.
7. Bataille, *Manet*, 71.
8. André Malraux, *Le Musée Imaginaire* (Paris: Gallimard, 1965), 51.
9. Richard Wollheim, *Art and Its Objects* (Cambridge: Cambridge University Press, 2015), 142.
10. Wollheim, *Art and Its Objects*, 145.
11. Anton Ehrenzweig, *The Hidden Order of Art* (Berkley: University of California Press, 1969), 21–22.
12. See *L'aventure de l'art au XIXe siècle*, ed. Jean Louis Ferrier (Paris: Chêne/Hachette, 1991), 429.
13. George Mauner, 'Manet et la vie silencieuse de la nature morte', in *Manet, les natures mortes* (Paris: La Martinière/Réunion des Musées Nationaux, 2001), 37–38.
14. Bataille, *Manet*, 51.
15. Thierry de Duve, 'I Want to Be a Machine', *La Recherche Photographique*, no. special (1989), 14.
16. Michel Foucault, *Manet and the Object of Painting*, trans. Matthew Barr (New York: Tate, 2009), 79.

17. Foucault, *Manet*, 68.

18. Foucault, *Manet*, 70.

19. Fernandez, *Le Musée*, 95.

20. Fernandez, *Le Musée*, 30.

21. Fernandez, *Le Musée*, 232–34.

22. Michael Fried, *Absorption and Theatricality: Painting and Beholder in the Age of Diderot* (Chicago: University of Chicago Press, 1980).

23. Fernandez, *Le Musée*, 31.

24. Émile Zola, *The Masterpiece*, trans. Thomas Walton (London: Elek Books, 1957), 45.

25. See Henri Loyette, 'Manet, La Nouvelle Peinture, La nature morte', in *Manet, les natures mortes*, 15–18.

26. Susan Sontag, *On Photography* (New York: Rosetta Books, 2005), 54–55.

27. Roland Barthes, *Camera Lucida*, trans. Richard Howard (New York: Hill and Wang, 2010), 88–89.

28. Stanley Cavell, *The World Viewed: Reflections on the Ontology of Film* (Cambridge: Harvard University Press, 1979), 23.

29. If I may refer you to my book: *La Peinture et l'image*, 'Photographie et peinture' (Nantes: Pleins Feux, 2002).

30. Walter Benjamin, 'Little History of Photography', in *Walter Benjamin: Selected Writings Vol. 2, Part 2, 1931–1934*, trans. Edmund Jepcott and Kingsley Shorter (Cambridge: Belknap/Harvard University Press, 1999), 510.

31. Barthes, *Camera Lucida*, 13.

32. Henri Bergson, *Matter and Memory*, trans. Nancy Margaret Paul and W. Scott Palmer (New York: Zone Books, 1991), 236.

33. The notion of the decisive instant was forged by Henri Cartier-Bresson in order to account for his practice in the preface that he wrote for his first of photographs. See Henri Cartier-Bresson, *Images à la Sauvette* (Paris: Verve, 1952), 53–55.

34. Henri Bergson, *Key Writings*, ed. Keith Ansell Pearson and John Mullarkey (New York: Continuum, 2002), 144–45.

35. Gilles Deleuze, *Bergonsism*, trans. Hugh Tomlinson and Barbara Habberjam (New York: Zone Books, 1991), 58.

36. Bergson, *Matter and Memory*, 82–83.

37. Honoré de Balzac, *Théorie de la démarche* (Paris: Pandora Editions, 1978).

38. André Bazin, *What Is Cinema? Volume 1*, trans. Hugh Gray (Berkeley: University of California Press, 2005), 108.

39. Bazin, *What Is Cinema? Vol 1*, 105.

40. Bazin, *What Is Cinema? Vol 1*, 107. Vauday's emphasis.

41. Gilles Deleuze, *Cinema 1: The Movement-Image*, trans. Hugh Tomlinson and Barbara Habberjam (Minneapolis: University of Minnesota Press, 2013), 141.

42. Vauday employs English in the original. [TR]

43. André Bazin, *What Is Cinema? Volume 2*, trans. Hugh Gray (Berkeley: University of California Press, 2005), 145. Translation modified.

44. Deleuze, *Cinema 1*, 160.

45. In English in the original. [TR]

46. In English in the original. [TR]

47. Jacques Rancière, 'Two Forms of Mute Speech', in *The Aesthetic Unconscious*, trans. Debra Keates and James Swenson (Malden: Polity, 2010), 31.

48. Gilles Deleuze and Felix Guattari, *A Thousand Plateaus: Capitalism and Schizophrenia: Volume 2*, trans. Brian Massumi (Minneapolis: University of Minnesota Press, 2005), 482.

49. Eric Rohmer, 'Le Cinéma, art de l'espace', *La Revue du Cinéma* (June 1948), 14.

50. Rohmer, 'Le Cinéma', 30–31.

51. The expression *trente glorieuses* refers to the thirty years of prosperity in France following the end of World War II. Since a translation would not make sense in English, I have left it in the original French. [TR]

52. Jean Baudrillard, *The Consumer Society: Myths and Structures*, trans. J.P. Mayer (London: Sage Publications, 1999). One should especially refer to the section 'Playtime or the Parody of Services' whose title explicitly references Tati.

53. Vauday employs English in the original.

54. Cavell, *The World Viewed*, 27.

55. This is an approximate translation of the famous line 'Atmosphere, atmosphere, est-ce que j'ai une gueule d'atmosphere?' in Carné's film *Hotel du Nord*—the singular way in which the actress, Arletty née Léonie Bathiat, exemplifies, among other things, the Parisian dialect of the time.

56. Jean-Luc Godard, *Godard on Godard*, trans. Tom Milne (New York: Da Capo Press, 1972), 175–77.

57. Deleuze shows quite aptly the predilection for cliché in this period of Godard's cinema: 'Making-false becomes the sign of a new realism, in opposition to the making-true of the old'. (Deleuze, *Cinema 1*, 213).

Chapter 4

Politics: Unmaking and Remaking Images

THE CONTEMPORARY ICONOCLASM

Within two different yet perfectly attuned registers, the dominant tone concerning images is one of iconoclastic imprecation. The first register is that of the choir perpetually singing in a low voice the catastrophist litany of the flood of mediatized images or other types, of the subversion of the mind by their incessant flux and of the proliferation of stupidity that follows, since it is well known that images do not think and are made to paralyse thought and incapacitate judgement. In this heightened state of ecological alarm sounded for the safety of spirituality, the theme of flux does not appear by chance. It connotes at least three things: (1) the irresistible force that carries away any inclination towards reflexive stability or remaining at a distance, (2) the saturating occupation of the mind which is not able to idly wander in order to gather other impressions any more than it can apply itself to other objects and (3) the reign of emotional intensity at the expense of conceptual distinctions. There is a triple danger: (1) the flux blocks the freeze-frame [*l'arrêt sur image*] that would allow for the image's transformation into a stable object of reflection. (2) This closes the field of sensibility to the synthesis of the diverse and the heterogeneous. (3) Finally, this movement anesthetizes our faculty of judgement. The second register of iconoclasm assumes the form of the soloist voice of the great imprecator who identifies within the multiform and proliferating multiplicity of images the invariable figure of the hatred of language, its refined categorizations, its regulated interconnections and its well-ordered hierarchies, all of which becomes drowned in the indistinction of the flux. Behind images, behind their apparent diversity and beneath their heterogeneity, it would be necessary to see the critical operation of the Image that stultifies all thoughts. If the ecologists of the mind call for a regulation of

images, for example, being against advertising images but in favour of educational images, then the iconoclastic theologians demand a pure and simple censure on the grounds that images alienate the mind.

Raised to the level of an idol of modern times even by its critics, the reign of the Image is denounced as the cultural decline of the masses who lack an exceptional character, being a product of the democratic levelling down of minds and tastes, the hardly concealed expression within the intellectual order of the dictatorship of the commodity and of the laws of the market. Jean Baudrillard has brilliantly illustrated this activity in order to show within such a reign the counterfeits and the simulacra which substitute for the experience of use value and the enjoyment of things the abstract consumption of signs for which images become the universal language. Absorbed by the images of their advertisement, things dematerialize in order to become pure trompe l'œil surfaces subject to the rhetoric of appearances. We no longer eat the vulgar and solid food of yesteryear; gone are the cracked and swelling tomatoes, the poorly peeled potatoes and speckled fruits. Henceforth we consume what is smooth, neutral and calibrated, seduced by the immaterial flash of things on glossy pages or in the depths of digitized screens. And only the materiality and texture of the world remains to bear the consequences of this spectacularization. Yet it is language itself which loses its meaning under the totalitarian reign of the simulacrum in becoming slogans. The slogan is what happens to speech captured by the image, its symbolic death under the fixed form of an order-word [*un mot d'ordre*]. It is not made to create meaning, provoke a response, draw out a discussion or set a narrative into motion. Short, easy to memorize to the point of being haunting, the slogan is not destined to be understood but recognized and tirelessly repeated in its uninterrupted sonorous identity. This is, in the order of language, the equivalent, at least for certain individuals, of the photographic image the reification and petrification of life frozen in its movement by the mechanical capture of the camera. Like the image, the slogan is given as an undecomposable and unanalysable being which submits its receiver to sonorous capture, to its passion that never minces words.

REGIMES OF THE IMAGE

What the trial against images upholds as evidence nevertheless cannot be taken for granted. What is in question is the idea itself of a reign, albeit usurped, of images, that of a government through images, an *iconocracy*,[1] following a term of Marie José Mondzain, which draws its force from the veneration of icons. I borrow from Patrice Loraux[2] the idea that a reign implies a homogeneous and undistributed power, the domination of a unique principle

that communicates to every member and every organ which depends on it. It is thus the solitary reign of the One, of the monarch whose reign historically bears its name; 'In the name of the king', this formula asserts that there is no other power than the unlimited, incomparable and incommensurable power of the monarch. A reign of images would thus be understood as a pure and undistributed reign of the image drawing its power from the singular virtues of iconicity. Yet, not any more today than in the past, images have never reigned without distribution [*sans partage*] or without being shared [*sans être partagées*]. They always have to work with other forces and in other registers which decide on their value and their effects. If the idea of a reign of images can be contested, it is from the fact that the inexistence of a pure power of the image disarms and invests itself into the subjects by the very stultification exerted upon them.

This is not to say inversely that images are deprived of their own power and that they would be beholden to their effects only in the discourses and apparatuses that stage them. In other words, such a power is never, as it is more or less imagined to be regarding the tyrant, solitary and absolute. 'The queen' who reigns is not, according to Baudelaire, the image, but a faculty of the imagination which plays its role for the subject and for the power of producing images that finds its underside in a capacity for enduring the subjection to them. There is no tyranny of images because there is no acheiropoietic image which has not been itself created, one way or the other, by human beings, if not by the gaze to which Duchamp would end up reducing art. There is nevertheless a virtue proper to the image that consists in putting into view, in showing or 'rendering visible' to reprise Klee's timeless formula. Marie-José Mondzain thus writes: 'The image is not a sign among others; it has a specific power: to make visible and to show forms, spaces, and bodies that it offers to the gaze'.[3] The image does not reproduce the visible; it produces and configures the visible. The image is not the reflection of a pre-given world but the mediation between the human being and the chaos that allows her to shape a world given over to experience and a diversity of interpretations. I have more difficulty following Marie-José Mondzain whenever she relates the visible of the image to an invisible transcendence that the image would incarnate, a divine Supreme Being withdrawing from all manifestation. This is why, in order to resolve the term's ambiguity, I prefer to replace the term *visible* with *visibility*, offering the double advantage of not referring to an ontology but to an archaeology of the modes of the organization of the visible and of not making the invisible into the transcendent cause of the visible but rather its immanent effect. If visibility is an artefactual configuration of the visible, it consequently produces an invisibility, exactly as light creates a shadow. It is no longer a question of a withdrawal outside of the visible but of a reserve, of a space devoted to invisibility at the very heart of visible space.

Against the inconsistent idea of a reign of the image that presupposes an Omnipresent Image or an Image of Everything, we will set in opposition the idea of regimes of images, borrowed from Jacques Rancière. Within the framework of the European history of art, Rancière notably distinguishes the representative regime inherited from Greek Antiquity from the aesthetic regime linked to the modern conjuncture of the arts.[4] Once again, I borrow Patrice Loraux's essential remark: 'The reign is solitary even though, by definition, a regime is a differential. One regime always deviates from another into which it feeds while still repelling it'.[5] We should understand this in the political, mechanical or indeed dietetic[6] sense: a regime in effect defines itself by a scale of differential relations between different institutional powers in the political case, between the relations in a gear shift in the case of a car motor and between modes of alimentation in a diet. The indifferentiation and absolutism of the reign is opposed by the regime's internal and external differential, internal through the definite relation, for example, between the executive, the legislative and the judicial branches, and external through the comparison of different types of political regimes by Aristotle or Montesquieu. If the characteristic of the reign is to be homogenous, without relation and without an outside, then it is in the nature of the regime to establish relations between heterogeneities and alterities. The former is the affair of an exclusive domination *over* subjects and territories; the latter is functionality *between* disparate elements. This is why politics only effectively begins with the regime, because it is solely the regime that poses itself the question of the invention of a commensurability between powers, classes and finely differentiated activities.

What is the connection with images? Images derive from a regime in the sense that they are not self-sufficient, and they draw on other registers according to variable relations. Endowed with their own power of making visible and of exposition which convokes and provokes the gaze, they show without saying, at least not always, what they show; showing that they show, they are at first silent concerning that to which they expose us. As Marie José Mondzain remarks, the image does not speak from out of itself and does not immediately make sense except in deciding upon the univocal intention of communication: 'As an image, it shows nothing. If it consciously shows something, it communicates and no longer shows its real nature, that is, the expectation of a gaze'.[7] To offer up a striking image of the speed of the TGV (French high-speed train),[8] an advertisement displays what is supposed to be a photograph of the landscape taken while the train was moving at high velocity. Naturally, we see nothing but a kind of abstract picture in blurry bands of colour. It is probably a question of exalting the speed of the TGV in showing how it challenges the rapidity of the camera's shutter, an indispensable condition for obtaining a clean and identifiable photo. Although the image is

reduced here to a message without the shadow of equivocation, I would not dispute its character of being an image, even if we agree that it is most likely nothing but the digital simulation of photography. However, it interests me because it indicates a decision concerning the difference between a successful and an unsuccessful photo. Not only is a photo [*un cliché*] showing nothing recognizable not a photo, meaning that an image must belong to the image *of* something, but what escapes identification and legibility is itself nothing real. Advertisement thus decides doubly on what the image and the real must be. Here is the first regime of the image in which a message prescribes the gaze. It nevertheless does not follow that the idea of a pure image, proceeding by way of self-revelation, makes sense.

In the preceding example, in order to give us an indication of the two senses of the term *cliché*,[9] I very vaguely evoked an abstract picture; without considering that it probably concerns a photograph [*un cliché*] here as well, I want to insist on the fact that I had to appeal to a comparison, a valorizing one to my mind, in order to envisage the possibility that what is generally considered failed photography can become authentic. In the same way that, according to Jacques Rancière, 'there is no art without the gaze that sees it as art',[10] there are no images that are distinguished as such. This means three things. (1) The first is that photography is not separable from painting and that it benefits from the illumination of pictures that instruct us to look at abstract landscapes in which what counts is not the reproduction of appearances but the production of a sensation through the distribution of lines, densities and material intensity—Cézanne, De Staël, Gerhart Richter and so forth. (2) The second is that words are necessary not in view of an imposition of meaning but in view of a raising-up of the image that will assure its existence and its consistency for the gaze and will provide for its supervision by way of an exception to the ordinary use of things. To regard a photograph of the type that has just been described implies at once a decision not about the being of the image but about the becoming of an image. We will assert that one realism is as good as another, and if such a photograph fails to create the image of a landscape pulverized into a colourful nebula, then it succeeds at least in creating an image of speed. We could even argue for its aesthetic value which unveils a new spectrographic vision liberated from picturesque anecdote and reduced to its essential elements, as it is not rare today to see examples of this in video art.[11] (3) The third is that the exposition value of an image is a function of its distance from other images that come before it and that contribute to the formatting of the gaze. The apparatuses of staging images produce an order of the visible and a police of the gaze, having the effect of legitimating and naturalizing a vision at the expense of other possibilities whose actualization in fact depends on singular and unpredictable displacements effectuated by art.

We thus have three components of a regime of the image, that is to say, three types of relation or regulation between different functions. (1) First, there is the regulation concerning the types of image placed into relation, for example, the pictorial, the photographic, the filmic, the videographic and animated cartoons. This regulation sets to work the differential of images and the arts and, more generally, other diverse modes of iconicity. (2) Next, there is the regime that puts the relation between language and image into play, along a continuum that does not efface their difference, such that there would neither be a possible reduction of one to the other nor exclusion through the sufficiency of one to the other. This implies, even in communication, advertisements or propaganda, the impossibility of an integral reabsorption of the image into words or inversely the reabsorption of language into images. There is an incommensurability between two registers that simultaneously galvanize and exceed one another, in the same sense that Foucault speaks of a fecund incompatibility between language and painting:

> The relation of language to painting is an infinite relation. It is not that words are imperfect, or that, when confronted by the visible, they prove insuperably inadequate. Neither can be reduced to the other's terms. . . . But if one wishes to keep the relation of language to vision open, if one wishes to treat their incompatibility as a starting-point for speech instead of as an obstacle to be avoided, so as to stay as close as possible to both, then one must erase those proper names and preserve the infinity of the task.[12]

(3) Finally there is the regulation, much closer to a deregulation, which opens up to the regime of the exceptional status of art. This translates as the triggering of crisis and reconfigurations of the established order of the visible. Hence, there are three functions: (1) a function of interpretation between the diverse types of images that play on their interpretations, influences, borrowings and also their specific differences. (2) There is a function which inscribes images into the field of sensibility and into the directionality of the gaze [*de sens du regard*]. (3) There is a critical function, deriving specifically from art, which produces and qualifies the ruptures and caesuras which make the production of images and visibilities into an event.

COUNTER-IMAGE

If a politics of images is possible, then there exists neither a reign nor a world of images against which resistance would impose itself. We must always deal with complex montages of images, discourses and practices. The public circulation of images presupposes legitimate discourses and practices which decide on the value and the meaning of images. There is a tendency towards

'celebrity culture' in the media characterized by the obscene exhibition of individuals and private lives in which one generally witnesses the deleterious effect of televisual imperialism, occurring as much through a social practice of language as through the exposition of an image. The overexposure of celebrities or anonymous individuals is not conceivable without the proper names that accompany them, without the effects of recognition and identification being put into play, without the speech patterns and behaviours that stage them. What does indeed exist are imposed, prescribed, authoritarian montages that censure others and impoverish in the very same instant the field of sensibility and experimental perspectives. So the question is no longer that of a choice between iconoclasm and iconophilia, the confrontation between the bad reign of images and the good government of words; it is rather a question of the invention of deregulations and the disarticulation of authoritarian montages. It concerns a free practice of montage capable of restoring play to images and liberty to those who create and regard them. It is not a question of being for or against images but the opposition between two regimes of the image, a regime of prescription that orders the gaze and a regime of disruption that liberates it by opposing a counter-image to dominant images.

The modernist iconoclasm is largely in solidarity with the idea of a naturally alienating image that captivates the subject in order to submit her to the passivity of appearances and to force her into rigid identifications. The result is that the arts, primarily painting, must become aniconic through a refusal of all referential or illustrative transitivity that is susceptible to surrendering them to the ideological servitude of the commodity. It follows that there arises a formalist theoretical discourse on painting with the tendency of reducing it, already operative in the case of Manet, to certain autotelic practices solely preoccupied with their autonomy and with the inventory and exposition of their components. Jacques Rancière has illustrated the paradox of pure painting apropos of the brilliantly theorized theses of Clement Greenberg. Striving to liberate painting from its representative tutelage and to take cognizance of a visibility without language that would be painting's essence, Greenberg in fact demonstrates the contrary in turning words and aesthetic analysis into the condition for the staging of pure visibility: 'The manifestation of pictorial expressiveness . . . is only present on the surface to the extent that a gaze penetrates it; that words amend the surface by causing another subject to appear under the representative subject'[13] or also 'Presence and representation are two regimes of the plaiting of words and forms. The regime of visibility of the "immediacies" of presence is still configured through the mediation of words'.[14] Painting thus always represents something; it is never singular and self-referential but creates this effect under representative regimes that differentially knot together the register of words and the register of the visible. This

does not imply that painting is made by words that render it distinct but that they doubly contribute to its visibility or even to its exposition. This occurs at first negatively through the failure of words to make this realization, in the gap and the breach in which the new style of painting keeps its distance from the institutionalized discourse about painting and then positively by drawing from this new visibility in order to bring its characteristics to the fore. The displacement effectuated by the singularity of an oeuvre, most likely nourished by a much broader conjuncture, creates the event which signals to the gaze that it thus belongs to the words of its interpretation.

The present iconoclasm thus has two aspects. The first, with which I began, appeals to language in order to thwart the image's irresistible attraction and seduction that, like the Medusa, ensnares the spectator in the mirror of its appearances. The canonical scene of Saint George tearing down the idolatrous paganism of images, the *eidôlona*, is its emblem. The second aspect draws from the idea that the image as representation which articulates the field of the visible is at bottom nothing other than a discourse dissimulated in the weave of appearances. It is since this time no longer surprising to find this idea in the analysis that we make of it. The operation proper to representation would be the fold that would allow for the integral reorganization of the visible in the snares of language. We have an example of this in the famous frontispiece that opens Hobbes's *Leviathan*. One sees as much as reads there the incorporation of all subjects into the monstrous body of the modern State, forming a mesh, or in reference to the biblical monster in the book of Job, the scales of the gigantic monarch's carapace dominating space, occupying the State respectfully and protecting it with two raised arms holding in one hand a sceptre and in the other a dagger. With this image, impressive in all respects, it was a question for Hobbes of giving the State the semblance of a terrifying physical body that is the sole possessor of right and force, and a question of making it the unifying and thereby pacifying mirror for every citizen. The politics of the image in Hobbes moves according to a double strategy: the first consists in giving a visible and lifelike body to the invisible and moral body of the State, backing up the demonstration of its necessity through an image that speaks to the imagination; the second plays on the usage and the reinforcement of the stultifying effect of the mirror which restrains the subject beneath the State's panoptic gaze.[15] If what is at issue here is a particular case of an image thought out in its minutest details in a close collaboration between Hobbes and the engraver Abraham Bosse, then we nevertheless see in it the principle of all representations at work, pushed to the limit, submitting the visible to the order of its reasons. Antithetical in their motivation, the first strategy rejects the image in the name of language and the second in the name of pure visibility. The two versions of the iconoclasm nevertheless reconnect on one point: they see in the image the threat of a subversion of

one order by another. In this strange mirroring, how could it be otherwise, given the common postulate of a radical autonomy between two orders that demands the excommunication of the image?

Abstraction was the common name for this excommunication. With this name, I do not evoke the pictorial current which set off under extremely varied forms, from Kandinsky to Rothko or Pollock, on the adventurous exploration of new spaces. Rather I want to evoke the aesthetic discourse that identified the word *abstraction* with a refusal of the image. The well-known anecdote of Kandinsky's discovery of abstraction goes in this direction, corroborating the idea that the only good painting is that which breaks free from the image, even if in his recounting the painter does not speak of the harmful character of the image but of the object that attributes a representative function to it.[16] It is yet again the confusion of the image with the object that is in question here. To take another example, one gives in to the same confusion with the interpretation of the arabesques ornamenting the surfaces of Islamic art as a censuring of the image. This would be to forget both that, according to Dora Vallier's observation,[17] flowers, birds and beasts, stylized certainly, are shown there and that the censure consequently applies to the human figure and at times to an ensemble of living beings.[18] Furthermore this would be to overlook that the arabesque space is an image of divine infinity.[19] Not only does the absence of the object fail to translate to the absence of the image, but it produces the paradox espousing that the presence of the image would in the last instance be in proportion with the absence of the object. Emancipated, without this being a necessary condition, from the representative constraint, the image can fully develop its intensive and expressive registers.

The misrecognition of different regimes of the image by the iconoclastic interpretation of pictorial abstraction would be of little consequence if it were not translated into a distorted effect whose stakes have a much greater reach beyond its artistic, aesthetic and civilizational registers. I want to speak about the well-known consequences of these moralisms, since this is indeed the question: capitulating to the worst part of that very thing against which we claim to struggle. In the context of contemporary societies in which images play, for better or for worse, a considerable role in the formation of sensibilities and of judgements, their aesthetic and ethic disqualification amounts to nothing short of leaving them at the hands of those individuals whose ambition it is to condition and format mass sensibility towards the best possible appraisal of the planetary market and its actions. While aesthetic purism, as hygiene was in the past, always drapes itself in 'white linen and candid honesty' (Victor Hugo) and laments the pollution of the mind, images are abandoned to the facile pleasures of those poor in spirit and sensibility, without acknowledging, moreover, that even here inventive resistances are born. After its meticulous decoupling from the model of representation, we

unexpectedly saw Foucault come to defend the cause of images during an exposition of the painter Fromanger, precisely in the name of a politics of images running counter to iconoclastic purism:

> Painting, for its part, has committed itself to the destruction of the image, while claiming to have freed itself from it. Gloomy discourses have taught us that one must prefer the slash of the sign to the round dance of resemblance, the order of syntagm to the race of the simulacra, the grey regime of the symbolic to the wild flight of the imaginary. They have tried to convince us that the image, the spectacle, resemblance and dissimulation, are all bad, both theoretically and aesthetically, and that it would be beneath us not despise all such trivialities.
>
> As a result of which, deprived of the technical ability to produce images, subordinated to the aesthetics of an art without images, subjected to the theoretical obligation to disqualify them, forced to read them only like a language, we could be handed over, bound hand and foot, to the power of other images, political and commercial, over which we had no power.[20]

In a remarkable article, Claude Imbert speaks to this idea of the 'extraction power' that the image would acquire after 'the vertiginous passage through abstraction'.[21] This is indeed what is at issue: how to extract or create free images worthy of being looked at from out of images formatted for the masses in order to anesthetize sensibility? In other words, how does one bring forth an image that does not preordinate the gaze?

EXTRACTION VERSUS ABSTRACTION

Cinema is an exemplary art in this regard. A child of the sciences and of the popular arts, it was from the outset partially linked to the new industry of mass leisure and could not avoid compromises with political propaganda by being put into the service of the ideological interests of states. Cinema remains one of the instruments of economic and political power, as the example of the United States testifies where it is still today the second-largest industry of the country. In its role of a great conductor of desire for objects produced for a mass market, cinema learned to forge the imaginary, the visual rhetoric and even the world that it required in order to capture the drives to the benefit of a consumerist form of life, thus contributing broadly to the reign of the society of consumption. On the screens of darkened theatres, there were not only actors striving to be stars in yearning for the identification of the viewer, there were also, by way of the sophisticated artifice of lighting and the framing of objects according to 'the American way of life',[22] gleaming limousines, black-and-white telephones, affluent and practical interior designs, impeccable suits and elegant outfits, the negligently smoked

cigarette, an entire decor of objects offering itself as a spectacle to the desire for an easy life in which their utility counts for less than their trophy status indicating a happiness at last revealed. In a number of films in the great Hollywood period, there are actors who play a secondary role for no other reason than to give credibility to the world of objects that surrounds them. These objects end up playing the leading role. Yet cinema's force is knowing how to rip from out of this stereotyped world an image of an entirely different order. In *Asphalt Jungle*, John Huston not only presents the sombre vision of the other side of American life's scenery, with 'loser' characters striving vainly to live up to the high standards of social success, but also he shows that these men are less frustrated by their dream of happiness than by their besmirched dignity, finding in the humiliation of their obscure lives the affirmation of their liberty. Their greatness is to confront the failure of the hold-up that they were organizing rather than resigning themselves to society's verdict. John Huston seizes upon the image made entirely from underdogs in order to overturn it into a counter-image in which gangsters, far from sanctioning morality's victory, are transformed into a manifestation of dignity and into an accusatory mirror for society. The slightly frustrated character Dix finds in Sterling Hayden the magnificent incarnation of what Deleuze calls *born losers*,[23] on one hand because society is not the community that it claims to be and also, on the other, because the dream of the individual, that of the prairies and horses of his childhood in Dix's case, does not respond to his expectation for adaption. As for the end of the film, collapsing dead in a field on his childhood farm, the vast sky above him, the camera, just above the ground, focuses on his face in a very wide shot. The painful grimace of his wife leaning over him alone accounts for, beyond the reprise of the Christian tradition of the *pieta*, the movement by which it invites the spectator to share the space of death and to place themselves there with him at the height of equality and in the renunciation of all judgement, erecting around him and behind the wild grass in the foreground a tomb for the lost dream of all of the exiles of the earth. The grandeur of cinema is not made by opposing the purity of films issuing from the world to the impurity of those compromised by it; rather it is made in knowing how to extract from it images that allow one to confront the world without succumbing to despair.

A large part of great twentieth-century painting testifies to the extraction of the image rather than its abolition. From Fernand Léger to Francis Bacon, passing through Malevich and Picasso, from surrealism to hyper-realism, painting never ceased to unmake agreed-upon images in order to remake others from out of them, subject to the evaluation of both thought and the gaze, and in order to broaden the territories of sensibility. Inherited from the toll-collector Rousseau and from cubism, and also borrowing from the graphic style of advertising images, Fernand Léger gave to the modern city

his constructivist image through the invention of a formal unifying language of forms with his famous tubular style and his frontal plastic space which integrates, in the fashion of collages, different levels at the surface of the picture. At the same time as Le Corbusier, Léger dreamed the modern city, aerated and joyous in the harmony of forms and movements.

At antipodes with the constructivist style, Francis Bacon's expressionist style shakes up the platitudinous character of advertising and photographic images. He creates a properly unheard of vision of the human figure founded on disfiguration and the capturing of forces traversing forms. The stakes were for him not only in the struggle against the usury and banalization of the human being's image in which an insensibility to mass extermination might find one of its sources but also in ripping away the masks and the identifiable face from the modern human, her visage in glossy prints and newspaper print, in order to give shape to her singular presence. Beyond the appearances and surface resemblances captured by photography, there is the body's work of individualization, its style of being and its flesh, the invisible anatomy of appearances. For example, one could compare John Deakin's photograph of Henrietta Morae with the extraordinary portrait that Francis Bacon drew from it (1963).[24] Everything occurs as if the model is effaced from the world of appearances in a violent extraction [*un arrachement violent*] from the trap of its own image and returns in force to uplift its surface and to impose its relief on to the torsions and contortions of its nervous, muscly face. Breaking with the unified, yet banalizing, egalitarian surface of images in the violent irruption of another image, that of bodies taken one by one in the singular density of their mode of existence, Bacon's effort, tirelessly repeated, moves towards the necessarily violent re-inscription of bodies into the world of dominant images that surrenders them to the oblivion of appearances. Returning the body to images and making it return from its erasure occurs by way of a violent extraction from the images that elide the body's presence. The defiguratory violence for which the painter was often reproached does not aim at the individual but at the false resemblance of the surface image that obviates the singularity of humanity and its action. 'But tell me, who today has been able to record anything that comes across as a fact without causing deep injury to the image?'[25] Bacon's profound remark is not against images but against the clichés that level down reality and render it insipid by depriving it of its intensity and complexity. Bacon opposes the work of the image to the complacency towards or hatred of images. In the field of contemporary art, Bill Viola is among those who continue this work by interrogating in his videos the disappearance and arrival of the body in its images (*The Messenger*).

The paradox of our time often identified with a 'civilization of the image' is the disappearance of bodies into the multiplication of their interchangeable images. It is not only the case, as phenomenology understands it, that

the body exceeds all representation and the only possible way about it would be to paint the impossibility of its figuration and thus its escape. This is Jean-Christophe Bailly's suggestion apropos of Giacometti's pictures, speaking of the 'unfigurability' inscribed at the very heart of the figure that incessantly gnaws away at it.[26] The visible is no longer as it was in the ancient system of representation, assignable to a fixed point of view but is what 'no longer stays in place, even when immobile, it is only pulsation, a contraction of movement from the front towards the back and towards the front, on the sides and in every direction'.[27] This is probably less a case of being delivered over to the panic and deregulation in an unstable world without a privileged point of view making the body absent from its representation than the projection and disincarnated overexposure of the body on the surface of magazine pages and screens. The problem is thus to not take the body away from images by representing its failure to appear or by playing the materiality of painting against the immateriality of the image, it is rather to make the body return in its unexpected figures that inscribe it anew into the field of the visible.

THE POLITICS OF THE PICTORIAL SPACE

One function of art belongs to playing the division of images against their censure. Deprived of essence in the sense that art derives itself from the gaze and from the words that will distinguish it from non-art, art's proper operation consists of a deviation and displacement in relation to the instituted visible in order to make arise within said visible another visibility which divides it. Since the time of the Platonic excommunication up to the modern debate over abstraction, passing through the Christian dispute over iconoclasm as well as through the conflict between sketch artists and colourists, art history is marked by decisive and memorable quarrels over the stakes of the images and over the borders and the efficacy of art. If a politics of art could be at issue, then it is first and foremost that politics, contrary to expert and technocratic governance, only exists at the price of a division of the community in regards to its reflexive interrogation of its values, goals and organization. The debate over the delimitation of art, present more than ever in the contemporary field, and which sees the confrontation between partisans of an elitism and essentialism of art and the supporters of artistic democracy, is inscribed from the outset into the register of politics. The responses to questions as decisive as these concerning the boarders between art and non-art, the borders amongst the arts themselves, and concerning the qualification of subjects and practices that might or might not derive from art, are intrinsically political. The quarrel between drawing and colour, which goes back at least to Aristotle's *Poetics*,[28]

was not merely aesthetic and did not simply oppose the idealisms of the trait against the sensualists of the colour blot, the poetic intelligence of *muthos* against the spectacle of the *opsis*. Rather it was understood to decide between the subjects and practices worthy of art from those that were unworthy of it, parsing the noble matters and manners [*les matières et les manières nobles*] of the aristocracy from ignoble and popular matters and manners. Judged to be popular and feminine, colour was only admitted to the temple of art as drawing's ornamentation. The same scenario played itself out again with the entry into the art world of popular arts, the exogenous arts, photography, cinema and the documentary and sociological practices of contemporary art.

But, more precisely, how do we understand the politics of art? A politics of art extends first in opposition to a theology or a religion of art. If politics divides, then it does not divide randomly. It divides the community by the right that the community dedicates to invisibility and that it creates for what is excluded from it. Contrary to the contemporary vulgate that makes an affair out of politicians and their cultural and artistic actions, but certainly not of politics, art is not reconciliatory or a citizen. It divides by distributing the community, throwing into question its order and communal subject, specifically the citizen who is called to perceive against the consent required by the community. Impressionism for a time divided the community; it included in the art scene popular modern subjects, the people of the open air cafés and bistros, the boat parties of boastful workers and grey ribbons, the tailed coated bourgeois and the ever moving crowds of the grand boulevards; but it especially interrupted historic and genre painting by foregrounding the aleatory and ordinary aspects of modern life. From fragments to multiplied reflections, impressionism unmade the representation that the community gave to itself with its subjects, scenes, hierarchies, practices, stable order and its locatable identities, substituting for this order a world of unstable appearances in constant transformation. It smudged the community's mirror, delivering it over to its constitutive indetermination. Monet's *Impression, Sunrise*: the sun does not rise on an ordered world; henceforth, it too is submitted to the chemistry of its incessant exchanges. To divide the scene of the visible is therefore not to carve out in counter-relief the absent presence of a transcendent invisible, but the visible invisible occluded by the ancient order of representation. The politics of art is therefore opposed to a negative theology of art which would make the visible the sign of unpresentable absence. But, neither does this oppose the impurity of prescribed visibilities by the ideological order of the market with a register of pure visibility, the sacred world of art withdrawn into the temple of simple appearance.

Next, a politics of art does not extend in the direction of a committed art [*un art engagé*], of an art of the message which would appeal to unalienated consciousness in order to change how we look at the world with regard to

its concrete transformation. It is here that formalism finds its entitlement by emphasizing the specificity and autonomy of art in relation, not only to discourse but also to the social sphere of representations. Although François Coppée's well-intentioned poetry may well take a path of humility, it did not remain, for any less, caught in the distribution of places of the existent order and the formal hierarchies of poetic discourse that correspond to it, even though at same time Rimbaud's poetry subverted versification by making all the registers of language communicate in a strict equality:

> *Dis, non les pampas printaniers*
> *Noirs d'épouvantables révoltes,*
> *Mais les tabacs, les cotonniers!*
> *Dis les exotiques récoltes!*
> Don't speak of springtime pampas
> Dark with dreadful revolt,
> Speak of tobaccos, cotton-fields,
> Exotic harvest-times![29]

In *What One Says to the Poet about a Flower*, ironically dedicated to the Parnassian Théodore de Banville, Rimbaud is not revolutionary through his anti-capitalist and anti-colonialist message. He is revolutionary in his manner of turning versification against itself and by the introduction of a grinding dissonance into flowery poetry. In adding to the equivalences and to the metaphorical equivocations of the first two verses the contrast between a refinement of the form excessively exhibiting a respect for poetic rules (rhymes and assonances) and a triviality of the content (revolts, tobacco, cotton-fields), he introduces a gap between syntaxic structure and semantic connotation in which the miserable prestidigitation of the Parnassian poet unfolds, all the way up to the mirror-image overturning of the quatrain 'Don't speak . . ./Speak', all while transforming 'dreadful revolts' into 'exotic harvest-times'.

Finally a politics of art is also not to be understood in the sense of a Marxist theory of reflection according to which works, despite whatever they elsewhere happen to be according to an author's personal ideology, are the mirrors of the structures of society. We recognize here, among others, Georg Lukacs's famous thesis regarding the revolutionary character of Balzac's realism in opposition to the reactionary positions of the writer himself. The Balzacian novel would reflect the transformation from artisanal production to industrial and finance capitalism and the transformation of literature into a commodity. Yet, beyond describing milieus and social transformations, what counts for Balzac is the invention of a prose of the object and the attention to the silent speech of things in which a symptomatic inventory of the everyday announces itself, an inventory from which psychoanalysis and sociology,

each its own way, would articulate their methods.[30] The excess and anteriority of art with respect to knowledge confirms Freud's discovery here.

Art is neither political in the sense of taking an ideological position, nor political in the sense of sociological reflexivity, which would, on one hand, submit art to the political order and, on the other, to the order of knowledge. Art is political in proportion to the invention of a new space which transforms the field of sensibility. Art is not essentially political as an expression of a subjective partiality or as objective information regarding the collective field; it is political by the invention of an unforeseen sensibility which suspends the perceptive habitus and occurs via the inscription of another space into the common space. I borrow from Jacques Rancière the condensed formulation of this displacement of art:

> Art is not, in the first instance, political because of the messages and sentiments it conveys concerning the state of the world. Neither is it political because of the manner in which it might choose to represent society's structures, or social groups, their conflicts or identities. It is political because of the very distance it takes with respect to these functions, because of the type of space and time that it institutes, and the manner in which it frames this time and peoples this space . . . the specificity of art consists in bringing about a reframing of material and symbolic space. And it is in this way that art bears on politics.[31]

Space is the common place of art and politics in the sense that the distribution and organization of heterogeneous visibilities play themselves out there. The repartitioning of which Jacques Rancière speaks can create confusion if we understand it in terms of the substitution of one order for another, of the good order for the bad, even though the essential is first and foremost in the interruption of the existing order, in the movement that relays habitually separated visibilities. One example among many others, one verified as much by painting and photography as cinema, would be the equality of treatment of the human figure and of things, of the visage and the landscape, of the body and the mountains, such as we see it in Cézanne and his cubist heirs. Or again we see it when, with the collage or the ready-made, the objects of ordinary life invite themselves into the world of representation and contest the boundary between the art world and the world of life. Art's distance is not tantamount to its introduction of breach within the museum's reserve of pure visibility, the absolute extracted violently from the sordid transactions of the world. This gap is confounded with the change of place and the disordering or abolition of boundaries, it is a displacement of the gaze, that is to say, a revival of the gaze paralysed by the training apparatuses of sensibility. Whenever the New Realists get ahold of lacerated advertisement posters, and in the proper sense since they would go so far as to remove the posters from the walls of public space in order to show them in galleries, what else are they doing but

effectuating, in all the senses of the term, a displacement? Art thus performs a triple displacement: first that which consists in changing their place and their space, from the street to the gallery or the museum. Next, there is the displacement which turns the medium against the message, the visual support against the function of communication, trash against object. Finally there is the displacement that transforms the advertising billboard into a gestural picture. Displacement is to be understood as an incongruous relationality, at once misaligned, of heterogeneous elements and in this case from the street to the gallery, from the visible to the legible, from the utilitarian to the aesthetic. At the same time, art is coupled with a function of free appropriation and free play alongside a market space devoted to the consumerist injunction, one of art's stakes doubtlessly being, as established by Kant in the *Critique of Judgement*, to give play back the faculties of feeling, imagining and judging liberated from utilitarian servitude and the constraint of an epistemic programme. Such an act of tearing away or laceration transgresses the ordered space of the advertisement image, disrupting its message and the appeal of its figures to identification. But this is for the purpose of making a chaotic surface emerge and recomposing in a kind of aleatory collage free associations between the remainders of words, forms and colours out of which other images, ironic fragments, comic or bizarre juxtapositions, improbable or monstrous couplings are all born. In a more spontaneous vein, one truly opposed to their constructivist inspiration, the New Realists discovered the polemic invention of photo montage in the style of Rodchenko. By means of a subtractive practice that proceeds by violent extraction and removal, they were concerned with making a new reality appear under the ordered reality of the space of the market, another space of visibility that was more composite, which, moreover, was not foreign to the fragmented nature and the disordered movement of new urban spaces.

FROM ONE SPACE TO ANOTHER: COURBET AND GAUGUIN

In order to give a more robust example of the politics of the art of images, I propose to return to a work which, in many regards, was revealed as decisive for the reconfiguration of the space of modern art. The entire oeuvre of Gauguin offers by its radicalism a beautiful example of the displacement effectuated by painting in the approach to space and the treatment of images. To be concise, even if it means having to explain it more a bit further along, I would say that Gauguin was the first to head straight away for abstraction, without breaking with the image but not without a profound renewal of the image's status and direction. In his case, displacement is not measured in

terms of distance, and we will see that there were several displacements of great magnitude measured in the first instance by his speed. It is probably a characteristic of art to move quickly, quicker for example than philosophy which must take its time except when proceeding by hammer blows and aphorisms or when critiquing the construction of a new problem and its deployment of argumentation. Gauguin's speed, however, was astonishing. A latecomer to painting[32] and at first a 'Sunday impressionist',[33] according to the excellent expression of Françoise Cachin, he would quickly become a full time painter by rapidly synthesizing the lessons of impressionism following Cézanne's example, yet embarking on an entirely different trajectory that would test impressionism's limits. Overall, hardly ten years had elapsed between the rudimentary days of his apprenticeship up to his first stay in Brittany that put him on the doorstep of his very own adventure. Next would come Panama, Martinique, again Brittany and his first visit to Oceania before he definitively took up residence there. Travelling was for Gauguin not what it was for others: it was an authentic chance for displacement and an imperious necessity for revolutionizing the gaze. 'In short, what distinguishes the two kinds of voyages is neither a measurable quantity of movement, nor something that would be only in the mind, but the mode of spatialization, the manner of being in space, of being for space'.[34] Deleuze and Guattari's remark applies without reserve to Gauguin's pictorial voyage and to his unpredictable manner of envisaging space, even if these voyages aided him and accompanied him during his introspective trajectory, the first step indisputably belongs to the appeal for a new mode of spatialization.

Gauguin's spatial revolution first begins with a reorganization of space on the surface and the picture plane rather than hollowing them out with perspectival depth. The picture is no longer a window opening on to the world or on to a theatrical stage; rather it takes the form and the function of a wood panel and a stained glass window. From one to the other, we witness the disappearance of the spatial envelop and the light with its chiaroscuro games that erect and sculpt figures while projecting their shadows. This is therefore a passage from a three dimensional space to a two dimensional space, from a hollow space to a level space. Let us compare Courbet's *The Meeting*, better known under the title *Hello, Mr. Courbet* (1854), with Gauguin's picture *Hello, Mr. Gauguin* (1889). It is quite obvious that this was intended and the comparison thus has the value of a manifesto. Abstracting from the iconographic interpretation, one observes an overturning of space. In Courbet's picture, there is an adherence to the rules of perspectival representation: there is a large opening extending out of sight beyond the scene in the foreground, a contrast between the verticality of the figures and the horizontality of the landscape, between the volume and relief of the bodies and the projection of shadows, and finally between an absence of frontality reinforced by the disposition of the

two individuals turned three quarters of the way towards us and the painter viewed from behind in the foreground. The picture does not face us: we are supposed to view it surreptitiously, as in the theatre. However, Gauguin's picture faces us: everything there is projected towards us in a frontality that excludes depth. The gaze can move throughout the picture only by sliding on its surface without being able to circulate in an imaginary fashion in space for the purpose of occupying different points of view. It is impossible to go around the characters or to make them pivot as the fence, reminiscent of a tourniquet, between Gauguin's figure and the Breton peasant might suggest. Even from behind, the peasant faces us. Gauguin employs the disappearance of light and shadow usually to the benefit of a singular differential intensity of pure colours as well as to the vertical treatment of the picture proceeding via the juxtaposition of planes and brushstrokes. The illusionistic space gives way to a simplified space, marked by the play of verticals and horizontals on which curves and sinuosity come to dance, modulated by the interplay of colours. And if perspective has not totally disappeared, then it no longer obeys the rule of continuous diminution that is supposed to facilitate the realist illusion of space, and is reduced to the symbol of an abbreviation.

If there is a politics in Courbet's picture, then it occurs through its scenography and the hierarchical relation that it sets up between the characters and space. The landscape is used as decor and the foreground as a stage that serves to frame the encounter. The apparatus remains very clearly that of the theatre with the very clear impression that the landscape, regardless of the otherwise extraordinary finesse of its production, is a trompe l'œil like those used in the theatre. Theatricality is found in the highly ceremonious and socially connoted postures of the three characters. We know that the picture represents Courbet's meeting with Bruyas, his patron and benefactor from Montpellier, and beyond this it stands for the social and political recognition of the prophetic role of the artist, proudly placed in the foreground, in a figure that at once convokes the errant Jew, a still living legend in the nineteenth century, and an Assyrian monarch. This is the scenography's eloquence: on the left, two static characters, one lower class and the other bourgeois, welcome with deference and respect the artist-genius who approaches them. The attitude of the characters, the place of their encounter, a corner of a deserted countryside, all of this indicates a displacement, one that is itself indicated by the dog at the picture's centre, moving from a fixed order from which the artist is excluded, expect through his vassalage, to a decentred and mobile space announced by the artist himself.

Gauguin's picture inscribes itself into the modernist turn of painting characterized by Michael Fried as 'facingness'[35] and as turning its back to 'absorption' [*l'absorbement*]. Executed after his stay in Arles during which he had the chance to see Courbet's painting at the Montpellier museum, it is

not surprising to find there, beyond the impact of Cézanne, the influence of Van Gogh, particularly felt in his choice of pure colours, especially the blues and the yellows, as well as the simplification of forms. Along with the wood panel and the stained glass window previously evoked, it is appropriate to add tapestry to this list, with its closely textured vertical brushstrokes and its refusal to illuminate a scene delivered over entirely to the reign of colour. Passing through colour, through its transparency and its interstices, like in a stained glass window, light no longer illuminates the picture in order to hollow out space, erect figures or cast shadows. Light is immanent to the picture. In the space of Courbet's picture, the light apportions shadows and transparencies while distributing places and organizing a hierarchy. The zone where Bruyas and his servant stand is plunged into the shadow of a bush that we are unable to see, whereas, in the zone where Courbet is standing, it is the artist's shadow which stands out from the sun-bathed ground. Light and space project an order of graspable and exchangeable places. Whenever we realize how much the solar metaphor, from Plato to Hegel,[36] is heavy with metaphysical and political meaning, then we cannot help being struck by this characteristic of Courbet's picture. As Jean Borreil has well observed,[37] Courbet probably wanted to invert the platonic perspective in placing the destiny of the community back into the hands of the artist whom Plato, for his part, had banished from the city. Probable still is that the coherence of this inversion goes so far as to assume the exact counter-position of the Platonic perspective by situating *The Meeting* in the open and indeterminate space outside the city walls. But does Courbet not preserve the essence of his apparatus by maintaining what could be called the picture's sun-dial that accords a royal status to light? And with this, he also accords it the idea of a unique order arranged with respect to the light of an absolute truth whose incarnation remains for Plato the figure of the philosopher king and for Courbet that of the artist. There is nothing extravagant about a question which touches on a painter whose political engagement, notably at the margins of and even sometimes at the heart of the Paris Commune, is entangled with a very profound awareness of the participation of his art in thinking.

Yet what does Gauguin do? First, within occidental art, he extinguishes the light that always shines from a truth overhanging things and beings in the position of a divine monarchical transcendence, the foundation of a unique *arkhé* [ground, sovereign principle]. *Hello, Mr. Gauguin* is not a new sunrise, even if the cloak wrapped artist occupies the picture's centre, but it is without a doubt a manifesto for the 'right to dare all' in painting that Gauguin strove to initiate.[38] Light no longer comes to illuminate the space of the picture in order to indicate the distribution of locations, places and even times. It is daybreak or dusk? It is difficult to apprehend the location, the characters and the time of day at issue. The scene leaves the sphere of realist representation in

order to open that of a representation more susceptible to indetermination and dreams. Françoise Cachin rightly underscores that 'Gauguin was one of the first painters to refuse a hierarchy of artistic values'.[39] Formulated with regard to his putting into question of the ancient distinction between major and minor arts, this remark also applies to the new space created by the painter which would be further affirmed in the course of his oeuvre. Free from the rules of *mimesis* and the hierarchies that it imposes on the representative scene, the space becomes a free space of composition on the picture plane, open to decorative motifs, to plastic rhythms and to the layering of forms and figures. The picture is no longer a projection surface, a window or a mirror, or a spectacle orchestrated by light offered to the mastery and the intrigues of the gaze, but it is a plane of resonance for the vibration of colours and the harmony of forms. What Gauguin invents, as paradoxical as it may appear, is a space for 'the eye which listens' to what it does not see.

'Art is abstraction', Gauguin's famous formula which marks occidental art's passage to abstraction does not nevertheless sound the death knell of the image, quite to the contrary. By abstraction Gauguin does not understand an art without figure but an art liberated from the norms of verisimilitude:

> Then came the Impressionists! They studied color, and color alone, as decorative effect, but they did so without freedom, remaining bound to the shackles of verisimilitude. For them there is no such thing as a landscape that has been dreamed, created from nothing. They looked, and they saw, harmoniously, but without any goal: they did not build their edifice on any sturdy foundation of reasoning as to why feelings are perceived through color. They focused their efforts around the eye, not in the mysterious center of thought, and from there they slipped into scientific reasoning.[40]

The picture no longer has to exist according to nature, regardless of its diverse modes of representation, but, conforming to a clearly Baudelarian aesthetic of inspiration, exists according to the imagination, to the dream and to the artist's thoughts. Emancipated from its mimetic function, which had ended up becoming, in artists like Bouguereau, a mummification of the appearances of the sensible, the image can take on functions other than resemblance in order to give form and visibility to the imaginary and to the adventures of thought. Far from the illustrative and reproductive functions which were often its own, the image recognizes a properly heuristic function that participates in thought: the image thinks and gives to thought. Gauguin reprises in his own way the art of abbreviation of which Baudelaire speaks[41] and which finds a form of expression in a simplification of images that Roman stained glass windows, Japanese stamps, oriental miniatures and the idyllic prints of Epinal all exemplify. Abstraction is the formula for a new pictorial grammar that allows the integration of images into a plastic surface through a graphic

art of lines and colour swaths. Drawing resources from popular imagery, the decorative arts and non-occidental arts, Gauguin returns anew the powers of evocation and sensible synthesis that belong uniquely to the image.

Seen in this way, the passage to abstraction derives from a politics of the pictorial space in two senses. First, the importation and the reprise in the pictorial field of popular art forms, advertising techniques, posters and decorative arts (for which Gauguin proved to be a particularly inventive ceramicist)[42] gratify an aesthetic dimension of excluded practices or practices confined to the margins of art. It is here a question of the first form of a de-hierarchization of artistic genres and practices that destabilizes the academic boundaries of the art field without nevertheless leading to a confusion between art and the artisanal. There is neither a subject nor a practice that would be a priori unworthy of art. Second, the critique of the illusionistic model of representation opened for Gauguin the way to relations with non-occidental aesthetics, sparked in all likelihood by his childhood in Peru, and to a rehabilitation of the forms of occidental art which, following the example of Roman art or the ancient Italians, had been chased out of the temple of good taste. 'The great error is the Greece, however beautiful it may be'.[43] Impassioned by extra-European forms of art that he notably discovered at the Universal Exposition of 1889 or during visits to the Egyptian Antiquities Department in the Louvre and in the British Museum, Gauguin was from the outset permeable to oriental styles, to the art of the ornamentation of surfaces and of the simplification of figures. This displacement towards heterogeneous aesthetics, reinforced by voyages to Central America and a stay in Polynesia where the mythology and the ornamental art of the Maoris would dazzle him, led to a synthetic art that discovered how to conjugate the European heritage of representation with modes of thinking and feeling that were foreign to them.

If one can speak of a displacement, it is in the sense that it concerns neither annexation nor conversion. By 'aesthetic annexation', it is necessary to understand an artistic practice that submits exogenous arts to the apparatus of occidental representation in the mode of an exoticism of subjects and motifs; this comes down to changing the content of representation, its picturesque embellishment and its decor, without changing its form. Pictorial orientalism was, in the wake of colonization, an exemplary illustration of this. 'Conversion' would be the inverse of annexation and would take the form of an imitation without mediation of the exogenous arts, for example in the case of a reprise by an occidental artist of the tradition of Arab or Chinese calligraphy. In contrast, this displacement consists of a transformation of space and the gaze proper to a pictorial tradition, however less through the introduction of heterogeneous elements than through heterogenization. The citation of Japanese stamps in several impressionist pictures derives from the first approach, whereas the reprise in the framework of representation of axonometric

perspective or techniques of exceeding the picture frame, practically a rule among Japanese stamp masters, derives from the second. The displacement consists in an alteration and a deformation of the space inherited from tradition by the attraction or inclusion of a space configured otherwise. We find both approaches operative in Gauguin's work, the first with the figuration Maori motifs and characters, the second in his search for a synthetic, plastic and rhythmic space that would make the image glide on to the picture plane. What matters is not only the Maori's presence on the scene of occidental representation, which, moreover, would not be entirely new and would prolong the vogue of exoticism, but that their presence passes through a transformation of the space of representation dominated by perspectival norms into a frontal space that composes and fuses different planes of the image with the picture plane. This transformation can be read as a synthesis of occidental art and non-occidental styles of diverse origins, including Japanese, Cambodian, Persian and Polynesian.

In order to fully understand the extent of this, let us compare *Faaturuma* (*The Melancolic*, 1891) and *Aita tamari vahine Judith te parari* (*Annah, the Javanese woman*). As much as the first painting, with the torsion of space and the diagonal position of the figure, is still composed according to perspective and concedes to melancholy with its sombre colours and the pensive expression of the woman, the second frankly assumes its frontality, the sensual stature of a feminine nude, the sumptuousness of colours and a decorative refinement. *Annah, the Javanese woman* marks at least a triple displacement and a triple affirmation: one, the successful synthesis of the European tradition and exogenous arts; two, the critical and provocative reprise of a conventional genre, as aesthetic as it is moral, of the bourgeois portrait; three, in middle of the period of colonial conquest, the explosive irruption upon the scene of occidental art of the beauty and dignity of non-European peoples. The picture attains at once extreme simplicity and extreme refinement. This is the simplicity of space unfolded on the surface of the picture, because what is striking in relation to *The Melancholic*, and more generally in relation to the staging of classic space, is the disappearance of the folds, not only of figures and clothing but of space itself, habitually and partially hidden from view by the depth of perspective, the relief of things and the succession of planes. The room and the armchair, like the sitting-standing nude, are vertically deployed into a frontality without the picture withdrawing or retreating. This is a refinement through the juxtaposition and composition of primary colours, blue yellow, and red clarified with pink, with the complimentary colours, orange, green, purple, all them nuanced with discrete reflections, greens, oranges, bluish hues and powerfully structured by the armchair's black frame and the foundation of the wall. In the picture's insolent outspokenness and frontality, it is nothing less than a declaration of war against the moral hypocrisy and

bourgeois 'good taste' that is convinced of its exclusive right to the image and the legitimacy of its modes of representation.

Gauguin's politics: the de-hierarchization of the arts, the overturning of the image against the image and the overturning of the rights *of* the image against the rights *to* the image, a synthetic space against a realist space, the multiple explosions of colour against the metaphysics and the imperialism of light.

NOTES

1. Marie-José Mondzain, 'Can Images Kill?', trans. Sally Shafto, *Critical Inquiries* 36 (2009): 20.

2. Patrice Loraux writes: 'What is under a reign enjoys a consistency indebted to incorporation, assimilation and fusion in view of a decision of the archon. The reign is homogenizing and does not leave any region free of its grasp. . . . Finally the reign is indeed solitary'. ('Qu'appelle-t-on un régime de pensée ?', in *La Philosophie déplacée. Autour de Jacques Rancière* [Paris: Horlieu éditions, 2006], 32.)

3. Mondzain, 'Can Images Kill', 28.

4. Jacques Rancière, 'Painting in the Text', *The Future of the Image*, trans. Gregory Elliot (London: Verso, 2007), 69.

5. Loraux, 'Qu'appelle-t-on un régime de pensée', 32.

6. The term *regime* in French can signify a regime in the structural and political sense evoked earlier; however, it also simply means *diet* in the sense of alimentary regime. [TR]

7. Mondzain, 'Can Images Kill', 30.

8. The TGV is a type of train with an extensive railway system in France. [TR]

9. In French the word *cliché* can refer to both a photograph and a cliché in the sense of an excessively used term that admits a lack of profound thought or insight.

10. Rancière, 'Painting in the Text', 72. Translation modified.

11. I am thinking notably of a video of Zineb Sedira, *And the Road Goes On*, 2006.

12. Michel Foucault, *The Order of Things: An Archeology of the Human Sciences*, trans. Pantheon Books (New York: Routledge, 1989), 10.

13. Rancière, 'Painting in the Text', 76.

14. Rancière, 'Painting in the Text', 79.

15. Concerning this subject see the remarkable work of Horst Bredekamp, *Thomas Hobbes visuelle Strategien. Der Leviathan: Urbild des modernen Staates, Werkillustrationen und Portraits* (Berlin: Akademie-Verlag, 1999).

16. He is cited in Dora Vallier's *Abstract Art*, trans. Jonathan Griffin (New York: Orion Press, 1970), 45–76.

17. Vallier, *Abstract Art*, 3–4.

18. Abdelwahab Meddeb further clarifies: 'It is the social effect of images which differs in Islam; they are sent off to the solitude of books and libraries. The subject of Islam is not against the image, she is circumspect as to its diffusion. The image can exist in nothing other than itself, but it can only constitute a socially shared event within scrupulously circumscribed limits'. (*Contre-prêches* [Paris: Seuil, 2006], 124.)

19. Apropos of the potentially infinite character of the oriental arabesque, see Aloïs Riegl, *Problems of Style*, trans. Evelyn Kain (Princeton: Princeton University Press, 1992).

20. Michel Foucault, 'Photogenic Painting', in *Gilles Deleuze, Michel Foucault and Gérard Fromanger, Revisions: Photogenic Painting*, trans. Daffyd Roberts (London: Black Dog Publishing, 1999), 88–89. Translation modified.

21. Claude Imbert, 'Les droits de l'image', in *Michel Foucault, la peinture de Manet, suivi de Michel Foucault un regard* (Paris: Seuil, 2004), 159. There is in the same volume Catherine Perret no less remarkable article 'Le Modernisme de Foucault'.

22. In English in the original. [TR]

23. Gilles Deleuze, *Cinema 1: The Movement Image*, trans. Hugh Tomlinson and Barbara Habberjam (Minneapolis: University of Minnesota Press, 2013), 145.

24. One will find its reproduction in David Sylvester, *Interviews with Francis Bacon: The Brutality of Fact* (London: Thames and Hudson, 2012), 39.

25. Sylvester, *Interviews with Francis Bacon*, 41.

26. Jean-Christophe Bailly, *Le Champ Mimétique* (Paris: Seuil, 2005), 289.

27. Bailly, *Le Champ Mimétique*, 290.

28. On this subject, refer to Jacqueline Lichtenstein, *The Eloquence of Color: Rhetoric and Painting in the French Classical Age*, trans. Emily McVarish (Berkley: University of California Press).

29. Arthur Rimbaud, *Arthur Rimbaud: Collected Poems*, trans. Martin Sorrell (New York: Oxford University Press, 2001), 108–9.

30. On this subject, notably regarding the Balzac's novels, see Jacques Rancière, 'Two Forms of Mute Speech', in *The Aesthetic Unconscious*, trans. Debra Keates and James Swenson (Cambridge: Polity, 2010), 31–43.

31. Jacques Rancière, *Aesthetics and Its Discontents*, trans. Steven Corcoran (Cambridge: Polity Press, 2011), 23–24.

32. In virtue of her excellent bibliography, one should refer in regard to this subject (among many others) to the work of Françoise Cachin, *Gauguin*, trans. Bambi Ballard (Paris: Editions Flammarion, 2003).

33. This idiom suggests that Gauguin was initially what considered an amateur painter. [TR]

34. Gilles Deleuze and Felix Guattari, *A Thousand Plateaus: Capitalism and Schizophrenia, Vol. 1*, trans. Brian Massumi (Minneapolis: University of Minnesota Press, 2005), 482.

35. Michael Fried, *Absorption and Theatricality: Painting and Beholder in the Age of Diderot* (Chicago: University of Chicago Press, 1980), 7–71.

36. See Book IV and Book VII of Plato's *Republic* and Hegel's *Reason in History* where it is shown that the realization of Spirit follows the trajectory of the sun from the Orient towards the Occident.

37. Jean Borreil, 'Préface', in *L'Artiste-roi* (Paris: Aubier, 1990).

38. Cachin, *Gauguin*, 284. She cites a part of Gauguin's letter to Henri de Monfried (November 1901) in which he speaks of what seemed to him to be the benefit of his paintings and those of his friends: 'Here, in my opinion, is something to console us for the loss of our two provinces [Alsace and Lorraine], for we have conquered all

of Europe with it, and especially recently, we have used it to create freedom in the visual arts'. (Cachin, *Gauguin*, 262)

39. Cachin, *Gauguin*, 46.

40. Paul Gauguin, *The Writings of a Savage*, ed. Paul Guérin, trans. Eleanor Levieux (New York: Viking Press, 1978), 139. Translation modified.

41. Charles Baudelaire, 'The Painter of Modern Life', *Selected Writings on Art and Literature*, trans. P. E. Charvet (New York: Penguin Group, 2006), 390–437.

42. Cachin, *Gauguin*, 44.

43. Paul Gauguin, *The Letters of Paul Gauguin to Georges Daniel De Monfreid*, trans. Ruth Pielkovo (New York: Dodd, Mead and Company, 1922), 89.

Conclusion

Towards a Civilization of Images

What is the image? From Plato to Sartre the response of philosophers to this interrogation has varied extraordinarily and even takes in the case of these two philosophers the form of a radical opposition. What is there effectively in common between a philosophy that places the image in the position of a quasi-object, seeing it wander everywhere across the surface of things, and a philosophy that interiorizes the image as the act of a subject in revolt against the givenness of the world? We did not fail to underscore the resemblance of Plato's cave to a movie theatre, Sartre being its exact contemporary. But Plato was not an anachronistically affable cineaste, and his cave is a theatre of marionettes in which human beings, chained in place, are captured by the lure of moving shadows and will be able, if all goes well, to turn back around in order to contemplate the models of these shadows. Victims of the images circulating between things, induced to commit errors by the trompe l'œil of painters, these humans can be freed from illusion and can learn to circumvent the trap of appearances. In Sartre's world, and this makes all the difference, we go to the movies—we choose to go there in order to escape the real and give ourselves a world other than the given one. The film is not a parade of images that we passively observe; it is an imaginary projection which presupposes the implication of the spectator. The image is not the object's deceptive shadow but is instead the shadow of the subject that enacts existence by opposing to reality the irreallizing negation of the imaginary.

Despite how much these responses differ, the question of the image has remained, from one philosopher to the other, surprisingly unchanged in its terms. In shuttling from an objective to a subjective status, the reflection on the image nonetheless did not cease to be commanded by the question of essence. This occurs in two ways. (1) The first consists in thinking the image through its primary dependence on being, in determining it, as Plato does, as

101

a false being, a *mise en abyme* [placement into an abyss] of being through its own reflections and simulacra. This consists, for Sartre, of thinking the image as a counter-being that places the imaginary in opposition to being itself. Plato fears the empire of the false in which being is undone, dispersed into the multiplicity and the inconsistency of appearances, and Sartre dreads the full saturation of being, the in-itself that would never make room for the existence of the subject. This is obviously not at all the same thing as Plato, but conceptually it comes down to conceiving the image as the negative of being's positivity. (2) The second path consists in apprehending the image in its transitive function of an *image of something*. This is obvious for Plato but much less so for Sartre, who substituted for the reified concept of the image—which renders it a degraded copy—the concept of an original imaginary relation to the real. But if the image is for him no longer fundamental to the image the object, it is fundamental to the image of the subject of which it is the expression rather than an imitation. In effect, this is probably a question, properly speaking, of resemblance, because there is no substantial being whose subject can sustain itself in its existence. Nevertheless, the fact remains that the images in which he deposits his imaginary reflect his choice regarding being, as Sartre attempted to show in a very controversial essay dedicated to Baudelaire.[1]

Such are the limits and insufficiencies of these two philosophies of the image that convinced me of the necessity of a lateral step in order to displace the question of the image's ontological register towards what, for lack of a better term, I call a *pragmatic of images*. This is a double displacement that, on one hand, cuts short the endless rehashing of the being or non-being of images in order to bring attention to their operative modes envisaged in terms of their production and their effects and, on the other, breaks with the presupposition of a homogeneous nature of the image in order for them to be composed in terms of heterogeneity. Before the extraordinary legacy of images transmitted by the history of civilization and, right in the middle of the astonishing contemporary invention of the arts perpetually in the process of creating and recomposing themselves, it is difficult to be satisfied with a speculative philosophy that would reduce images, in the quasi-culinary sense, to a common stock, one that, since Aristotle's *Poetics*, carries the name of representation, even we spice it up, historically or otherwise, in order to vary its presentation. My theoretical sidestep consisted in evading the trap which encloses the image in a choice between the representation of an object and/or a subject in order to think it under a Deleuzian aegis and in such a way as to effectuate a relation between disparate elements. Images are not simply specular reflections or pure imaginary projections; rather they are interventions that bring about connections according to varied modalities between things, whatever they happen to be. Even in a fortuitous manner, a photograph can still reveal an unperceived relation. The conception and the

mode of composition of images induce specific and unexpected aesthetic effects, variations in sensibility and new manners of feeling. The aesthetic is not passive but active, creating agreements and contrarieties on the stage of the visible.

But it is especially poetics, the mode of production of images, which best teaches us to see and understand them. Their effects are no more alien to their materials [*leurs matières*] than to their manners and to their apparatuses and consequently to the distinction between different arts. Whether pictorial, photographic or cinematographic, images borrow from such materials their intensity, their figures and their fixed or charged movements, that is to say, their relations to space. In Manet, painting weaves together its figures in the texture of brushstrokes and still assumes a pose within the uprightness of the frame. In the photographic instant, sensible anecdote and the passage of time take precedence. In cinema, the relation between the visible and the invisible is made in the off-screen that deepens it through an interplay which redirects images to words and sounds. The difference between the arts nevertheless does not imply their reciprocal indifference. Manet's characters are frozen in the stupor of photography's magnesium flash and the aloofness of their public exposition. The pictorialist photographs of the nineteenth century take up once more the pose and the composition of painterly pictures [*des tableaux*] just as today there are photos that rival the monumentality of historical painting (Jeff Wall). Eisenstein's cinema takes up in its own way the Russian school's pictorial and photographic formalism in order to create a dynamism of composition and a montage of shots.

Finally, if, under the condition of art shown by Jacques Rancière, politics traverses and distributes the field of images, then, contrary to the iconoclastic imprecations against the brainwashing of the sensationalism of appearances, images contest the distribution and hierarchies of the visible world, transgressing the boundaries of art and non-art and blurring the differences between the arts themselves. Confronted with a purist discourse, it appears that the displacement of art, which is translated today as an aesthetic and a critical distance in relation to common and anesthetizing images, can, rather than exclude images, play itself out in the creation of counter-images as the work of Bacon and Gauguin demonstrates.

Those who speak of a civilization, images, for better or for worse and in order to either condemn or make room for them, presuppose at least two things. The first would be a reign of images, under the form that Régis Debray calls 'the visual', at the expense of a spoken or written language that would be nothing more than its ornament or its redundant prolongation. The second is that the tide of images that threatens to submerge the regime of articulation and symbolic distancing would be homogeneous and undifferentiated. Yet, far from being established once and for all, these two views indeed derive

from a simplistic point of view regarding the mind that caricatures facts in order to better fold them into its catastrophist perspective. The simple example of televised news programmes should allow us to demonstrate that these perspectives are not assured. One sees news presenters, including the inescapable weather report, more often than images themselves, and when the image's turn comes, they usually become the object of very short sequences that are quickly covered back over and reframed by the commentary responsible for discharging their meaning. Supposedly attesting to facts, especially during a live broadcast, images are reduced, even though their selection and interpretation is up for discussion, to a precautionary and illustrative role according to formatted rubrics and opinions. Under the double pressure of an eagerness to not see and the instantaneous nature of commentary which fails to offer room for doubt, it is rare that time is afforded for regarding images, for a gaze that would allow us to perceive the image's details and measure its informative value. The informative potentialities of images are a function of a choice, a temporality of the gaze and the modalities of articulation and register-shift between the visible and the discourse. The frequent association of the image with instantaneity in opposition to the linearity of language is common place and derives from an imposed regime of the image. In contradistinction, time is required to see an image, to perceive its composition, or to remark on such singular details as 'a little patch of yellow wall'.[2] A slip of the tongue is noticed in an instant, but time is required to be attentive to visual details that cover over and isolate it. It is not the fault of images or of the fascination that they produce; rather it is a problem of time and speed in the apprenticeship and exercise of the gaze. One of the paradoxes of having an economy abundant with images is the time spent not looking at them.

As for the presupposition of the homogeneity of images, if it is partially explained by the televisual reign of images with its tendency, deriving from the screen's presence, towards the uniformization of the materiality and format of images, then it does not any more for that matter resist critical scrutiny. This does not hold only for the considerable technical progress realized as much in material depiction as in the staging and visual analysis of images, especially since differentiated regimes of the image indeed exist. Whenever the introduction of advertisement on television during the broadcast of films became an issue, Jean-Luc Godard, with his characteristic taste for disturbing paradox, suggested putting them to a test that would decide between the films that really make cinema and the others that only pretend to make it in clinging to a narrative thread. According to his reasoning, the consistency of a film would have been measured by its force of resistance towards the dissolvent and distracting images of advertising. And Eric Rohmer, fully engaging in the debate about the death sentence of cinema pronounced by television, rather than militating against the broadcast of films on the small screen, saw therein

a test of their force and of their artistic value. This is because the power of images obeys conditions other than the singular force of the visual impact tailored to anesthetize sensibility and the critical gaze. We saw how all this is connected more with the mode of composition, with the style of the montage and to the type of sound/image articulation that creates the space of images than to the format and the instantaneous emotional charge of this or that particular image. Differential, the power of the image is a matter of density in a milieu of images, and its force can be measured by a triple capacity: a capacity to conserve its form in an eminently unstable audio visual landscape, a capacity to perpetuate and renew its effects in neglected or changing contexts, and finally a capacity to interweave the narratives that initiate with it in order to prolong its impact and produce meaning. Just as in physics density does not refer to any substantial absolute, the density of images does not express an artistic essence that would tether it to a deep sense of the human condition in opposition to the lightness and distracting insignificance of everyday images. Rather density expresses a relation, a distance, a displacement that translates to a suspension of meaning, the respiration of an empty space and dead time, and if only through the absence of music, or even through the absence of sound, it allows the image to exist. Quasi-systematic in everyday life, just as it is on the screens, the contemporary coupling of image and music is a symptom, among others, of the fear, if not the hatred, of images. Far from the reign of 'telecreens',[3] assuring an undifferentiated reign of images, this televisual domination allows one, under critical and selective conditions, to differentiate between regimes of the images. We must henceforth add to this the possibility of interrupting the televisual flux by the viewing of DVDs of our choosing or image searches on the internet. Finally, the faculty of diversion from the screen remains at the disposal of other ends, as shown very early on by cineastes such as Chris Marker, by the artists of the Fluxus movement and by video artists today. Not only has the influx of images not put a stop to pictorial practice that continues to exist in a major mode by playing on the difference between its materials in relation to the analogical or digital image, but it gave birth with video to a new art of the analysis and creation of images, offering in its best realizations an alternative to dominant images.

In this context, rather than hear the announcement of the mind's shipwreck, we should see that there is a unique paradox in the desire for the advent of an authentic civilization of the image, commensurate to a civilization of writing and to the critical power sparked on the obverse of a new form of domination itself invented by this civilization. Inasmuch as we do not understand by the term *civilization* only the reign of an exclusive principal but also the struggle and the conflicts that therein play themselves out in order to make human life more livable, rich and dignified, it is important that a knowledge [*un savoir*], a practical know-how [*un savoir-faire*] and an

art of living with images be prioritized. To take but one example, there is the show Freeze-frame, otherwise excellent, about which it might be regretted that it only rarely lives up to its title; most of the time, the analysis bears on a news event related in images, but without stopping, precisely, on this or that particular image or sequence of images that could provide time to look and develop methods of analysis.

Yet if, far from excluding writing and speech, images call on writing and speech, then it is probably less in order to make themselves seen and understood in the well-known register of commentary and explication than through an entirely different function that we might call interruptive or interpellative. If it is undoubtedly true that images occasionally require the interpretation of speech in order to exist and bring forth their meaning, particularly in a context that ignores and misrepresents them, it is also undoubtedly true that it is often images alone that bring into existence what not a single word would have been able to reveal. This does not mean that the power of images, certain images at least, merely prosper from the impotency of speech and take up residence in its failure. Rather it means that there is an affirmative force proper to images in which it remains for speech only to take part and to take up its effects in order to marshal its energy and the force of its displacement. The relation between words and images is not univocal and does not entirely hold in the staging of their visibility and their interpretation. This relation is not simply a matter of reflection that claims that images make and think without being aware of it; it is also overturned in order to take in the force of its concussion and its misunderstood obviousness. Whenever Gauguin, to use him one last time as an example, speaks of 'the eye which listens', he is speaking of the *energeia* of the image, the lines and pure colours carrying away the unknown intensities of speech and then leaving them in suspense.

Images come about that force words to invent new turns of phrase and new ways of speaking. When painting stopped being a window open on to history, no longer displaying scenes or portraits, nor interiors or objects, and painters began painting any sort of fragment, tracing erratic lines and juxtaposing patches of colour, it was necessary to find a new language capable not only of putting the revolutionary passage from the form to the formless into words but also of accomplishing such a revolutionary promise within its own order. The critic was able to teach us how to see the novelty in a photograph or a film only by learning from them about the insufficiency of the old narratives and the necessity of seeing the characters and beyond them the space of their relations in another manner, and not without a feedback effect on our reception and perception of literature. Impressionism, cubism, fauvism and expressionism, in modifying our perception of space, induces transformations in our way of writing. They outlasted the very mode of description that painted space around or behind characters with the stability of an unchanging tableau.

For Joyce in *Ulysses* or for Proust in *In Search of Lost Time*, space ceased being a picture spread out before our eyes in order to become a labyrinth in which we lose ourselves or a landscape unfolding before us.

A civilization of images is a civilization that listens to images and gives itself the means to decide between those images made to impose silence and blindness and those images that give way to a displacement of the gaze; between those that command a cadence and a complicity and those that enter into resonance with forgotten and dissonant visibilities, between those that gather themselves together into a common identification and those that divide the community, in us and outside of us.

NOTES

1. Jean-Paul Sartre, *Baudelaire*, trans. Martin Turnell (New York: New Directions Publishing, 1967).

2. At the end of Proust's *In Search of Lost Time*, the author Bergotte passes away in front of Vermeer's *View from Delft*. 'A little patch of yellow wall' is the phrase that captures the minute detail that Proust's narrator recollects from this closing scene. [TR]

3. This term is George Orwell's famous invention in his novel *1984*.

Bibliography

Agamben, Giorgio. *Stanzas: Word and Phantasm in Western Culture*. Translated by Ronald L. Martinez. Minneapolis: University of Minnesota Press, 1993.

Alliez, Eric. *Défaire l'image. De l'art contemporain*. Paris: Les Presses du Réel, 2013.

Aristotle. *Complete Works: Volume 2*. Edited by Jonathan Barnes. Princeton: Princeton University Press, 1984.

Audry, Collette. *Sartre et la réalité humaine*. Paris: Seghers, 1966.

Bailly, Jean-Christophe. *Le Champ mimétique*. Paris: Seuil, 2005.

Balzac, Honoré de. *Théorie de la démarche*. Paris: Pandora Editions, 1978.

Baqué, Dominique. 'L'Impossible visage'. *Artpress* (November 2005), 317.

Barthes, Roland. *Camera Lucida*. Translated by Richard Howard. New York: Hill and Wang, 2010.

Bataille, Georges. *Manet*. Translated by Austryn Wainhouse and James Emmons. New York: Skira, 1983.

———. *Visions of Excess*. Edited by Allan Stoekl. Minneapolis: University of Minnesota Press, 1985.

Baudelaire, Charles. *Paris Spleen*. Edited by Thomas Cole. New York: New Directions Publishing, 1971.

———. *Selected Writings on Art and Literature*. Translated by P.E. Charvet. London: Penguin Books, 1972.

Baudrillard, Jean. *The Consumer Society: Myths and Structures*. Translated by J. P. Mayer. London: Sage Publications, 1999.

Bazin, André. *What Is Cinema? Volume 1*. Translated by Hugh Gray. Berkeley: University of California Press, 2005.

———. *What Is Cinema? Volume 2*. Translated by Hugh Gray. Berkeley: University of California Press, 2005.

Belting, Hans. *Florence and Baghdad: Renaissance Art and Arab Science*. Translated by Deborah Lucas Schneider. Harvard: Harvard University Press, 2011.

Benjamin, Walter. *Walter Benjamin: Selected Writings Vol. 2, Part 2, 1931–1934.* Translated by Edmund Jepcott and Kingsley Shorter. Cambridge: Belknap/Harvard University Press, 1999.

Bergson, Henri. *Key Writings.* Edited by Keith Ansell Pearson and John Mullarkey. New York: Continuum, 2002.

———. *Matter and Memory.* Translated by Nancy Margaret Paul and W. Scott Palmer. New York: Zone Books, 1991.

Bonitzer, Pascal. *Le Champ aveugle. Essais sur le cinéma.* Paris: Cahiers du Cinéma/ Gallimard, 1982.

Borreil, Jean. 'Préface'. In *L'Artiste-Roi.* Paris: Aubier, 1990.

Bredekamp, Horst. *Thomas Hobbes Visuelle Strategien. Der Leviathan: Urbild Des Modernes Staates, Werkillustrationen Und Portraits.* Berlin: Akademie-Verlag, 1999.

Cachin, Françoise. *Gauguin.* Translated by Bambi Ballard. Paris: Editions Flammarion, 2003.

Canguilhem, Georges. *The Normal and the Pathological.* Translated by Carolyn R. Fawcett. New York: Zone Books, 1991.

Cartier-Bresson, Henri. *Images À La Sauvette.* Paris: Verve, 1952.

Cavell, Stanely. *The World Viewed: Reflections on the Ontology of Film.* Cambridge: Harvard University Press, 1979.

Damisch, Hubert. 'D'un Narcisse l'autre'. *Nouvelle Revue de Psychanalyse Narcisse* 13 (Spring 1976).

De Certeau, Michel. *L'Absent de l'histoire.* Paris: Maison Mame, 1973.

Debord, Guy. *The Society of the Spectacle.* Translated by Donald Nicholson-Smith. New York: Zone Books, 1995.

Deleuze, Gilles. *Bergsonism.* Translated by Hugh Tomlinson and Barbara Habberjam. New York: Zone Books, 2011.

———. *Cinema 1: The Movement-Image.* Translated by Hugh Tomlinson and Barbara Habberjam. Minneapolis: University of Minnesota Press, 2013.

———. *Francis Bacon: The Logic of Sensation.* Translated by Daniel Smith. New York: Continuum, 2003.

———. 'Pericles and Verdi: The Philosophy of François Châtelet'. Translated by Charles T. Wolfe. *The Opera Quarterly* 21 (2006): 716–24.

Deleuze, Gilles, and Felix Guattari. *A Thousand Plateaus: Capitalism and Schizophrenia, Volume 2.* Translated by Brian Massumi. Minneapolis: University of Minnesota Press, 2005.

Denis, Maurice. 'Définition du néo-traditionalisme'. In *Théories.* Paris: Hermann, Miroirs de l'art, 1964.

Descartes, René. *Meditations on First Philosophy.* Edited by Stanely Tweymen. London: Routledge, 1993.

Descola, Phillipe, ed. *La Fabrique des images: Visions du monde et formes de la représentation.* Paris: Musée du quai Branly, Somogy Editions d'Art, 2010.

Diderot, Denis. *Diderot on Art: 1: The Salon of 1765 and Notes on Painting.* Translated by John Goodman. London: Yale University Press, 1995.

Dufrenne, Mikel. *The Phenomenology of Aesthetic Experience.* Translated by Edward S. Casey. Evanston: Northwestern University Press, 1989.

Duve, Thierry de. 'I Want to Be a Machine'. *La Recherche photographique* Special (1989).

Ehrenzweig, Anton. *The Hidden Order of Art*. Berkeley: University of California Press, 1969.

Fernandez, Dominique. *Le Musée d'Émile Zola*. Paris: Stock, 1997.

Ferrier, Jean-Louis, ed. *L'aventure de l'art au XIXe siècle*. Paris: Chêne/Hachette, 1991.

Foucault, Michel. *Manet and the Object of Painting*. Translated by Matthew Barr. New York: Tate, 2009.

———. *The Order of Things: An Archeology of the Human Sciences*. Translated by Pantheon Books. New York: Routledge, 1989.

———. 'Photogenic Painting'. In *Gilles Deleuze, Michel Foucault and Gérard Fromanger, Revisions: Photogenic Painting*. Translated by Daffyd Roberts. London: Black Dog Publishing, 1999.

Fried, Michael. *Absorption and Theatricality: Painting and Beholder in the Age of Diderot*. Chicago: University of Chicago Press, 1980.

Gauguin, Paul. *The Letters of Paul Gauguin to Georges Daniel De Monfreid*. Translated by Ruth Pielkovo. New York: Dodd, Mead and Company, 1922.

———. *The Writings of a Savage*. Edited by Paul Guérin. Translated by Eleanor Levieux. New York: Viking Press, 1978.

Godard, Jean-Luc. *Godard on Godard*. Translated by Tom Milne. New York: Da Capo Press, 1972.

Gombrich, E. H. *Art and Illusion: A Study in the Psychology of Pictorial Representation*. Princeton: Princeton University Press, 2000.

Gunthert, André. 'La Révolution de l'instantané photographique 1880–1900'. In *Cahiers D'une Exposition 15*. Paris: Bibliothèque nationale de France, 1996.

Hegel, G. W. F. *Aesthetics: Lectures on Fine Art, Vol. 1*. Translated by T. M. Know. New York: Oxford University Press, 1988.

———. *Reason in History*. Translated by Robert S. Hartman. Upper Saddle River: Prentice-Hall, 1997.

Henri, Loyette. 'Manet, la nouvelle peinture, la nature morte'. In *Manet, Les natures mortes*, Paris: La Martinière/Réunion des Musées Nationaux, 2001.

Imbert, Claude. 'Les Droits de l'image'. In *Michel Foucault, La peinture de Manet, Suivi de Michel Foucault, un regard*. Paris: Seuil, 2004.

Jacques, Derrida. *The Truth in Painting*. Translated by Geoff Bennington and Ian McLeod. Chicago: University of Chicago Press, 1987.

Kant, Immanuel. *Anthropologie d'un point de vue pragmatique*. Translated by Michel Foucault. Paris: J Vrin, 1988.

———. *Anthropology from a Pragmatic Point of View*. Translated by Robert B. Louden. Cambridge: Cambridge University Press, 2006.

Lacan, Jacques. *Écrits*. Translated by Bruce Fink. New York: W. W. Norton, 2006.

———. *Seminar XI: The Four Fundamental Concepts of Psychoanalysis*. Translated by Alan Sheridan. New York: W. W. Norton, 1998.

Leiris, Michel. *Brisées*. Paris: Mecure de France, 1966.

———. 'L'Ethnographe devant le colonialism'. *Les Temps modernes* 58 (1950).

————. *Miroir de l'Afrique*. Paris: Gallimard, 1996.

Lessing, Gotthold Ephraim. 'Laocoön: An Essay on the Limits of Painting and Poetry'. In *Classic and Romantic German Aesthetics*. Edited by J.M. Bernstein. Translated by W. A. Steel. Cambridge: Cambridge University Press, 2003.

Lichtenstein, Jacqueline. *The Eloquence of Color: Rhetoric and Painting in the French Classical Age*. Translated by Emily McVarish. Berkeley: University of California Press, 1993.

Loraux, Patrice. 'Qu'appelle-T-on Un Régime de Pensée?' In *La Philosophie déplacée. Autour de Jacques Rancière*. Paris: Horlieu éditions, 2007.

Loyette, Henri. 'Manet, la nouvelle peinture, la nature morte'. In *Manet, Les Natures Morte*. Paris: La Martinière/Réunion des Musées Nationaux, 2001.

Lucretius. *On the Nature of Things*. Translated by Frank O. Copley. New York: W. W. Norton, 1977.

Lyotard, Jean-François. *Discours, Figure*. Paris: Klincksieck, 1971.

————. *Discourse, Figure*. Translated by Antony Hudek and Mary Lydon. Minneapolis: University of Minnesota Press, 2011.

Maldiney, Henri. *L'art, L'éclaire de l'être*. Paris: Comp'act, collection Scalène, 1993.

————. *Regard, Parole, Espace*. Paris: Cerf, 1973.

Malraux, André. *Le Musée imaginaire*. Paris: Gallimard, 1965.

Marin, Louis. *Des Pouvoirs de l'image*. Paris: Seuil, 1993.

Mauner, Georges. 'Manet et la vie silencieuse de la nature morte'. In *Manet, Les Natures Mortes*. Paris: La Martinière/Réunion des Musées Nationaux, 2001.

Meddeb, Abdelwahab. *Contre-Prêches*. Paris: Seuil, 2006.

Merleau-Ponty, Maurice. *L' œil et l'esprit*. Paris: Gallimard, 1964.

Mondzain, Marie-José. 'Can Images Kill?' *Critical Inquiries* 36, no. 1 (Autumn 2009): 20–51.

Nancy, Jean-Luc. *Multiple Arts: The Muses II*. Translated by Simon Sparks. Stanford: Stanford University Press, 2006.

Noudelmann, François. *Sartre: L'incarnation imaginaire*. Paris: L'Hamattan coll. L'ouverture philosophique, n.d.

Perret, Catherine. 'Le Modernisme de Foucault'. In *Michel Foucault, La Peinture de Manet, Suivi de Michel Foucault un Regard*. Paris: Seuil, 2004.

Philostratus the Yougner. *La Galerie de tableaux*. Edited by François Lissarrague. Translated by Auguste Bougot. Paris: Les Belles Lettres, 1991.

Philostratus the Yougner, and Callistratus. *Philostratus. Imagines Callistratus. Descriptions*. Translated by Arthur Fairbanks. Vol. 256. Loeb Classic Library. London: William Heinemann, 1931.

Plato. *Complete Works*. Edited by John M. Cooper. Cambridge: Hackett Press, 1997.

————. *The Republic*. Translated by Alan Bloom. USA: Basic Books, 1991.

————. *The Symposium*. Translated by Seth Benardete. Chicago: University of Chicago Press, 2001.

Pliny the Elder. *Natural History Books XXXIII–XXXV*. Translated by H. Rackham. Cambridge: Cambridge University Press, 1938.

Rancière, Jacques. *Aesthetics and Its Discontents*. Translated by Steve Corcoran. Cambridge: Polity, 2011.

———. *The Aesthetic Unconscious.* Translated by James Swenson and Debra Keates. Malden: Polity, 2010.

———. *Disagreement.* Translated by Julie Rose. Minneapolis: University of Minnesota Press, 1999.

———. *Film Fables.* Translated by Emiliano Battista. New York: Berg, 2001.

———. *The Future of the Image.* Translated by Gregory Elliot. London: Verso, 2007.

———. *The Politics of Aesthetics.* Translated by Gabriel Rockhill. New York: Bloomsbury, 2015.

Riegl, Aloïs. *Problems of Style.* Translated by Evelyn Kain. Princeton: Princeton University Press, 1992.

Rimbaud, Arthus. *Arthur Rimbaud: Collected Poems.* Translated by Martin Sorrell. New York: Oxford University Press, 2001.

Rohmer, Eric. 'Le Cinéma, Art de l'espace'. *La revue du cinéma* 14 (June 1984).

Rousseau, Jean-Jacques. *The Discourses and Other Early Political Writings.* Translated by Victor Gourevitch. Cambridge: Cambridge University Press, 1997.

Said, Edward. *Orientalism.* New York: Vintage Books, 1994.

Sartre, Jean-Paul. *Baudelaire.* Translated by Martin Turnell. New York: New Directions Publishing, 1950.

———. *The Imaginary: A Phenomenological Psychology of the Imagination.* Translated by Jonathan Webber. New York: Routledge, 2004.

———. 'Intentionality: A Fundamental Idea of Husserl's Phenomenology'. Translated by Joseph P. Fell. *Journal of the British Society for Phenomenology* 1, no. 2 (1970): 4–5.

Schaeffer, Jean-Marie. *L'image précaire. Du dispositif photographique.* Paris: Seuil, 1989.

Segalen, Victor. *Essay on Exoticism: An Aesthetic of Diversity.* Translated by Yael Schlick. Durham: Duke University Press, 2002.

Simon, Gérard. *Archéologie de la vision.* Paris: Seuil, 2003.

Sontag, Susan. *On Photography.* New York: Rosetta Books, 2005.

Soulages, Pierre. *Image et signification.* Paris: Rencontre de l'école du Louvre, La Documentation Française, 1984.

Sylvester, David. *Interviews with Francis Bacon: The Brutality of Fact.* London: Thames and Hudson, 2014.

Valéry, Paul. *The Collected Works of Paul Valéry, Volume 1: Poems.* Edited by Jackson Mathews. Translated by David Paul. Princeton: Princeton University Press, 1971.

Vallier, Dora. *Abstract Art.* Translated by Jonathan Griffen. New York: Orion Press, 1970.

Vauday, Patrick. 'A Che Cosa Fa Pensare La Maccia Di Pittura?' In *Ai Limiti Dell'immagine*, 199–209. Macerata: Quodlibet Studio, 2005.

———. *Faut Voir! Contre-Images.* Paris: Presses Universitaires Vincennes, 2014.

———. *La Décolonisation du tableau.* Paris: Seuil, 2006.

———. *La Peinture et l'image. Y a-t-il une peinture sans Image?* Nantes: Plein Feux, 2002.

———. 'La photographie d'Est en Ouest. Echange de clichés et troubles d'identité'. *Diogène* 193 (2001): 62–74.

———. 'Sartre: L'envers de la phénoménologie'. *Sartre contre Sartre, Rue Descartes/ PUF*, no. 47 (2005): 8–17.

———. 'Vers des images sans corps?' *Revue Pratiques* 31 (February 1993).

Wollheim, Richard. *Art and Its Objects*. Cambridge: Cambridge University Press, 2015.

Zola, Émile. *The Masterpiece*. Translated by Thomas Walton. London: Elek Books, 1957.

Index

115

ightning Source UK Ltd.
ilton Keynes UK
HW03n1431160418
1131UK00001B/16/P